MOUNTAIN BREW

MOUNTAIN BREW

A GUIDE TO COLORADO'S BREWERIES

ED SEALOVER

Charleston London

THE
History
PRESS

Published by The History Press
Charleston, SC 29403
www.historypress.net

Copyright © 2011 by Ed Sealover
All rights reserved

Cover design by Karleigh Hambrick.

Front cover, bottom: Photo by Chrys Rynearson, exposur3.com.

First published 2011

Manufactured in the United States

ISBN 978.1.60949.177.2

Library of Congress Cataloging-in-Publication Data

Sealover, Ed.
Mountain brew : a guide to Colorado's breweries / Ed Sealover.
p. cm.
Includes index.
ISBN 978-1-60949-177-2
1. Breweries--Colorado--History. I. Title.
TP528.C6S43 2011
641.2'309788--dc23
2011102034

For my beautiful and inspiring wife, Denise, who has given me the confidence to believe that I can achieve my dreams.

Map 1

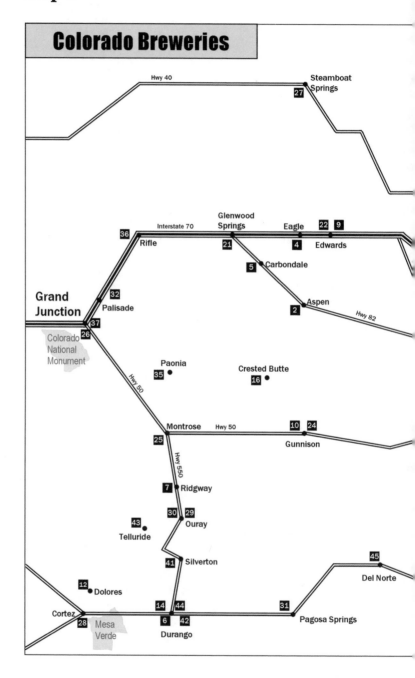

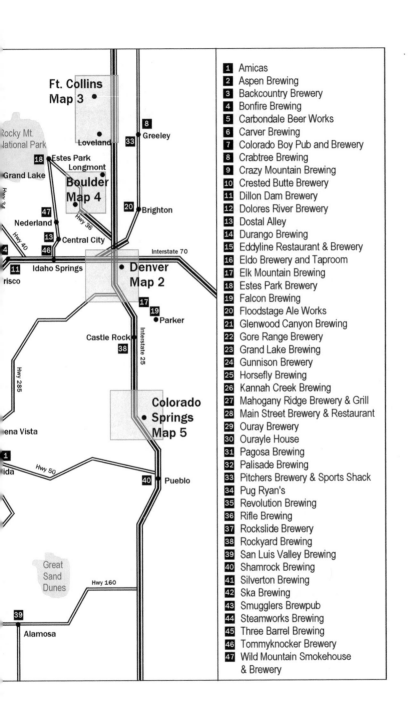

Ft. Collins
Map 3

Rocky Mt.
National Park

Loveland

33 Greeley

8

18 Estes Park
Longmont

Grand Lake

Boulder
Map 4

47

Nederland

20 Brighton

13 Central City

46

Interstate 70

11 Idaho Springs

Frisco

Denver
Map 2

17

19
Parker

Castle Rock

38

Interstate 25

Hwy 285

Colorado
Springs
Map 5

Buena Vista

1

Salida

Hwy 50

40 Pueblo

Great
Sand
Dunes

Hwy 160

39

Alamosa

	
1	Amicas
2	Aspen Brewing
3	Backcountry Brewery
4	Bonfire Brewing
5	Carbondale Beer Works
6	Carver Brewing
7	Colorado Boy Pub and Brewery
8	Crabtree Brewing
9	Crazy Mountain Brewing
10	Crested Butte Brewery
11	Dillon Dam Brewery
12	Dolores River Brewery
13	Dostal Alley
14	Durango Brewing
15	Eddyline Restaurant & Brewery
16	Eldo Brewery and Taproom
17	Elk Mountain Brewing
18	Estes Park Brewery
19	Falcon Brewing
20	Floodstage Ale Works
21	Glenwood Canyon Brewing
22	Gore Range Brewery
23	Grand Lake Brewing
24	Gunnison Brewery
25	Horsefly Brewing
26	Kannah Creek Brewing
27	Mahogany Ridge Brewery & Grill
28	Main Street Brewery & Restaurant
29	Ouray Brewery
30	Ourayle House
31	Pagosa Brewing
32	Palisade Brewing
33	Pitchers Brewery & Sports Shack
34	Pug Ryan's
35	Revolution Brewing
36	Rifle Brewing
37	Rockslide Brewery
38	Rockyard Brewing
39	San Luis Valley Brewing
40	Shamrock Brewing
41	Silverton Brewing
42	Ska Brewing
43	Smugglers Brewpub
44	Steamworks Brewing
45	Three Barrel Brewing
46	Tommyknocker Brewery
47	Wild Mountain Smokehouse & Brewery

Map 2

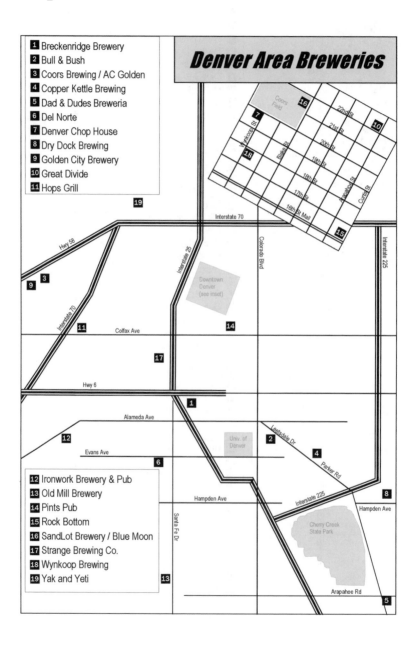

Denver Area Breweries

1 Breckenridge Brewery
2 Bull & Bush
3 Coors Brewing / AC Golden
4 Copper Kettle Brewing
5 Dad & Dudes Breweria
6 Del Norte
7 Denver Chop House
8 Dry Dock Brewing
9 Golden City Brewery
10 Great Divide
11 Hops Grill

12 Ironwork Brewery & Pub
13 Old Mill Brewery
14 Pints Pub
15 Rock Bottom
16 SandLot Brewery / Blue Moon
17 Strange Brewing Co.
18 Wynkoop Brewing
19 Yak and Yeti

Map 3

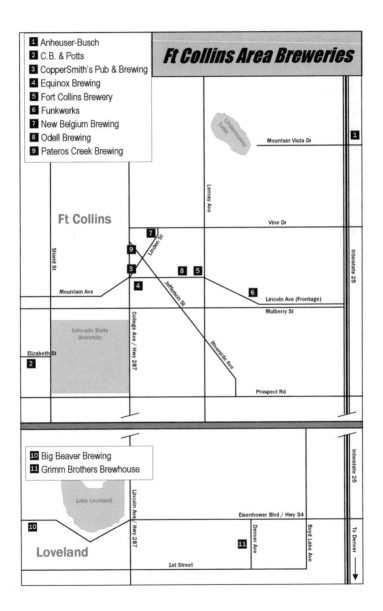

Ft Collins Area Breweries

1. Anheuser-Busch
2. C.B. & Potts
3. CopperSmith's Pub & Brewing
4. Equinox Brewing
5. Fort Collins Brewery
6. Funkwerks
7. New Belgium Brewing
8. Odell Brewing
9. Pateros Creek Brewing

Lindenmeier Lake

Mountain Vista Dr

Lemay Ave

Ft Collins

Vine Dr

Shield St

Linden St

Mountain Ave

Jefferson St

Lincoln Ave (Frontage)

Mulberry St

College Ave / Hwy 287

Colorado State University

Riverside Ave

Elizabeth St

Prospect Rd

Interstate 25

10. Big Beaver Brewing
11. Grimm Brothers Brewhouse

Lake Loveland

Lincoln Ave / Hwy 287

Eisenhower Blvd / Hwy 34

Denver Ave

Boyd Lake Ave

Interstate 25

To Denver

Loveland

1st Street

Map 4

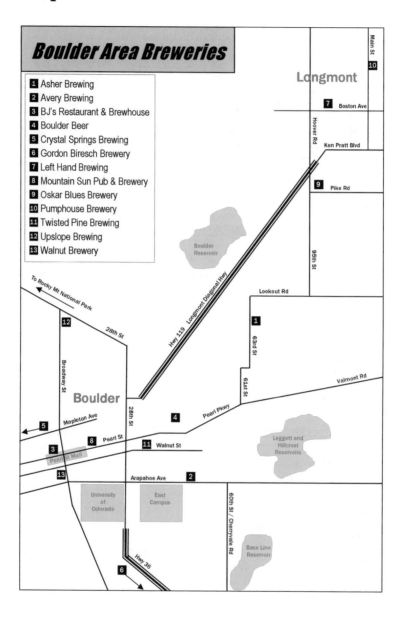

Boulder Area Breweries

1 Asher Brewing
2 Avery Brewing
3 BJ's Restaurant & Brewhouse
4 Boulder Beer
5 Crystal Springs Brewing
6 Gordon Biresch Brewery
7 Left Hand Brewing
8 Mountain Sun Pub & Brewery
9 Oskar Blues Brewery
10 Pumphouse Brewery
11 Twisted Pine Brewing
12 Upslope Brewing
13 Walnut Brewery

Longmont

Boston Ave

Main St

Hoover Rd

Ken Pratt Blvd

Pike Rd

95th St

Boulder
Reservoir

To Rocky Mt National Park

Lookout Rd

Hwy 119 Longmont Diagonal Hwy

28th St

63rd St

Valmont Rd

Broadway St

61st St

Boulder

Mapleton Ave

28th St

Pearl Pkwy

Pearl St

Walnut St

Leggett and
Hillcrest
Reservoirs

Pearl St Mall

Arapahoe Ave

University
of
Colorado

East
Campus

60th St / Cherryvale Rd

Base Line
Reservoir

Hwy 36

Map 5

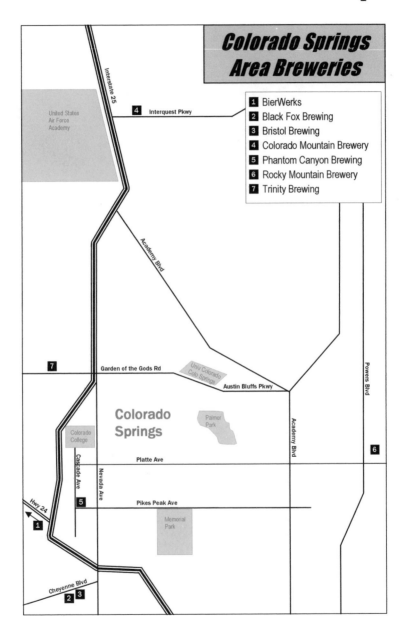

Colorado Springs Area Breweries

1 BierWerks
2 Black Fox Brewing
3 Bristol Brewing
4 Colorado Mountain Brewery
5 Phantom Canyon Brewing
6 Rocky Mountain Brewery
7 Trinity Brewing

CONTENTS

Acknowledgements 17
Introduction 19

1. COLORADO'S PIONEER BREWERIES
Boulder Beer 21
Carver Brewing 28
Coors Brewing 30
Crested Butte Brewing 32
Durango Brewing 33
Estes Park Brewery 35
Ironwork Brewery & Pub 36
Old Mill Brewery & Grill 37
Walnut Brewery 39

2. THE DOWNTOWN SAVIORS
Wynkoop Brewing 41
CooperSmith's Pub & Brewing 46
Glenwood Canyon Brewing 47
Gore Range Brewery 49
Phantom Canyon Brewing 50
Pints Pub 52
Pumphouse Brewery & Restaurant 53

CONTENTS

Rockslide Brewery 55
Shamrock Brewing 56

3. THE GREEN AND THE GRACIOUS: COLORADO'S ENVIRONMENTALLY AND SOCIALLY CONSCIOUS BREWERIES
New Belgium Brewing 58
Asher Brewing 64
Aspen Brewing 66
Big Beaver Brewing 67
Bristol Brewing 68
Eddyline Restaurant & Brewery 70
Odell Brewing 72
Revolution Brewing 73
Steamworks Brewing 75
Upslope Brewing 77

4. EXPERIMENTAL BREWERIES
Avery Brewing and Great Divide Brewing 80
BierWerks Brewery 86
Crazy Mountain Brewing 87
Crooked Stave 89
Left Hand Brewing 90
Pagosa Brewing 92
Strange Brewing 94
Twisted Pine Brewing 95

5. NICE NICHE: COLORADO'S MAKERS OF UNIQUE STYLES AND PACKAGES
Oskar Blues Brewery 97
AC Golden Brewing 102
Black Fox Brewing 103
Del Norte Brewing 105
Fort Collins Brewery 106
Funkwerks 107
Grimm Brothers Brewhouse 109
New Planet Beer 111
Pateros Creek Brewing 112

CONTENTS

6. THEY HAVE A BREWERY IN THIS TOWN? COLORADO'S SMALL-TOWN BREWERIES

Colorado Boy Pub & Brewery................114
Amicas Pizza & Microbrewery................119
Carbondale Beer Works................120
Dillon Dam Brewery................121
Dolores River Brewery................123
Eldo Brewery and Taproom................124
Grand Lake Brewing................126
Ouray Brewery................127
Silverton Brewery................129
Three Barrel Brewing................131
Wild Mountain Smokehouse & Brewery................132

7. AGAINST THE GRAIN: COLORADO BREWERIES THAT RUN COUNTER TO THEIR SURROUNDINGS

Trinity Brewing................135
Dostal Alley Brewpub................140
Falcon Brewing................141
Golden City Brewery................143
Palisade Brewing................145
Pug Ryan's Steakhouse Brewery................146
Rifle Brewing................147
Rockyard American Grill & Brewing................149
SandLot Brewery at Coors Field................151
San Luis Valley Brewing................152
Tommyknocker Brewery................154
Yak and Yeti................155

8. AMATEUR DREAMS: FROM HOMEBREWER TO PROFESSIONAL BREWER, OVERNIGHT

Dry Dock Brewing................157
Copper Kettle Brewing................161
Crabtree Brewing................163
Crystal Springs Brewing................164
Dad & Dudes Breweria................166
Elk Mountain Brewing................167

Gunnison Brewery 168
Horsefly Brewing 170
Ourayle House Brewery 171
Rocky Mountain Brewery 172

9. BEER HERE, THERE AND EVERYWHERE:
MULTIPLE-LOCATION BREWERIES
Rock Bottom Restaurant and Brewery 174
Anheuser-Busch 180
BJ's Restaurant and Brewhouse 182
Breckenridge Brewery 184
C.B. & Potts 185
Denver ChopHouse & Brewery 187
Gordon Biersch Brewery Restaurant 189
Hops Grill & Brewery 190
Mountain Sun Pub and Brewery 191
Smugglers Brewpub 192

10. INDEFINABLE BREWERIES
Ska Brewing 194
Backcountry Brewery 201
Blue Moon Brewing 203
Bonfire Brewing 205
Bull & Bush Pub and Brewery 206
Colorado Mountain Brewery 208
Equinox Brewing 209
Floodstage Ale Works 211
Kannah Creek Brewing 212
Mahogany Ridge Brewery & Grill 214
Main Street Brewery 215
Pitchers Brewery & Sports Shack 217

Index 219
About the Author 223

ACKNOWLEDGEMENTS

This book, like all great ideas, sprang from the twin muses of insobriety and desperation. It was conceived in late 2008 at a beer festival when friends goaded me to put my love of Colorado beer to more use. And two months later, when the owner of the *Rocky Mountain News* informed those of us on staff that it was looking to close the paper, I knew I had to find something else to do with my life. That led to the long and wonderful journey that ended in the printing of *Mountain Brew*, for which I have more people to thank than I have space to mention their names.

I want to start by thanking Kristy Swanson of the Brewers Association, who spurred me forward by telling me that a book like this needed to be written, and the wonderful folks at The History Press, who took the risk of putting this on paper. Kudos go especially to my commissioning editor, Becky LeJeune.

I want to thank all the brewers who took the time to sit down with me over the past two years to tell me their stories and reaffirm why what they do is so important. I have a special appreciation for Jason Yester of Trinity Brewing, who was my first interview for my first beer column with the *Colorado Springs Gazette* in 2003 and continues to help me understand the brewing world more deeply.

I have to thank my friends who helped me produce this book. Chase Stephens designed the web page, Andrew Mohraz advised me on my

contract, Dennis Schroeder tried to make me look good in a photo and Mary Winter and Cliff Foster edited me.

I want to thank also the friends who didn't abandon me when I disappeared into my home office for four months to write this book. And I must give a shout out to my current bosses at the *Denver Business Journal* who understood when I told them, "I can't cover that, I have an interview at a Fort Collins brewery."

I couldn't have done this either without the friends who ventured before me into the book-writing business and passed their knowledge down to me. Those include Brian Yaeger and especially Adam Schrager, who unselfishly gave his time to help me understand this business.

I feel I should thank influences from throughout my life who guided me inadvertently toward this project—from my parents, Ed Sealover and Sandra Walker, who instilled in me a love of reading, to my college professor Bob McClory, who encouraged me in 1994 to write my final Magazine Article Writing paper on the emerging craft brewing scene. I also have to thank God, for I know that whatever writing abilities I have came from Him and not from myself.

And last, but truly not least, I have to thank my wife and partner, Denise Sealover, without whom this book could never have been written. She was my driver for cross-state brewery trips, the designer of the book's maps, my planner, my executive assistant and my final editor. Most of all, she is my inspiration to try something greater than I think that I can do and to aspire to be something bigger than I could be on my own. Thank you for more than words can say.

INTRODUCTION

Over the past decade, the brewing industry in Colorado has made its mark on this state in much the same way that gold mining and ranching once did. Colorado has become known for its amber ales and IPAs just as much as it is revered for its snow-covered mountains and spacious national parks.

The number of breweries is increasing by the month. Twenty-two breweries featured in this book opened between the time I began work on it in January 2009 and the day I had to deliver the manuscript to my publisher in May 2011. And I can tally at least three others that were not open by my deadline but could be churning out beer by the time this book goes on sale.

I spent more than two years traveling the state, visiting with owners and brewers. I have lived in Colorado since 2000 but did not know before I started my trek that places like Ridgway or Paonia or Del Norte even existed. Now I know not only that these small towns are alive and well but that they are home to breweries that make astonishing beer.

Ken Jones, head brewer at Glenwood Canyon Brewing, put it best when he told me, "In Colorado you're not on the map unless you have a brewery in your town." This book is about those breweries and the cities and towns that are home to them. It is meant for beer geeks who want to sup up every drop of knowledge about the businesses that make this state "the Napa Valley of craft beer." It also is meant for tourists seeking

an offbeat experience and for beer-drinking Coloradans who set out to discover more about their home state. It is meant, in fact, for all who will take a sip of their beverage and want to know its full story.

The term "brewery" can mean a lot of things, and to properly convey the story of the brewing industry in Colorado, I chose to narrow the definition and exclude two types of fermented beverage makers: the state's half-dozen meaderies, which make a wonderful product but one that I feel is outside the classical boundaries of beer, and the four extract breweries, which, with their more simplistic brewing methods, I could not compare to beverage artists like Great Divide or Odell Brewing.

For the other 101 Colorado breweries, I've tried to recount the stories and traits that make them stand apart from their competitors. Breweries are grouped under categories that reflect their mission, location or most notable characteristic. Maps are available in the front of the book to use for touring, with each brewery getting one notation. For breweries with multiple locations, only their main facility is highlighted.

This is not a guide of what to drink. Though I've noted breweries' signature beers, I believe that only the drinker knows what's most enjoyable to him or her. Instead, the descriptions of each brewery are meant to serve as a complement or even companion to your time enjoying the beer.

I hope that by the time you've finished reading this—and, perhaps, visiting each of the breweries as I did—you have a greater appreciation of Colorado beer and the brewing culture that makes this state a standout in the industry. That culture is marked by a spirit of independence that will inevitably inspire dozens and dozens more brewers to make their magic in locations from three-story brewpubs to garage-based nanobreweries in the coming years. And it will continue to elevate Colorado in the eyes of beer lovers throughout the world.

Cheers.

CHAPTER 1
COLORADO'S PIONEER BREWERIES

BOULDER BEER

2880 Wilderness Place www.boulderbeer.com
Boulder (Map 4) 303-444-8448
Signature beers: Hazed and Infused (dry-hopped amber ale),
Mojo IPA, Singletrack Copper Ale
11:00 a.m. to 10:00 p.m. Monday–Friday; noon to 8:00 p.m. Saturday

Jeff Brown can still picture the summer of 2002, when he would show up to beer festivals and watch other brewers walk the length of the show to try Hazed and Infused, a dry-hopped amber ale that would forever change the fortunes of Boulder Beer Company.

Hazed and Infused wasn't the brewery's first head-turning beer. Boulder Beer, after all, is the oldest craft brewery in America, having opened in 1979. And it would not be the last great beer made by the pioneer brewery, which owns more than twenty-five medals from national and international competitions. Its Mojo IPA is lauded as one of the most unique citrus-flavored beers of its kind.

But after nearly two decades of fits and starts, of innovative recipes and severe marketing gaffes, of drawing the attention of every beer connoisseur in America and then nearly watching the brewery close, Hazed and Infused was the sign that Boulder Beer's legacy would live on. And it ensured that

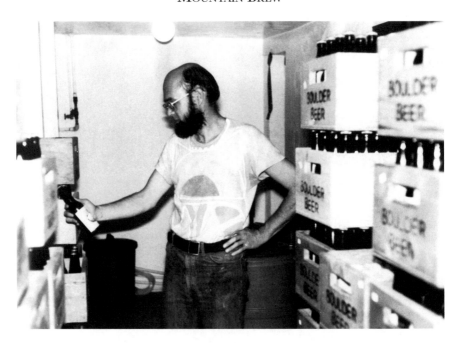

Boulder Beer cofounder David Hummer examines bottles from the first craft brewery to open in Colorado since Prohibition in the company's early days. *Courtesy of Boulder Beer.*

Colorado breweries that open today can owe a debt of gratitude not to a footnote in the history of craft brewing but to a beer maker that is as alive and vibrant as it was when it shocked the country by rolling out one of the first porters made in the United States in more than a century.

"I think people take a sense of pride in a brewery like ours that has a community," says Brown, Boulder Beer's president. "I still feel like we're the neighborhood brewery. Because we've been around since '79, I think there are some people who have the perception that we're much larger than we are."

Boulder Beer's story began in the most unlikely of places: the Joint Institute for Astrophysics at the University of Colorado. Physics professor David Hummer demonstrated to a colleague that he'd figured out how to make an English-style mash in a five-gallon Thermos cooler and brew a beer that couldn't be found in any local store. That colleague, physics professor and homebrewer Randolph "Stick" Ware, came up with an idea.

"I told David: 'We have to start a brewery,'" Ware recalls. Such words bordered on absurd back then. Only forty-two breweries existed in the

United States, and though some entrepreneurs were producing hoppier and darker selections, no one was challenging the big boys.

"I think the glorified homebrew concept was interesting and cute and didn't seem quite as crazy as somebody saying they were going to start a large-scale brewery," says Sierra Nevada Brewing founder Ken Grossman, a fellow pioneer who corresponded with the professors in the early days.

Hummer and Ware built a one-thousand-square-foot, two-story brewery on a Boulder County goat farm, a place Grossman remembers as "primitive." They chose the farm because their wives nixed the idea of a basement brewery, Hummer later told the *Rocky Mountain News*.

Colorado's first microbrewery began selling its products on July 4, 1980. Producing a bitter, a stout and that breakthrough porter, Hummer and Ware found people intrigued by these new versions of classic English-style beers. Brewing legends like English beer writer Michael Jackson and American Homebrewers Association founder Charlie Papazian dropped by to see what was happening.

But after six months of success, the wheels started to come off. The funneling system got infected with lactobacillus, a type of bacteria, and

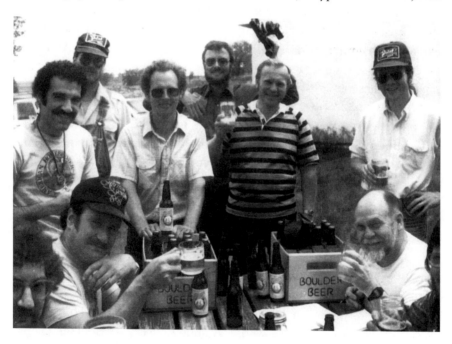

Early admirers enjoy Boulder Beer, including British beer writer Michael Jackson (lower left corner) and Great American Beer Festival founder Charlie Papazian (standing at left). *Courtesy of Boulder Beer.*

brewers had to dump entire batches. With no cash to pay for the losses, both Hummer and Ware mortgaged their homes. They couldn't pay salaries or payroll taxes, so the brewmaster left.

Ware remembered meeting someone years before who had pitched the idea of taking companies public by issuing penny stocks. He tracked down that man and signed on to the plan. And Boulder Brewing Company, as it was originally known, suddenly found itself sitting on $1.7 million in cash.

Confident they were over the hump, Hummer and Ware stepped away from day-to-day operations, though Ware remained on the board of directors. In 1984, the board built the current, spacious brewery in an industrial section of Boulder. It produced eight thousand barrels a year and sold beer in twenty-six states. As beers like Sam Adams and Sierra Nevada were catching on nationally, Boulder was among the leaders in a new trend.

But the company wasn't making money. And that drove the board to make decisions that were meant to improve the bottom line but that nearly killed the brewery. The first misstep was the "Ugly Beer" campaign, recalls Brown, who at the time was a restaurateur and sponsor of the fledgling Great American Beer Festival. Featuring an image of a sunglasses-wearing beer bottle hidden under a brown paper bag, the ad explained that unfiltered beers looked hazier and cloudier than American megabrews and suggested that if drinkers didn't like that, they could just pour out the sediment-filled last ounce. It bombed.

Then in 1987 came Sport, a Corona-style filtered light beer meant to appeal to the mass audience. Not only was the beer nothing like the darker, more flavorful beers with which Boulder Beer had burst onto the scene, but it was contract-brewed in Shiner, Texas. "It's almost like they told people: 'You're right. We're never going to get people to drink craft beer, so we're going to make a mass-produced product,'" Brown says.

Mike Lawrence, the brewery's fifth president in six years, told the *Boulder Daily Camera* in 1990: "I'll admit we prostituted ourselves." But the self-reflection came too late. Boulder Beer's full-time staff had shrunk from twenty-six workers to six in just two years. Investors filed a notice of intent to repossess the brewery.

In its darkest hour, the board, which no longer included Hummer or Ware, turned to Frank Day, whose Walnut Brewery in Boulder set the stage for his national chain of Rock Bottom brewery restaurants. Day and

his wife, Gina, bought Boulder Brewing, took it private and cleaned house. Gina brought in David Zuckerman from Portland's BridgePort Brewing to take over beer-making duties. Brown came on to oversee operations.

Zuckerman retooled the classic recipes. He also introduced Buffalo Gold, which thrilled fans of the nearby University of Colorado sports teams—whose mascot is the buffalo—and coaxed lighter-beer drinkers toward craft brews.

The new management team severed almost all of its distribution contracts outside of Colorado until it got problems under control. It expanded the brewery's kitchen to attract the lunch crowd from the surrounding business park. It opened a tasting room and started tours. And it did something that hadn't been done in a long time: it asked customers what they thought of the beer.

"In the early '90s, after we got the brewery turned around, there were a lot of people that really wanted the brewery to be successful," Brown says. "I think people really want to be able to say, 'This beer's made in my hometown' and be able to promote it to their friends."

Boulder Porter won a gold medal at the 1992 Great American Beer Festival, the largest gathering of brewers in the country and the annual standard for beer craftsmanship. Between 1990 and 1994, company sales grew by more than 800 percent and production jumped from three thousand barrels a year to more than twenty thousand.

Zuckerman began to introduce one or two new beers a year, including Singletrack Copper Ale, a medium-bodied, full-flavored malty beer that captured national honors. The company changed its name to Rockies Brewing Company to reflect its regional popularity.

In 2001, Zuckerman challenged his brewers to create more assertive styles. That's when brewer Aaron Hickman pitched the idea for a big batch of his favorite homebrew style—a dry-hopped amber ale he called Hazed and Infused.

As Boulder Beer leaders saw the reaction it got, they knew they had to make a big deal out of it. The company packaged Hazed and Infused with psychedelic-looking labels, and it became the brewery's top seller within eleven months.

"That was a turning point for us," Brown says. "Really, I think the success of the company was in producing a beer like nothing else on the market and then being able to market that beer."

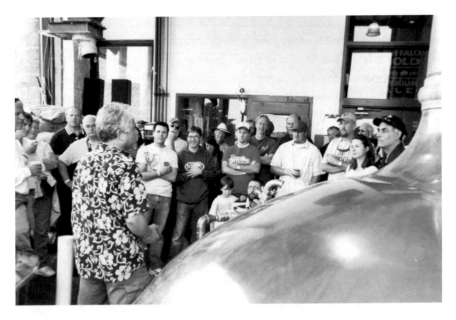

Current Boulder Beer head brewer Steve Trese gives a tour of the company's spacious brewery. *Courtesy of Boulder Beer.*

What followed Hazed and Infused in the "Looking Glass" series was a line of hoppier, maltier and higher-alcohol beers: Mojo IPA, Mojo Risin' Double IPA, Killer Penguin Barleywine, Obovoid Empirical Stout. These inspired brewers even further, and by the end of the decade the brewery was churning out pilot batches of Oak-Barrel Vanilla Stout and spice-enhanced beers.

In 2004, the brewery, by now assured of its future success, held its first annual Goatshed Revival to honor its past. Papazian presented Hummer and Ware with a plaque recognizing the pioneering spirit that helped launch craft beer in the United States.

In 2005, the brewery changed its name again to Boulder Beer Company to honor its roots and its community. Its stamp is seen throughout Boulder. It hosts city functions and charitable events, and Brown encourages his staff members to suggest ways the company can support their favorite nonprofits.

Today, Brown is a dispenser not only of beer but of advice as well. Brewers who seek out his counsel often ask how to weather the tough times and survive. "I think our influence has also been what you can

do to really remake yourself as a brewery, having gone through some very rough times in the late 1980s and having come back from that and having remade ourselves again with Hazed and Infused and Mojo," he says.

Ware, who can often be found in the taproom sipping a Mojo, laughs in retrospect at the missteps of two college professors wading into the corporate world. "We made every mistake in the book. We weren't businessmen, and I wanted to make beer," the cofounder acknowledges.

But he also understands that from that crazy idea came not just a company that is stronger than ever as it enters its fourth decade of business but an industry of more than one hundred small, local breweries in the state that followed it—as well as thousands nationwide.

"We had no dream that this would be this popular," Ware said during the thirtieth-anniversary celebration of Boulder Beer. "I guess it worked out well."

Boulder Beer celebrates its pioneering heritage at an annual festival called the Goatshed Revival, in honor of the farm structure that first housed the brewery. *Courtesy of Boulder Beer.*

CARVER BREWING

1022 Main Avenue www.carverbrewing.com
Durango (Map 1) 970-259-2545
Signature beers: La Plata Pilsner, Old Oak Amber Ale,
Jack Rabbit Pale Ale
6:30 a.m. to 10:00 p.m. daily

Not long after brothers Bill and Jim Carver opened a bakery on Main Street, Durango, in 1986, they decided making beer was an extension of making bread. So in December 1988, Carver Brewing opened in that bakery, becoming the second operating brewpub in Colorado, just two months behind Wynkoop Brewing.

Since then, some one hundred other brewpubs have opened in the state, and Durango is home to three other breweries. But Carver remains in the heart of town, and you can only get its beer at the brewpub—a reflection of the owners' close-to-home mindset.

Current Carver Brewing co-owners Erik Maxson, Aaron Seitz and Michael Hurst gather with founder/owners Bill (second from left) and Jim (far right) Carver. *Courtesy of Carver Brewing.*

"We're not looking to take over the world," says Erik Maxson, head brewer since 1999 and a co-owner. "It's not important to us that you get a Carver's beer in Texas...What's important to us is to take care of the people where you live."

Like many early brewpubs, Carver's existence began with hiccups. The truck driver who was supposed to deliver its first kegs quit in mid-job and left them instead at a rest stop 190 miles away in Grants, New Mexico. The brothers found their way south to retrieve them.

After that, Durango residents migrated to the new brewery. Locals took to the La Plata Pilsner and the Raspberry Wheat Ale, one of the first beers nationally to use raspberries. Families enjoyed the hot soups served in beer-bread bowls, and the Carvers let them know kids were welcome by putting out a box of toys.

By the time the second wave of Durango breweries was opening, Carver was an institution. Ska Brewing cofounder Dave Thibodeau remembers nervously approaching the brothers to ask if he could put his first tap in town in their restaurant. They embraced the idea, and a Ska tap remains in the brewpub today.

Carver's beers "straddle one foot in England and one foot in the U.S.," Maxson says. The brews include ambers and browns, pale ales and imperial pilsners. One fermenting tank is always dedicated to a cask ale.

Maxson also embraces experiments. An herb shop sits next door to the brewpub, and he frequently wanders in to find something that he can use to spice up his beers. Or he meanders to the kitchen of the brewpub and picks out some freshly roasted beans for his Powerhouse Porter with Coffee.

If Ska and its nationwide distribution chain is the bullmastiff in town, Carver is the Jack Russell terrier, the "little dog on the block," as Maxson puts it. But it's also become the patriarch of the local brewing scene.

Each April 7, Carver turns into a speakeasy, where members of the four local breweries' "Bootleggers Society" discuss the history of Prohibition in the town.

"I have huge ambition," Maxson says, "but I focus my ambition here."

Coors Brewing

Twelfth and Ford Streets www.millercoors.com
Golden (Map 2) 303-277-BEER (2337)
Signature beers: Coors, Coors Light, Killian's Irish Red
Tours 10:00 a.m. to 4:00 p.m. Monday–Saturday, noon to 4:00 p.m.
Sunday; closed Tuesday–Wednesday, Labor Day to May 31

To call Coors brewery, founded in 1873 in Golden, simply a Colorado beer-making pioneer would be a gross understatement. The truth is, much of American beer is a descendant of Coors.

The brewery introduced the aluminum can to the United States. It described its main product as a "light lager" before other megabreweries caught on to the concept. And it pioneered refrigerated trucks to keep its beer fresh on cross-country journeys.

And it all came from humble beginnings.

A Colorado classic—Coors Brewing Company has been brewing with Rocky Mountain water since 1873. *Courtesy of Coors Brewing.*

Adolph Coors stowed away on a ship from Germany to the United States at age twenty-one and made his way to Colorado. He originally named his business Golden Brewery and introduced Golden Lager in 1874. It won awards at the 1893 Chicago World's Fair.

Coors kept his brewery alive through Prohibition by producing malted milk and manufacturing ceramic dinnerware and pottery. Coors Brewing emerged in 1933 without having laid off a single employee, and it was one of the few breweries in the western United States that returned seamlessly to making beer.

Coors didn't market itself for the next forty-five years, yet it grew a national mystique. The plot of the 1977 movie *Smokey and the Bandit* revolved around bootlegging Coors cross-country.

In 1978, the company debuted its "Silver Bullet," the Coors Light brand that would go on to represent 70 percent of its sales. In the next decade, it expanded sales to every state and introduced creations like Keystone and Killian's Irish Red.

Though the company merged with Molson in 2005 and then formed a joint venture with Miller in 2007, its soul remains in Golden, where it continues to operate the largest single-site brewery in the world. Coors Banquet is brewed only there—with the Rocky Mountain spring water that has defined the company's advertising campaign.

Today, the brewery tour attracts 250,000 visitors per year. It includes a spin by the statue of Adolph Coors in downtown Golden, and free samples are offered at the end.

The brewery encourages volunteerism among its employees in order to keep close touch with its hometown. It's the same altruistic spirit that led it to create the aluminum can but not patent the product, so that all of America could use it.

Al Timothy, longtime Coors vice-president of community affairs, hopes beer drinkers support craft brewing and go out from time to time to brewpubs that began popping up more than a century after Adolph Coors began his business. But, he adds jovially, "When they come home, we hope they'll have a case of Coors Light in their refrigerator."

CRESTED BUTTE BREWING

212 West Highway 50 www.cbbrewingco.com
Gunnison (Map 1) 970-641-4487
Signature beers: Red Lady Ale (red ale), White Buffalo Peace Ale (pale ale)
3:00 p.m. to close Monday–Friday; 11:00 a.m. to close Saturday–Sunday

In the early 1990s, Gary Garcia cut a striking pose. The founder of Crested Butte Brewing traveled throughout the state with a horse trailer in tow to bring liquor stores his hand-bottled beer. "It was like Lonesome Dove delivering craft beer," remembers Joe Peters, manager of Applejack Wine and Spirits in Wheat Ridge.

Crested Butte was the seventh brewery to open post-Prohibition in Colorado, and its beers, especially Red Lady Ale, caught the state's imagination. Located in the Idle Spur restaurant in downtown Crested Butte, it was a haven for locals and visiting skiers.

After Garcia died, the brewery passed to his son Randy and to Randy's father-in-law, actor Tom Skerritt, best known as the star of the TV series *Picket Fences*. Skerritt pumped money into the business, and in 2000 it went big time, distributing its beer to twenty-two states.

But before the end of that year, the brewery buckled under missed orders. Its owners retreated and sold beer only out of the restaurant.

In 2008, more bad fortune: a snowfall brought down the roof of the Idle Spur. Robin Loyed, who had bought the brewery a year before, moved Crested Butte Brewing to Gunnison, roughly twenty-eight miles away, and did not reopen it until late 2010.

Loyed knew that Crested Butte Brewing had produced nationally award-winning beers and gained a loyal following. But it was only as he was preparing to resurrect the brewery that he learned just how influential the pioneer brewery had been. Months before Crested Butte even began putting out its product again, Denver bars called to inquire about ordering his beer. When asked how they knew about it, they said that they asked patrons to recommend guest taps, and many recalled their love of Red Lady Ale and other products.

"They were great beers," Loyed says. "Some people would come to Crested Butte, and they would ski or they would mountain bike, and they'd have a Red Lady and it was a great experience."

The new Crested Butte Brewing features a kitchen, giant patio and five classic beers on tap. In addition to Red Lady—a beer so famed it appeared in a 2000 national microbrew calendar—there is Paradise Crisp Golden Ale, White Buffalo Peace Ale, Jokerville IPA and Rodeo Stout Oatmeal. Loyed hopes to create a new batch of seasonals and offer as many as eleven beers on tap.

Eventually, he plans to distribute to liquor stores again, too. This time, he'll stick to Colorado—and the beers won't be sold out of a horse trailer.

DURANGO BREWING

3000 Main Avenue www.durangobrewing.com
Durango (Map 1) 970-247-3396
Signature beers: Durango Wheat, Durango Dark Lager,
Durango Derail Ale (strong ale)
Noon to 10:00 p.m. Tuesday–Saturday; 3:00 to 9:00 p.m.
Sunday–Monday

For the first sixteen years after its 1990 opening, Durango Brewing was a sleepy outpost with a cook-it-yourself grill and a reputation that didn't extend very far outside of southwest Colorado.

But in 2006, managing brewer Scott Bickert took over the historic brewery and vowed to change its "sit back, relax, that's cool, let's make some beer" attitude. It hasn't become an overly serious place—the Wednesday night open-mike bluegrass jam sessions don't bring in the buttoned-down crowd—but Durango Brewing now feels like it's got somewhere to go.

In 2007, Bickert began exporting his brews to bars throughout Denver. Durango Brewing is also bottling its classics and experiments, such as the two-time gold medal–winning Derail Ale double golden ale.

Recipes for the four staple beers—a wheat, a golden ale, an amber ale and a dark lager—remain largely true to the originals. These days, there are just more of them to enjoy. When Bickert took over, Durango Brewing had been producing about 1,100 barrels a year; by 2009, he had nearly doubled that total.

The new owners also built a taproom, popular with the happy hour crowd, in 2007. Half the nights of each week, cooks post menus on a

In addition to distributing statewide, Durango Brewing, founded in 1990, fills its bombers for local residents. *Courtesy of Durango Brewing.*

chalkboard. The other nights the brewery sells meat, supplied by the farmer who gets the brewery's spent grain, and lets customers cook it themselves.

Durango Brewing makes beer that, except for the 8.5 percent alcohol-by-volume Derail Ale, "is pretty much…the most drinkable, cleanest beer possible," Bickert says. The amber ale is decidedly unhoppy. The wheat is popular with the college crowd. And though Great American Beer Festival judges say the blueberry wheat ale is too subtle, that means the fruit is not overpowering and at the right level for Bickert.

Durango Brewing touts its pioneer history on its labels and on signs throughout the brewery. But it isn't stuck in the past. Rather, it's looking forward to letting a new generation of statewide drinkers know of beers that were conceived early in the craft-brewing movement that its fans find very satisfying even today.

"I want to say there's an end, there's a ceiling" to growth, Bickert says. "But I don't know until I get there."

ESTES PARK BREWERY

470 Prospect Village Drive www.epbrewery.com
Estes Park (Map 1) 970-586-5421
Signature beers: Longs Peak Raspberry Wheat,
Stinger Wild Honey Wheat, Redrum Ale
11:00 a.m. to 10:00 p.m. Sunday–Thursday; 11:00 a.m. to 11:00 p.m.
Friday–Saturday

While Colorado's earliest craft breweries concentrated on introducing their hometowns to new styles of beer, Estes Park Brewery set out to enlighten a different audience. Tucked in a vacation town at the mouth of Rocky Mountain National Park, it spread the craft-brewing message to visitors from the Midwest and elsewhere.

Colorado brewing pioneer Gordon Knight began his High Country Brewery in Boulder in 1993 but moved it northwest one year later to combine it with Ed Grueff's Events Center in Estes Park. Knight offered the coffee-tinged Estes Park Porter and hoppy Renegade IPA. But he discovered that the country music concertgoers at the events center favored mass-market light lagers.

So Knight developed a lighter option, Longs Peak Raspberry Wheat, in 1994. After he sold his half of the brewery later that year, current co-owner and brewer Eric Bratrud created Stinger Wild Honey Wheat. The two beers remain the brewery's most popular.

Today, the brewery offers eleven year-round beers, ranging from its golden Staggering Elk Lager to its 10 percent alcohol-by-volume Estes Park Barley Wine. Estes Park also makes two beers for the nearby Stanley Hotel, the haunted lodge that inspired Stephen King's *The Shining*. You can ask at the hotel or brewery for Redrum Ale or The Shining Pale Ale.

The brewery, which hosts Rocky Mountain Brewfest in its parking lot each summer, also features a souvenir store that is as expansive as its selection of beers. Behind it is the tasting bar, where guests can sample beers for free. Upstairs is a restaurant serving pizza, burgers and homemade beer chili.

Estes Park brewery has grown, but its beer is still distributed only in Colorado, except for one grocery chain in Wisconsin that sends drivers to pick up a supply. In fact, Estes Park is known as the quiet brewery among

the state's pioneers; it doesn't market itself much and hasn't changed its packaging in fifteen years.

"We try to be more of a destination place," Bratrud says.

IRONWORK BREWERY & PUB

12354 West Alameda Parkway www.ironworksbrewery.com
Lakewood (Map 2) 303-985-5818
Signature beers: Hopkilla IPA, Doc Henry's Irish Stout, Agave Wheat
 3:00 p.m. to 2:00 a.m. daily (open earlier on football weekends)

When restaurant turnaround specialist Mike Mader bought the Ironwork Brewery & Pub in 2007, it was, as he remembers it bluntly, "a dump."

The brainchild of founder Larry Irons, Irons Brewing Company had opened in 1989 as a draught-only place that served customers who hauled jugs into the brewery. It earned a substantial following, but as it changed owners and tried unsuccessfully to bottle its product, it ran into problems in the succeeding decades.

Mader, who had owned and sold other restaurants, saw promise. He was intrigued by the idea of brewing and serving beer, even though he had never been a homebrewer. He went through several brewers before finding the right one, and he set about to make Ironwork a family-friendly, sports-themed local hangout.

The brewpub now features a dance floor, a trio of pool tables and a couple of dartboards. Under a sign that reads "Area Club"—taken from the old McNichols Arena—is a door leading to a 925-square-foot back patio that is home to beanbag-tossing games in warm weather.

And it is a haven for Denver Broncos fans. Ironwork opens early on Saturdays and Sundays in the fall and is decorated with the football team's gear, a testament to Mader's devotion to the team. (Just ask him about his Super Bowl memorabilia.)

The brewery features seven taps, and its beers are classic styles, with German-inspired seasonals like a marzen and Oktoberfest joining a year-round lineup that includes a stout, a blonde and an amber ale. It also features what Mader touts as the first agave wheat beer produced in Colorado.

Customers are particularly fond of a range of dark but approachable stouts that Ironwork offers. And Mader says he knew he had a signature beer on his hands when, instead of asking for the IPA, regulars started saying, "Give me the Hopkilla."

The refurbishing of the brewpub remains a work in progress, but Mader says he likes what he sees.

"A lot of new people come in every day. You might have three generations of drinkers coming in at any time," he says of the grandfathers, fathers and sons who will order beer together. "It's changed a lot in twenty years...I want it to be a local pub."

OLD MILL BREWERY & GRILL

5798 South Rapp Street www.oldmillbrewery.com
Littleton (Map 2) 303-797-CHEF (2433)
Signature beers: Riverside Red, Old Mill Pilsner,
Rapp Street Lager (amber lager)
11:00 a.m. to 11:00 p.m. Sunday–Thursday; 11:00 a.m. to midnight
Friday–Saturday

Perhaps no brewery in Colorado is located in such a historic building as the Old Mill Brewery, which features the oldest grain elevator standing in the Denver metro area. Sitting on land homesteaded by city founder Richard Little, the Columbine Mill, opened in 1901, later became a mercantile company, a fuel company and, finally, a restaurant. That restaurant changed hands several times before a brewpub opened in 1994.

Owners Bill and Kathy Frangiskakis added their chapter to its storied history when they bought the brewpub in early 2008. And one of their first duties was to put an emphasis back on the beer. Old Mill offers seven signature beers that are always on tap: pilsner, red ale, brown ale, stout, IPA, lager and wheat. A former brewer bragged that he would offer Riverside Red in a blind taste test against better-known microbrews and would have it picked as the winner consistently.

But what really brings in the crowds, Frangiskakis says, is the rotating selection of fruit-flavored beers, three or four of which are typically on

Old Mill Brewery features the oldest standing grain elevator in the Denver metro area. *Courtesy of Old Mill Brewery.*

tap at a time. They include a strawberry wheat, a raspberry ale and a coconut porter—and have generated loyal followers for the brewery despite industry experts warning Bill that they wouldn't. "We have people who come in for the coconut porter and the strawberry wheat, and they get upset if they run out," said Frangiskakis, a Greek immigrant and restaurant industry veteran.

In addition to its history and its fruit beers, the Old Mill is known now for its customer service. If you order brand-name light lagers, the staff will also offer a free sample of the Old Mill Pilsner. If you order a sampler tray, there's a decent chance the brewers themselves will bring it to you and teach "Beer 101."

Between six-dollar-growler night and buy-one-get-one-free burger night, the Old Mill attracts a diverse crowd. Frangiskakis says you might not expect all of this inside a suburban former flour mill, but he hopes it will offer a pleasant surprise to visitors.

"You see the building from the outside, and it's a very, very satisfying thing once you walk in," he says. "We have built it into a regular customer base."

WALNUT BREWERY

1123 Walnut Street www.walnutbrewery.com
Boulder (Map 4) 303-447-1345
Signature beers: Old Elk Brown Ale, St. James Irish Red Ale,
Sled Dog Red
11:00 a.m. to midnight Sunday–Wednesday; 11:00 a.m. to 2:00 a.m.
Thursday–Saturday

Picture 1990: the early boom days of the brewpub movement. Boulder's newly opened Walnut Brewery had simple reds and browns on tap. University of Colorado staffers crammed into the place. And the bartender poured as many shots of liquor for the staff as draughts of beer for the customers.

You're not likely to see the shot-fest anymore. But little else has changed about Boulder's first brewpub. It eschews experimental beers for classic American styles like a brown ale and red ale. The interior, with fermenting tanks above the bar, looks the same. And the UofC crowd still supports the place.

Walnut's longevity might be based on its consistency. Brewmaster Rodney Taylor has left the Big Horn Bitter and Devil's Thumb Stout recipes unchanged for more than two decades. And even the seasonal Sled Dog Red, the product of a day-with-the-brewer contest in 2000, is still made annually by the same local homebrewer whose name was pulled from a hat at the turn of the century.

"My philosophy of this job is that I feel like it's a lot bigger than me," says Taylor, brewmaster since 1999 and a regular since Walnut opened. "There are people who were here before me and who will be here after me, and this is their place. I'm just trying to take care of it while I'm here."

Walnut founder Frank Day had operated Old Chicago restaurants for fourteen years before getting in on the brewpub craze in 1990. The success of the Walnut inspired his Rock Bottom brewpub chain, which now has thirty-four locations in sixteen states.

The early days of the Walnut were wilder, Taylor admits. Some regulars still talk about an employee many years ago who was enjoying relations with a woman in the mill room above the brew house—without realizing that everyone in the bar could see.

Today's most discussed activities are a little saner. Longtime customers have formed a Walnut Activity Club that will hike or bike on weekends before coming back and enjoying a few pints. Despite being only steps from the UofC campus, Walnut attracts college staffers and longtime Boulder residents more than students. And it shows its age in its approach to brewing that has created those unswervingly loyal customers.

"It's maybe not real easy on the eyes. It's a little beat up. And there's a little dust here and there," Taylor says with a smile. "But it's well worn, and that really appeals to me."

CHAPTER 2
THE DOWNTOWN SAVIORS

WYNKOOP BREWING

1634 Eighteenth Street www.wynkoop.com
Denver (Map 2) 303-297-2700
　　Signature beers: Rail Yard Ale (amber ale), B3K Schwarzbier,
　　　　　　　　　　Patty's Chile Beer
　　　　　　　　11:00 a.m. to 2:00 a.m. daily

Were it not for a couple of well-timed layoffs, the notion that a brewpub could bring new life to dead downtowns may never have taken hold.

Oh sure, a few places had discovered in the late 1980s that a business that offered food and unique beer could draw people back to the city center. But it took a recently unemployed cook, an award-winning homebrewer and an out-of-work geologist to demonstrate that a brewpub could be the spark that turns a deserted section of a big-city downtown into a thriving entertainment district.

And within a few years of Wynkoop Brewing's 1988 opening in Denver's Lower Downtown district, the partners—chef Mark Schiffler, brewer Russell Schehrer and ex-geologist John Hickenlooper—were setting up pubs in renovated downtown buildings from California to West Virginia.

Wynkoop Brewing was the national model for restoring a blighted business district through a brewpub. The strategy has been successfully replicated across the country. *Courtesy of Wynkoop Brewing.*

"Brewpubs were fresh and new and they had a cachet. They had a romance," says Hickenlooper, who fifteen years later would become the mayor of Denver and twenty-two years later would be elected Colorado governor. "The appeal is universal. People do love beer. And you know it's one of those cool things. It got people excited and it brought attention to the downtowns."

Hickenlooper didn't start out wanting to be a brewer. In the early 1980s, he was a geologist, and a pretty good one at that, he'll tell you. Then, on July 5, 1986, he got laid off—with two years' worth of severance pay. He bought a bright red Chevy Malibu and drove to California to help his brother fix a house. While there, he unsuccessfully pitched scripts for the television shows *Night Court* and *Moonlighting*. But his life-changing moment came when he dropped in to the Triple Rock Brewery in Berkeley, one of America's first brewpubs.

Hickenlooper had never considered brewing and selling beer at one location, but the line out the door of the Triple Rock—on a Wednesday night, no less—got him thinking. By early 1987, he'd found his career path.

At the time, there wasn't a brewpub between Chicago and California. So when he started stumping for money to launch the business, he often was shown the door. Even his mother wouldn't give him a loan. "She kept saying, 'Who's going to want to eat dinner in a brewery?' I said, 'No, no, no, Mom, it's like a bakery. It's fresh, it smells good, it's appetizing.'"

The six partners (three others played smaller roles or left the business sooner) looked at thirty-four historic buildings to set up shop, seeking a place that played off Denver's history as well as the traditional role of

pubs as a center of community. The J.S. Brown Mercantile Building, built in 1899, fit the bill.

But their plan carried plenty of risk. Lower Downtown Denver, or LoDo, was a ghost town at the time. No new restaurants had opened in the district in five years. Tumbleweeds literally blew down two of the main streets. "It was a totally unknown concept in seemingly a crazy location," Schiffler remembers. "There wasn't anything down there, any reason to work down there."

To even begin operations, the partners had to get laws changed. After Prohibition, state statutes allowed a business to manufacture, distribute or sell beer but not to do all three. Hickenlooper and his partners successfully lobbied the state legislature to change the rules to allow Wynkoop to make and sell its beer in one location.

The opening of Wynkoop on October 14, 1988, was big news in Denver. Mayor Federico Peña cut the ribbon. All three local TV stations covered the event. The *Denver Post* ran a front-page color picture of a bartender hoisting a pint.

Crowds packed the new brewpub. Workers in the business district farther east would take the city's shuttle bus to Wynkoop for lunch. Within a few years, Hickenlooper and his partners built an upscale billiards hall on the second floor and converted the building's upper floors into residential lofts—only the second such housing in downtown.

LoDo had life again. Ten restaurants opened in the area over the next four years. Two other brewpubs debuted.

While this was going on, Hickenlooper and Schiffler were planting seeds elsewhere. By the end of 1988, they had an agreement with an entrepreneur to help open CooperSmith's Pub & Brewing in Fort Collins. By 1991, Schiffler found himself in Rapid City, South Dakota, helping to open Firehouse Brewing. He had met a few Broncos fans from South Dakota the summer before, and they wanted in on this relatively new concept.

Indeed, brewpub fever was spreading. From 1985 to 1995, the National Trust for Historic Preservation estimated that an average of one brewpub a week opened in the United States.

Hickenlooper was the schmoozer of the group. He talked to people who flocked to Wynkoop when the Great American Beer Festival was in town. He spoke at brewers' conferences. He got invitations to talk about the economic power of brewpubs to groups across the country.

A cornerstone of the revitalization of Denver's Lower Downtown neighborhood in the late 1980s, Wynkoop Brewing is located in the 1899 J.S. Brown Mercantile Building. *Courtesy of Wynkoop Brewing.*

In 1993, Schiffler spent nearly the entire year on the road consulting with potential brewpub owners. The men who christened Wynkoop also put up the money and expertise that launched pubs in Buffalo, Des Moines, Green Bay, Omaha, San Francisco and Wheeling, West Virginia. All of them went into renovated historic buildings.

Neither Hickenlooper nor Schiffler, nor just about anyone involved in downtown revitalization, can put their finger on the exact reason brewpubs offer a shot of adrenaline for dormant neighborhoods. Schiffler theorizes that people make a historical connection when old buildings are brought back to life and an old industry moves into them. Every decent-sized town in America had a brewpub before Prohibition. Hickenlooper says brewpubs have wide appeal because they are a social equalizer, a place where suits and hardhats can connect over a common denominator—the beer in front of them.

Jon Schallert, a Colorado-based national retail consultant and downtown redevelopment expert, thinks there's something else going on as well. Most downtown brewpubs advertise largely by word of mouth and pick up customers who believe they've found something cool and

different. Most also have mug clubs or some special privilege for regulars that creates a sense of membership and belonging that isn't found at a chain restaurant. "They can go into marginal locations, they could go into where other businesses can't succeed...and as customers come in and people become exposed to the product, it becomes this great little secret that they find," Schallert says. "And people really like things that are a secret."

Wynkoop has undergone several changes through the years. Schehrer, the original Wynkoop brewer who died in 1996, once poured every beer British style, with hand pumps and at cellar temperatures. "Warm and flat is where it's at," he'd declare. While Wynkoop still has several hand-pumped beers, its menu includes more American styles now, served colder and more carbonated. The brewpub also has augmented its six original offerings with many more complex and challenging beers.

The remaining owners bought out Hickenlooper in 2007 when he sold off his business holdings to concentrate on his political career. He never lost his love of the place, though. After taking his oath as Colorado governor in January 2011, he rode to his inaugural reception in a horse-drawn Wynkoop beer carriage.

Schiffler is now the chief operating officer of a company that owns six Denver bars and one Colorado Springs brewpub. In 2011, it entered into a joint venture with the owners of Breckenridge Brewery.

But some things don't change. Martha Williams, one of the original six owners, remains a floor manager at the Wynkoop.

"We were successful in spite of ourselves, not because of ourselves," Schiffler jokes. "It was one of those serendipitous times when everything worked when nothing should have worked."

For his part, Hickenlooper has a "right time, right place" take on it all. "There was something viable in the concept. And I think that downtowns were waiting," he says. "There was a potential energy there.

"In society, downtowns are valuable. And there were enough Baby Boomers like myself who were coming of age who were bored. They were sick of mowing the lawns. They were bored with their suburban lives. They would rather spend more time at pubs drinking with their friends, telling stories and going to movies and, you know, hanging out."

But he's quick to defend one ritual of suburbia: "I like backyard barbecues. You can drink beer there too."

COOPERSMITH'S PUB & BREWING

5 Old Town Square www.coopersmithspub.com
Fort Collins (Map 3) 970-498-0483
Signature beers: Punjabi Pale Ale, Albert Damm Bitter,
Sigda's Green Chili
11:00 a.m. to 11:00 p.m. Sunday–Thursday; 11:00 a.m. to midnight
Friday–Saturday

Scott Smith knew a good thing when he saw it. Shortly after Denver's Wynkoop Brewing debuted in 1988, he sought out the founders for advice and a business plan. And less than a year later, he and business partner Brad Page opened CooperSmith's Pub & Brewing in Fort Collins.

Like Wynkoop, CooperSmith's helped revitalize a downtrodden section of downtown. It opened in Old Town Square, a neighborhood where government and private investors joined forces to renovate seven turn-of-

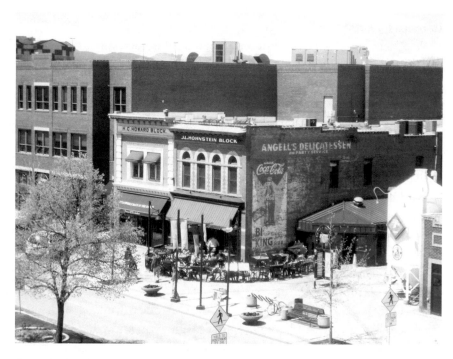

CooperSmith's Pub & Brewing went into a former grocery store and became one of the catalysts of the redevelopment of Old Town Fort Collins. *Courtesy of CooperSmith's.*

the-century structures and build five new additions. CooperSmith's is in an old grocery store in what is now the thriving heart of the city.

But in 1989, it took guts to open in Old Town. And it took a good deal of patience to sell light-lager drinkers on the concept of hand-pumped, English-style ales, never mind the chili beer the brewers introduced just a year later.

"I don't want to say that we revived Old Town, but we were there when Old Town really started to bear fruit and became a viable retail and entertainment district," says Dwight Hall, head brewer. "I think it wasn't completely a coincidence."

CooperSmith's has fourteen taps and seventy-six rotating recipes. Among them are English-style IPAs, Belgian-style krieks and Sigda's Green Chili, believed to be the first regularly served chili ale in the state when CooperSmith's added it in 1990.

CooperSmith's is just blocks from Colorado State University, but it serves mostly young professionals and families. It isn't a rocking college hangout, though its pool hall across the walkway from the pub stays open until 2:00 a.m.

Don't let the management tell you they don't have a little college humor left in them, though. If you want a hand-drawn version of their best-selling Punjabi Pale Ale, request it by its name: Hanjabi.

You won't find CooperSmith's beer on tap anywhere else. It's a local place, and that's the way its owners want it. "We are so interwoven into the fabric of the Fort Collins community," Hall says, "I really feel like we are Fort Collins's hometown brewpub."

GLENWOOD CANYON BREWING

402 Seventh Street www.glenwoodcanyon.com
Glenwood Springs (Map 1) 970-945-1276
Signature beers: Vapor Cave IPA, Hanging Lake Honey Ale,
Strawberry Daze
11:00 a.m. to 11:00 p.m. Sunday–Thursday; 11:00 a.m. to midnight
Friday–Saturday

As downtowns across Colorado blossomed with the introduction of brewpubs in the early 1990s, Glenwood Springs residents watched with

envy. They wanted in on the action, and they hoped someone would step up and open a place.

So after the success of a local beer festival, Steve and April Carver decided to replace the last of the line of failing restaurants on the bottom floor of their historic Hotel Denver with Glenwood Canyon Brewing. "There were people here who felt they were somehow getting left out of [the downtown brewpub boom], so they were looking for a place like this," says Ken Jones, the brewery manager since it opened in 1996. "It is really gratifying to be a part of this because it is a social center for the town—and in a way that other bars and restaurants can't quite duplicate."

Glenwood Springs is a historic town, known for its hot springs, the Hotel Colorado and the unmarked grave site of Doc Holliday. Soon after Glenwood Canyon opened, downtown began to change. The brewpub helped to pull pedestrians and cars off Grand Avenue to the old downtown area east of that main thoroughfare.

Glenwood Canyon's beers are not envelope-pushers but are exemplary of their styles. The Vapor Cave IPA is a classic English ale, the award-winning Carbonator doppelbock is German-influenced and top-selling Hanging Lake Honey Ale is very close to the golden ale style guide. "Most

Glenwood Canyon Brewing Company is located in downtown Glenwood Springs, just a few blocks off the banks of the Colorado River. *Courtesy of Glenwood Canyon Brewing.*

The Downtown Saviors

of what we do is make something that would fit your expectations," Jones says of his beer, sold only at the brewery.

But there are diversions from the norm, such as Strawberry Daze, an amber ale brewed with three hundred pounds of strawberries for the town's annual Strawberry Days festival in June. Locals buy boxes of growlers at a time, and it usually sells out in a week.

There was a pre-Prohibition brewery in town, though Jones, a history buff, says research on it has turned up very little. But he hopes his creations are writing the next chapter in Glenwood Springs' brewing annals. "I feel I'm just a contemporary part of that story," he says.

GORE RANGE BREWERY

105 Edwards Village Boulevard, Building H www.gorerangebrewery.com
Edwards (Map 1) 970-926-BREW (2739)
Signature beers: Powder Day Pale Ale, Great Sex Honey Ale,
Fly Fisher Red Ale
11:30 a.m. to 10:00 p.m. Monday–Saturday; noon to 10:00 p.m. Sunday

When Jeremy Pluck told a brewery coworker in 1997 that he was leaving for a start-up brewery in the Vail suburb of Edwards, she was dumbstruck. "She's like, 'Edwards? There's nothing in Edwards,'" Pluck remembers.

And at that time, she was pretty close to right. There were about four restaurants in the town, which is fifteen minutes west of the famed ski area, and Gore Range Brewery was going up near a strip mall that was under construction.

A decade and a half later, Edwards is home to some ten thousand people, and the town has grown up around Gore Range and the restaurants that followed it. The brewery, which has a constant mouth-watering smell of barbecue, has proved that there is something in Edwards.

Pluck keeps six beers on tap, including the bestselling Powder Day Pale Ale, which has been increasingly hopped over the years, and a brew with a full-of-promise name, the Great Sex Honey Ale. In recent years, he also has expanded the menu of seasonals and experimental offerings, producing treats like the Discombobulation Belgian tripel and the Lupulus Maximus IPA.

49

But Gore Range's usual brewing style harkens back to its origins, when many customers were just starting to explore craft brewing. Pluck makes down-to-earth beverages a person can enjoy while eating a burger, and he still guards against going off the charts with his creations. "I don't want to see beer and brewing be mired in a lot of…pomp and pretentious snobbery," he says. "I think that, fundamentally, beer is about enjoyment."

That attitude was an immediate hit. Gore Range often ran out of stock in its first year as it tried to serve an ever-growing crowd.

While the Vail Valley is best known as a winter vacation destination, Gore Range does just as much business in the summer. Its back patio teems with locals when the sun shines. "On a warm day, that deck is a beer consumption machine," says Pluck.

PHANTOM CANYON BREWING

2 East Pikes Peak Avenue www.phantomcanyon.com
Colorado Springs (Map 5) 719-635-2800
Signature beers: Cascade Amber Ale, Phantom I.P.A.,
Queen's Blonde Ale
11:00 a.m. to close daily

The historic building now housing Colorado Springs' oldest all-malt brewpub was just days from demolition when John Hickenlooper, founder of Denver's Wynkoop Brewing, put down his own money to save it. That impulse purchase kick-started Phantom Canyon Brewing, gave a jolt to downtown and helped to persuade other restaurateurs to set up shop in the area. Within three years of its 1993 debut, another six breweries had moved nearby. Nearly two decades later, the former railroad office is a brewing institution.

"We had in mind that we wanted to bring brewpubs to the world," founding partner Mark Schiffler says. "We were going into places where no one else had been but where few people wanted to venture."

After buying the building, Hickenlooper sold it to Wynkoop Holdings, making it the brewpub pioneers' second Colorado business. They brought in equipment and furnishings from all over, including a first-floor bar embedded with fossilized fish. They also set up a second-floor pool

Phantom Canyon is a downtown Colorado Springs landmark, opened in 1993 in a former railroad office. *Courtesy of Phantom Canyon Brewing.*

hall and a top-floor banquet hall that hosts events as varied as wedding receptions and theology talks.

At the bar, one can find six permanent beers on tap, plus a couple of seasonal and cask ales. The Queen's Blonde Ale has long been the bestseller, but the Phantom I.P.A. has the most fanatical backers.

In recent years, Phantom Canyon has become more experimental, with brewer Alan Stiles offering "extinct styles" such as pre-Prohibition pilsners.

There are no canyons near the brewpub, but there are a couple of phantoms. In 2009, members of a paranormal society examined strange happenings in the place. They concluded that two spirits—a male and female who don't get along—hang around the brewpub. They don't bother customers, but general manager Robin Hubbard has heard her name whispered in a hallway when no one's around, and the cleaning staff have seen ashtrays fly off tables and smash against walls.

None of those ghost stories would be told today if Hickenlooper, Schiffler and partners hadn't taken a chance on a building in an aging part of Colorado's second-largest city.

"It was successful from the get-go," Schiffler says in retrospect. "Certainly we were some catalyst and showed people there is vitality downtown."

PINTS PUB

221 West Thirteenth Avenue www.pintspub.com
Denver (Map 2) 303-534-7543
Signature beers: Phone Box Amber Ale, Dark Star Ale
(cask-conditioned brown)
11:00 a.m. to close daily

If you talk long enough with Pints Pub brewmaster Tom Scott, you'll hear a trace of an English accent. Scott is a full-blooded American, but he attributes the dialect to "too much Monty Python as a teenager" and to more than fifteen years hanging out with Brits at his business.

The red brick pub with the state's largest selection of whiskey was just the second restaurant to open in the "bail bond district," down the street from the state capitol, in 1993. But as the area has improved, it has become a haunt for British ex-pats and curious Gen X-ers alike.

Pints Pub serves up English-style ales and a solid menu of pub fare, right down the street from the Denver Art Museum. *Courtesy of Pints Pub.*

"The main reason people come here is it's a pub and what that means," Scott says. "Not a sports bar. Conversation. Cozier. Quieter."

Pints opened when many beer drinkers expected frothy, cold ambers and blondes from breweries. Yet customers at Pints found a different menu: hand-pumped, cask-conditioned ales served at fifty degrees. That attracted a lot of foreign-born customers, though the clientele has since diversified.

And as the surrounding landscape morphed, with the reconstructed city library and then the Denver Art Museum expansion, the beers at Pints evolved as well. Originally just a server of British ales, it began making its own beer in 1996. To its list of traditional English-style beers, Pints added a stout, a blonde and a wheat. The nine-beer list covers most essential styles.

But some things don't change, and Pints still keeps two cask-conditioned ales on tap: Lancer India Pale Ale and the popular Dark Star Ale of the nut-brown variety. They age between six weeks and three months before being dry-hopped for a second fermentation, and they are believed to be the first cask-conditioned, locally brewed beers to be offered in the state.

And the ingredients remain solidly British. Hops and grain are imported from the United Kingdom. Even the water is altered with additional calcium, gypsum and salt to make it harder and resemble British water. And in keeping with the pub's pedigree, Pints features a red London phone booth and a daily selection of British newspapers.

PUMPHOUSE BREWERY & RESTAURANT

540 Main Street www.pumphousebrewery.com
Longmont (Map 4) 303-702-0881
Signature beers: Shockwave Scottish Ale, Flashpoint IPA,
Sour Watermelon Wheat
11:00 a.m. to midnight Sunday–Wednesday; 11:00 a.m. to 1:30 a.m.
Thursday–Saturday

The old red brick building anchoring the north side of Longmont's Main Street has been many things: a roller rink, an Oldsmobile dealership and even a church. So when a quartet of engineers decided to convert it to a brewery in 1996, some old-timers were skeptical it would last. This was,

Pumphouse Brewery occupies a building in downtown Longmont that previously housed everything from a roller rink to a church. *Courtesy of Stephanie Whitehill.*

as head brewer Dave Mentus said, a downtown that "had more pawn shops than restaurants."

But all that has changed. Longmont is now a center of boutique shops, eateries and culture east of Boulder. And the Pumphouse Brewery & Restaurant played a large part in the transformation.

"I think that this place inspired other local people to open businesses on Main Street," said Mentus, who began work at the brewery in 2000. "It would be a different town without this place."

In the early years, Pumphouse churned out kolsches and altbiers to compete with mass-produced light lagers. Now Mentus hears endless grief if his Shockwave Scottish Ale, a 7.9 percent alcohol-by-volume malt monster, runs out. Regulars clamor for a selection of challenging beers, including his Backdraft Imperial Stout, Flashpoint IPA and Firestone Double White.

Pumphouse also serves about fifteen experimental fruit beers a year. Come at the right time and you could order a Cherry-Tamarind Sour Ale, a Sour Watermelon Wheat or an ale made with lulo fruit, a sort of South American kiwi.

In addition to the main brewpub, Pumphouse features its late-night Red Zone sports bar next door. Walk down the back hallway of the building to view the brewery's collection of more than 250 rare beer bottles, including an artichoke beer from Japan and a beer made for the Schwinn bicycle company.

And from the front of the house, you'll also see Mentus brewing in a glass area behind the bar. "I'm kind of like the monkey in the zoo," he says.

ROCKSLIDE BREWERY

401 Main Street www.rockslidebrewpub.com
Grand Junction (Map 1) 970-245-2111
Signature beers: Widow Maker Wheat, Kokopelli Cream Ale,
Cold Shivers Pale Ale
11:00 a.m. to close Monday–Saturday; 8:00 a.m. to close Sunday

Downtown Grand Junction still has an air of 1950s America, with department stores, local restaurants and shoe stores lining Main Street. Rockslide Brewpub didn't save the center of the Western Slope's largest city, but it certainly helped to move it into the twenty-first century.

Located in a former clothing store, the brewpub is home to a mix of young professionals, devoted regulars and European tourists from the nearby Amtrak station. At lunchtime, Rockslide turns on its stock ticker and draws the business crowd. On Thursday nights in the summer, it welcomes people who cram downtown for the weekly farmers' market.

"We're not in a town of ten to twelve microbreweries, and we were the first here," says Justin Bauer, Rockslide's brewer since 1999. "I think the downtown location is a lot of our uniqueness…It's an old-time downtown."

Grand Junction has been slow to change when it comes to beer. Rockslide opened in 1994, but Bauer only started upping the hops in the pale ale and other beers a few years ago.

Among his other creations is the Holiday Porter, a recipe reputed to have come from George Washington. Made with cinnamon, molasses, brown sugar and apple cider, it often sells out before Christmas. Another local favorite is the Cream of Wheat, a mix of Rockslide's bestselling

Widow Maker Wheat and its Kokopelli Cream Ale. The brewery consistently keeps nine of its beers on tap.

You won't find Rockslide outside Grand Junction, except at a few Western Slope beer festivals.

The bar also serves major-label light lagers. But when asked about domestic beers, one of Rockslide's bartenders is famous for pointing at the tanks in the glass-walled room next to the bar and remarking: "It doesn't really get much more domestic than that."

Rockslide, like many Colorado breweries, has a mug club with discounts for members. And some of the regulars have a special place at the bar. "There's a couple of customers, if I didn't see them for two days, I might actually put out a missing persons [report] on them," Bauer says.

SHAMROCK BREWING

108 West Third Street www.shamrockbrewing.com
Pueblo (Map 1) 719-542-9974
 Signature beers: Irish Red Ale, Extra Plain Porter, Belgian White
 11:00 a.m. to midnight Monday–Thursday; 11:00 a.m. to 1:00 a.m.
Friday; 10:00 a.m. to 1:00 a.m. Saturday; 10:00 a.m. to 11:00 p.m. Sunday

There's been an Irish pub at 108 West Third Street in Pueblo since the mid-1940s. But by the beginning of the twenty-first century, it was having trouble recapturing its glory. So when Realtor and restaurateur Shawn Sanborn heard that the longtime owner of the Shamrock Irish Brew Pub wanted to sell the building, he went from broker to buyer.

And then he learned exactly how much work he needed to do.

He found an early 1900s sign in the bathroom declaring the building to be the Johnson Bros. bicycle shop. It covered a hole in the wall over sewer vents. The floor that had appeared at first to be white oak turned out to be red oak when decades of crud was cleaned off. The building's electrical work had been cobbled together, requiring a rewiring. And Sanborn replaced the sometimes used, open-fermenting brewing system purchased a decade before with a closed-fermenting system twice its size.

The new Shamrock Brewing opened in August 2005. Younger residents cheered, while others approached the place with suspicion. The one-

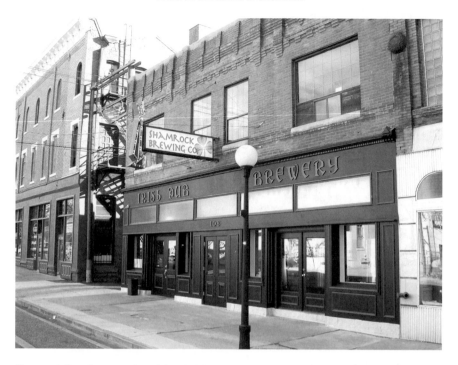

Shamrock Brewing occupies a historic Irish tavern in the heart of downtown Pueblo.
Courtesy of Shamrock Brewing.

time dark-lit bar had turned into a family-style eatery. And surprisingly, original brewer Alan Stiles, a Belgian beer specialist, found that blue-collar Pueblo took to his coffee stout and saison.

Jason Buehler took over as brewer in 2009 and created many German-style beers to go with the Irish red ale and Irish porter that are always on tap. And he introduced the popular and occasional Poacher's Pale Ale, made with hops he picks beside a favorite mountain biking trail.

More than five years after Shamrock's opening, downtown Pueblo remains a work in progress, but one that's attracting more artists, young professionals and empty-nesters. Even skeptics who told Sanborn that a microbrewery would never make it come in to enjoy sampler platters from Colorado's only Irish-themed brewery.

"You can sit at the bar at happy hour and see the guy who can't make it through the metal detector at [Denver International Airport] next to the legal secretary, next to the biker, next to the accountant, next to the family with the two-year-old, four-year-old and five-year-old," Sanborn says. "You have that mass appeal."

CHAPTER 3
THE GREEN AND THE GRACIOUS

COLORADO'S ENVIRONMENTALLY AND SOCIALLY CONSCIOUS BREWERIES

NEW BELGIUM BREWING

500 Linden Street www.newbelgium.com
Fort Collins (Map 3) 970-221-0524
Signature beers: Fat Tire (amber ale), Abbey (Belgian ale),
La Folie (sour brown ale)
10:00 a.m. to 6:00 p.m. Tuesday–Saturday

By 2011, the idea of joining corporate profitability with environmental sustainability in the brewing business had meshed like Brettanomyces yeast and Belgian ale. But in 1991, when the husband-and-wife team of Jeff Lebesch and Kim Jordan founded New Belgium Brewing in their Fort Collins basement, a marriage of these concepts was largely unheard of, if not viewed as out-and-out foolish.

Today, New Belgium is the third-largest craft brewery in America and is, in the view of many, the face of Colorado brewing to the world. And its commitment to making high-quality products in an environmentally friendly way is the reason it has reached those heights.

It can be argued that New Belgium has been the biggest catalyst for the greening of the brewing industry. And the company's meteoric growth, coming as it pushed the boundaries of Belgian-style and experimental beers in the United States, is a story that still seems almost unreal to the people who shepherded it through its first two decades.

New Belgium Brewing's link to bicycle culture originates from founder Jeff Lebesch's bicycle trip across Belgium, where he got the inspiration for the brewery. *Courtesy of New Belgium Brewing.*

"I still, after all this time, regularly have 'pinch me' moments where I can't believe this thing called New Belgium is a part of my life," says Jordan, the company's CEO. "We've come a long way, but New Belgium still has the foundational roots that Jeff and I identified as being important way back then."

The idea for the brewery came to Lebesch when, as a thirty-two-year-old electrical engineer, he rode his bike across Belgium, soaking in the European country's unique beer culture along the way. When he returned home, he got to work brewing two beers that captured the spirit of what he found overseas: a Belgian-style ale named Abbey and an amber ale with a name inspired by his two-wheeled mode of transportation—Fat Tire.

The early years resembled those of any budding brewery. Lebesch and Jordan would come home from their jobs—she was a social worker at the time—and work through the night to perfect their recipes. Jordan was pregnant with her second child but would put in long hours bottling their products and getting labels made at the local Kinko's. While Lebesch brewed, she would load her older son into the car and deliver beer around Fort Collins as he did his homework in the front seat.

"I was a little embarrassed that the poor kid knew the town by the liquor stores by the time he was eight years old," Jordan says with a laugh. But the hard work paid off, and within fourteen months, New Belgium had moved into an old train depot in the college town. Then,

in December 1995, it moved into its current location, which has been expanded roughly twenty times in fifteen years.

Perhaps New Belgium's defining moment came in 1998, when the employee-owners of the company voted to get 100 percent of the brewery's energy from wind power. The cost temporarily pillaged the bottom line yet instantly made it the largest commercial wind power buyer in the state and reinforced its principle of promoting environmental stewardship at every turn while being profitable.

But Jordan and her cohorts didn't stop at wind power. In 2002, New Belgium built a wastewater treatment plant on its fifty-acre site. The methane produced by the plant supplies roughly 15 percent of New Belgium's electrical needs. The building itself features a bevy of green designs. Solar tubes capture sunlight to illuminate the packaging hall and

New Belgium Brewing's sustainable initiatives include solar tubes illuminating parts of the plant and brew kettles that are 65 percent more efficient than standard kettles. *Courtesy of New Belgium Brewing.*

warehouse. The brew kettles, which heat thin sheets of wort rather than the whole kettle at once, are estimated to be 65 percent more efficient than standard kettles.

"We have long known that environmental ethos was part of who we are," says Jenn Orgolini, New Belgium's sustainability director. "It permeates everything that we do."

The green-friendly moves caught the eye of other brewers. Bryan Simpson, media relations director, notes that both Brooklyn Brewery in New York and Uinta Brewery in Salt Lake City have cited New Belgium's influence in their decisions to go fully wind powered.

But Jordan's daring business ventures also captured the fancy of Coloradans who are, by the nature of their surroundings, inclined to embrace environmentalism. Ron Vaughn, owner of Denver's Argonaut Liquors store, saw sales of New Belgium beers spike when people became more aware of the company's practices.

"New Belgium in particular has probably made business decisions that financially weren't the best but environmentally were tremendous," Vaughn says. And Jordan, he says, has "developed into one of the more influential people in the country, up with [Boston Beer founder] Jim Koch." Jordan and Lebesch are divorced, and he is no longer involved in the business.

But Jordan notes that New Belgium's popularity couldn't have been possible if the beer wasn't something special. New Belgium was the first U.S. brewery to make Belgian-style beers. That first beer, Fat Tire, was a breakthrough on the American landscape. In the early 1990s, with few craft beers on the market, the amber ale offered a darker hue and more substantial taste than commercial brews.

New Belgium then introduced the country to wood-aged beers in 1996. And it was the first brewery to use Brettanomyces yeast to produce a sour beer when it debuted its Biere de Mars in 2000.

Today, some beer-geek circles complain that the signature Fat Tire is bland and no longer represents the spirit of craft brewing. But New Belgium brewmaster Peter Bouckaert, a native of Belgium whom Lebesch recruited in 1995, says Fat Tire is both a gateway for new consumers of craft brews and the perfection of New Belgium's ode to Belgian beers.

"I always emphasize that it is the best Belgian beer we make," Bouckaert says. "Abbey and Trippel, they are very Americanized…but Fat Tire, that's spot on. That's exactly what an amber ale is in Belgium."

The drinking public has not immediately embraced everything that New Belgium has crafted, however. It made its first saison beer in 1996. But the reaction was so negative that it didn't brew it again until 2008, when Americans were beginning to enjoy the Belgian farmhouse style.

"We love to be intellectually stimulated," Jordan says. "And we become, in some instances, pioneers because we think that someone has to put money at risk to move the body of knowledge and practice forward."

New Belgium now brews what Bouckaert calls five different categories of beer. First is "Fat Tire and Friends," the core beers that reach a nationwide audience. Those "friends" include Sunshine Wheat, 1554 Enlightened Black Ale and Blue Paddle pilsner.

The Explore series sells in slightly lower volume but still gets nationwide distribution. This category includes year-round products like the Ranger IPA and Mothership Wit and seasonals such as Hoptober golden ale and Frambozen raspberry brown ale.

Third is the beer geeks' delight—the Lips of Faith series. Its most notable member is La Folie, a sour brown ale introduced daringly in 1997 that is now the top-selling barrel-aged beer in America. Others in this genre include the Belgo IPA, Sahti Ale and the Transatlantic Kriek, a lambic that was the first international collaboration between American and European brewers.

The final two categories are typically found only at the brewery or specialty bars and liquor stores. The Loose Lips series includes occasional experiments based on suggestions of employees who win in-house tasting contests; the Trip series is a collaboration with Seattle's Elysian Brewing.

For all of New Belgium's successes, none seems to make Jordan as proud as what she calls the company's "high-involvement culture." Employees become partial owners in the brewery after one year on the job and are allowed to see the company's books and advise it on all decisions. Employees now own 55 percent of New Belgium Brewery, while Jordan and her sons own 45 percent but maintain a majority voting block. Workers are inducted into ownership at ceremonies twice a year where they are given a "mojo"—a handmade fob of metal and ceramics stamped with the word "love" or "talent" that represents their connection to New Belgium—and are asked to express what ownership means to them.

The other company perks are legendary as well. One year gets you a bike, five years gets you a trip to Belgium, ten years gets you a tree in the

company's fruit orchard and fifteen years gets you both $1,000 in cash and $1,000 to invest in a micro-lending site that aids community-based small businesses. "We just thought it was an interesting way to jump-start philanthropy," Jordan says.

New Belgium has donated roughly $5 million to various charities. One dollar per barrel is given to charities promoting water stewardship, sustainable agriculture, bike advocacy or youth environmental education.

Its best-known source of giving is through the Tour de Fat, a national series of events that push, as Orgolini says, "civil disobedience, as it were, against the forces that conspire to keep us in the car." Attendees can exchange their vehicles for hand-built commuter bikes—yes, some actually make that trade—and they are urged to live car-free for a year. "Bicycles are a great part of a life well lived, and I feel like we've played a part of that," Jordan says, noting that many of the company's employees bike to work.

It's an understatement to say that New Belgium has played a big part in making craft beers popular nationally. In 2010, it produced 635,000

Bikes aren't just for logos at New Belgium Brewing in Fort Collins. Many of the company's employees bike to work the majority of the time. *Courtesy of New Belgium Brewing.*

barrels of beer, and its rocket ride to the top of the craft-brewing industry shows no signs of slowing.

Jim Shpall, owner of Applejack Wine and Spirits store in Wheat Ridge, notes that many great brewers have come from Colorado. But in his view, Jordan represents a special kind of brewing entrepreneur. "The great thing was, she acted on her beliefs: environmentally sound, business sound. I give her more credit than anyone," Shpall says. "I think what she did, more importantly than anything else, she really set the tone of being environmentally accountable, great ethics in business, take care of your workers—very much like a whole world philosophy."

ASHER BREWING

4699 Nautilus Court, Suite 104 www.asherbrewing.com
Boulder (Map 4) 303-530-1381
Signature beers: Greenade Organic Double I.P.A.,
Green Monstah Organic Strong Ale
3:00 p.m. to 9:00 p.m. Sunday–Wednesday, 3:00 p.m. to 10:00 p.m.
Thursday–Saturday

Steve Turner and Chris Asher opened Asher Brewing in late 2009 hoping to make a statement. They wanted their business to be the first all-organic brewery in Colorado, and they accomplished that goal.

The partners have since set their sights on another objective: becoming the first all-organic brewery in the state to can its beer—an environmentally friendly practice that would earn it double green chops.

But first and foremost is the commitment to put out quality products. "The beer has to be good first before it's organic," says Turner. "If we're successful, then people will copy us. If we go down in flames, they won't."

Brewing all-organic beer doesn't require a new process, just a number of specific—and often more expensive—ingredients. The malts are the key, as they often push the beer over the 95 percent of organic ingredients needed to achieve U.S. Department of Agriculture certification.

But the partners use all-organic hops as well, imported from New Zealand, where many growers shun pesticides. Chemicals attract naturally occurring antioxidants that cling to the harvest, so beers with

Asher Brewing of Boulder was Colorado's first all-organic brewery. *Courtesy of Asher Brewing.*

those hops oxidize more quickly and lose some shelf life, Asher notes. The use of organic hops avoids such drawbacks and gives the brewery's beers a slightly different taste. There is a hint of blackberry in the Green Bullet Organic I.P.A. because of the hops, for example.

Asher was brewing for Boulder's Redfish Fish House and Brewery when he came up with an organic IPA that became its bestseller. When Redfish closed, he pursued his dream of setting up an all-organic brewery. Using organic ingredients has limited Asher's selection somewhat, as there are only certain varieties of hops that are available and certain types of beer that are made well with those varieties.

But the limitations haven't made the brewery less ambitious. The Greenade Organic Double I.P.A., Green Monstah Organic Strong Ale and Tree Hugger Organic Amber, for example, weigh in with big alcoholic content and flavors enhanced by the organic process.

Asher Brewing is tucked into an industrial park in the Gunbarrel area northeast of Boulder, but its less-than-primetime location doesn't

stop locals from seeking it out. Asher brews are also available on tap in Boulder County and the Denver area.

"People are very excited to just have a locally brewed organic option," Asher says.

ASPEN BREWING

304 East Hopkins Avenue www.aspenbrewingcompany.com
Aspen (Map 1) 970-920-BREW (2739)
Signature beers: Independence Pass IPA, This Season's Blonde, Ajax Pilsner
Noon to 9:00 p.m. Monday–Saturday; noon to 6:00 p.m. Sunday

As University of Colorado students, fledgling brewers Brad Veltman and Duncan Clauss were fanatics, constantly experimenting with beer styles until they got them right. They never repeated the same recipe, and when they needed to clear out their inventory, they would invite friends to their apartment for brew and barbecue, Clauss remembers.

When they graduated, the roommates decided to put Veltman's business degree to work. And in March 2008, they opened Aspen Brewing. Veltman was twenty-three years old, Clauss twenty-two and brewer/ partner Rory Douthit twenty-one at the time, and with investment help from friends and relatives, they leaped into brewery ownership. Young and idealistic, the trio embraced business practices they learned in Boulder that, as Veltman put it, do not "mess up the planet."

They use wind power at their brewery and buy their grain locally, supporting the Aspen-area economy and reducing their carbon footprint. They reduce waste by giving the spent grain used in the brewing process to an area farmer to feed livestock. And they instituted a punch-card system that encourages people to buy growlers to cut down on packaging materials. "I think it's just laziness that people don't do what we're doing," Veltman says.

Aspen is a celebrity ski town with a Dom Perignon taste, and local bars don't have many craft beer taps. So a big challenge for these brewers was marketing. While tourists make up part of their customer base, locals account for most of their sales.

Aspen Brewing beers "go for taste and strength," Veltman says. The bestselling Independence Pass IPA is aggressively hopped. The Brown Bearale does not lack in chocolate malt. Even the Ajax Pilsner is hopped like a traditional German offering.

The Spring Blonde Ale, introduced in 2009, was supposed to be a limited seasonal offering, but the light wheat beer proved so popular that it became a summer offering and, finally, a year-round staple. It's now called This Season's Blonde.

The brewery is located just one block off Aspen's main drag.

"This is what Aspen used to be like," Veltman says of the laidback vibe in the brewery. "It was mellow. It was a mountain town. It was locally oriented."

BIG BEAVER BREWING

2707 West Eisenhower Boulevard, Unit 9 www.bigbeaverbrew.com
Loveland (Map 3) 970-443-3733
Signature beers: Screw the Pooch Pale Ale, Potent Peter IPA,
Wonder Wiener Wheat
3:00 p.m. to 7:00 p.m. Monday–Thursday; 2:00 p.m. to 8:00 p.m.
Friday–Saturday; 2:00 p.m. to 6:00 p.m. Sunday

It may come as a surprise that the man with arguably the brainiest background of Colorado's brewers—Peter Villeneuve holds a doctorate in microbiology from Colorado State University—is the same man behind the most suggestively named watering hole in the state, Big Beaver Brewing.

Villeneuve got the brewing bug while working on his PhD dissertation on using yeast as food during a manned space flight to Mars. He fell in love with growing yeast, began homebrewing and within a decade had set up a microbrewery-sized system in his garage.

Big Beaver sells beer to go only in growlers and tap-a-drafts to encourage glass recycling, and Villeneuve is experimenting with combusting his spent grain for energy. "I want to be known for being carbon neutral, sustainable and having great beer," he says.

Yet what has grabbed attention more than his green practices are his suggestive beer names—Shaved Tail Ale, Beaver Stubble Stout,

Wonder Wiener Wheat—and the name of his brewery. He once got an anonymous e-mail saying Big Beaver would single-handedly destroy the maturing brewing industry with its juvenile sensibilities.

The name, Villeneuve said, comes from his honeymoon, when he and his wife discovered they were fishing next to an extremely large beaver. But he admits most of the monikers are double-entendres. "It's a great screening mechanism for people who are offended by it, because they don't have a sense of humor anyway, and we don't want them in here," Villeneuve says. "They would just spoil the party."

Big Beaver opened to quite the party, with one hundred people signing up to be "members" on its debut weekend in October 2010. Its dozen bar stools often are full.

Villeneuve's beer, made with his library of yeast strains, is a mix of European styles (Belgian summer ale, brown ale) and West Coast hoppy pales. He serves it in mason jars and claims it doesn't induce hangovers like the beer from other breweries.

Eventually, he hopes to open a string of Beaver offshoots with the same glass-recycling concept—and the same drink-with-a-sense-of-humor attitude.

"Beer, to me, is meant to be drunk locally and fresh," he says. "And you shouldn't get too pretentious about it."

BRISTOL BREWING

1647 South Tejon Street www.bristolbrewing.com
Colorado Springs (Map 5) 719-633-2555
Signature beers: Laughing Lab Scottish Ale,
Winter Warlock Oatmeal Stout
10:00 a.m. to 9:00 p.m. Monday–Friday; 9:00 a.m. to 9:00 p.m.
Saturday; noon to 6:00 p.m. Sunday

Inside Bristol Brewing, you'll find pony-tailed regulars at the bar, young professionals playing shuffleboard and homebrewers analyzing international bitterness units on the brewery's daily beer menu board. An eclectic community supports the brewery. And it's the community that owner Mike Bristol supports in return.

The Green and the Gracious

Bristol Brewing's taproom features numerous beers, including its Laughing Lab Scottish Ale, which has won more Great American Beer Festival medals than any other Colorado beer. *Courtesy of Michael Myers.*

Bristol has created beers to benefit local causes. And you cannot walk into a charitable fundraiser in town without seeing a Bristol sponsorship.

"In the U.S., the brewery has gotten so far away from the community, and I think we've lost something there," Bristol says. "We really believe that beer ought to be a local thing."

A Colorado native, Bristol left the corporate world and came home to start Bristol Brewing in 1994. He opened his taproom four years later.

Locals come for the Laughing Lab Scottish Ale, which has won more Great American Beer Festival medals than any other Colorado beer and has influenced the brewery's personality. Bar pretzels are served in dog bowls. They come, too, for Winter Warlock Oatmeal Stout, a seasonal favorite that spawned the strongest beer in Colorado history—the 18.4 percent alcohol-by-volume XXX Warlock that took three years to brew. And they file in for the long line of experimental beers, such as the Skull 'n Bones Belgian series and Edge City 1.5 IPA, served almost exclusively at the brewery.

Bristol also makes four seasonal beers a year that fund community causes. Smokebrush Porter helps an arts foundation. Cheyenne Cañon

Piñon Nut Ale benefits a parks group. Profits from the sale of Local 5 Ale go to the group that maintains the national Fallen Fire Fighters Memorial in town. And Venetucci Pumpkin Ale, a Halloween seasonal, assists the Pikes Peak Community Foundation. Lines snake out the brewery and around the corner on the morning of its annual release.

Bristol has had requests from out-of-state distributors, but he turns them all down. "Ever since the beginning, we always wanted to be the local brewery," he says. "We don't have any desire to go outside of Colorado."

EDDYLINE RESTAURANT & BREWERY

926 South Main Street www.eddylinepub.com
Buena Vista (Map 1) 719-966-6000
Signature beers: Kickin' Back Amber Lager, Crank Yanker IPA,
Drag Bag Lager
11:00 a.m. to 10:00 p.m. daily

In 2005, Mic and Molley Heynekamp started looking for a Colorado mountain town to open their second brewery. They wanted a place with outdoor recreation, good schools and a close-knit community.

Buena Vista, at the foot of the towering Collegiate Peaks, won them over. And the name of their business—an eddyline is the area of a river between two currents—is inspired by the nearby Arkansas River, a mecca for water sports.

The Heynekamps had founded Socorro Springs Brewing in Socorro, New Mexico, in 1999, a long-held goal after Molley wrote a brewpub business plan for her senior accounting project in college.

As soon as Eddyline opened in 2009, it plugged in to the community and its values. It's a main sponsor of the local Boys and Girls Club and also hosts a weekly movie night to raise money for river preservation projects.

In a nod to the green-minded patrons, the restaurant's pizza ovens are fired by pecan wood grown in New Mexico. Water is reused for heat transfers. And the brewery planned to begin canning beers by mid-2011, since aluminum is more recyclable than glass.

The Heynekamps and their in-laws, who serve as restaurant managers, buy as much of their barley, hops and wheat locally as possible. They

Eddyline Restaurant & Brewery in Buena Vista is located next to the Arkansas River, a popular spot for rafters and kayakers. *Courtesy of Eddyline.*

shop farmers' markets for ingredients for their pizzas. And a local rancher raises cows for the restaurant.

Outdoor tourism drives Buena Vista's economy in the summer, but locals are Eddyline's main focus, Mic says. Eddyline has discount programs for them during the busy season and to keep them coming back in the sometimes-harsh winters.

Eddyline makes beers that manager Brian England—Mic's brother-in-law—says are brewed close to classic style. Kickin' Back Amber Lager immediately became a bestseller, but regulars took to the seasonal Pumpkin Patch Ale as well.

Folks in Buena Vista also like robust beers, and they convinced the brewers to make the Crank Yanker IPA so big and bitter that it falls outside IPA style guidelines.

"The thing I like about these small little mountain towns is the people," Mic says. "They're big, strong, healthy people—and that's how they want their beers. They want their beers the way they live their lives."

ODELL BREWING

800 East Lincoln Avenue www.odellbrewing.com
Fort Collins (Map 3) 970-498-9070
Signature beers: 90 Shilling (Scottish ale), Easy Street Wheat,
Bourbon Barrel Stout
11:00 a.m. to 6:00 p.m. Monday–Thursday; 11:00 a.m. to 7:00 p.m.
Friday–Saturday

Odell Brewing is legendary for its aggressive and experimental oak-aged beers. But founder Doug Odell would rather talk about his brewery's impact on the Fort Collins community than its impact on America's taste buds.

An employee committee picks two charities a month to receive donations from the brewery, and taproom workers give all of their monthly tips to a third environmental, educational or humanitarian charity. Add in Odell Brewing's large grant program, and its giving equals $2.50 per barrel produced—or $100,000 a year.

Odell Brewing completed a massive expansion of its brewery in 2010 and dedicated half of the new space toward barrel-aged and experimental beers. *Courtesy of Odell Brewing.*

"I think people really want to know about the company that they're buying things from...and they want to agree with what the company believes in," Odell says. "We attribute a lot of our success to the loyalty and the backing of the people of Fort Collins, and we want to be helpful in return."

Odell's first helpful act was teaming up with CooperSmith's Pub & Brewing to begin the Colorado Brewers Festival in Fort Collins in 1990. The brewery was less than a year old at the time, the culmination of Odell's twenty-year homebrewing hobby.

A decade later, Odell began experiments that brought his company into the spotlight, first with highly hopped beers and then with barrel aging and daring ingredients like wild yeasts. Half the space in a 2010 expansion was set aside for barrel-aged and limited-release beers. Odell is one of a few American breweries that ages beer in virgin oak barrels, a technique making vanilla and wood flavors more pronounced.

The brewery's taproom features as many as twelve pilot-batch beers at one time, ranging from nitro offerings to imperial pilsners to larks using cherries or blue corn. "Unless people come in every day, they're almost assured of seeing something they haven't tried before," Odell says.

Yet Odell's bestsellers remain two that first appeared in 1989: 90 Shilling Scottish ale and the unfiltered Easy Street Wheat. Even with the allure of oak-aged double marzens and peach-infused imperial porters, Odell knows there will always be a place for approachable beers.

And their sales might help a child in need.

REVOLUTION BREWING

325 Grand Avenue www.revolution-brewing.com
Paonia (Map 1) 970-260-4869
Signature beers: SEIPA, Colorado Red Ale, OAO XXX
(imperial amber ale)
4:00 p.m. to close Tuesday–Sunday

On a Friday night, the scene at Revolution Brewing is reminiscent of a small-town family reunion. Folks gather at the taproom, in a former church. The place is so popular that customers spill out of the brewery

Revolution Brewing owners Mike and Gretchen King had to build a fence around their church-turned-brewery to keep the weekend crowd from spilling onto the sidewalk. *Courtesy of Revolution Brewing.*

onto the front lawn. Owners Mike and Gretchen King built a picket fence to keep people off the sidewalk.

If Paonia is the hippie town of the Western Slope, Revolution Brewing is the business embodiment of that spirit. The Kings use local ingredients, can their beer and distribute it almost exclusively on the Western Slope to reduce their carbon footprint. Those practices reflect Revolution's principles: Buy locally. Serve locally. Welcome all who come.

"I think sustainability is about economic sustainability, too," Mike says. "And if you want a cool community, you have to keep the cash in your community."

The Kings chose Paonia, population 1,500, as their home when they moved from Alaska to start a brewery. They began making beer in 2008 on a three-quarter-barrel system, but the products were so popular that they had to limit their days of operation to avoid running out. They expanded to an old Lutheran church in 2009 and now serve beer six days a week.

The beer is made with Colorado grain and as much local malt and hops as the Kings can wrangle. The names reflect their love of the new-energy lifestyle: the SE in SEIPA stands for "solar energy."

Within the little brewery lies big creativity. The OAO XXX is an orange-hued imperial amber ale, and the Nitro Sticky Thickett is a smooth English ESB.

Mike and Gretchen know almost all of their customers, including the barefooted local who sits outside on summer nights and plays chess until the place closes.

They call Revolution a "lifestyle brewery," a place they run not to get rich but to enjoy life with friends. You can find their beer elsewhere, but to understand it, you've got to come here.

"We live next door," Mike notes. "Nobody makes any money, but we have a great life."

STEAMWORKS BREWING

801 East Second Avenue www.steamworksbrewing.com
Durango (Map 1) 970-259-9200
Signature beers: Steam Engine Lager, Colorado Kolsch,
What in the Helles?
11:00 a.m. to midnight Sunday–Thursday; 11:00 a.m. to 2:00 a.m.
Friday–Saturday

Steamworks Brewing cofounder Kris Oyler could be considered Colorado's beer ambassador. He's been the lone hopmeister extolling the virtues of malted barley at the Aspen Food and Wine Classic, and he's made trips to New York's culinary James Beard House to pitch the idea that beer pairs better with fine foods than wine does.

Oyler also is an environmentalist who persuaded his fellow Durango brewers to get 100 percent of their power from renewable energy sources. Steamworks even has a worm farm on-site to turn its waste into compost for area gardens.

And he's a philanthropist, hosting fundraisers at his downtown brewpub and leading the annual charge at Durango's Pints for Pints blood drive.

Steamworks Brewing offers sixteen taps of beer to a thriving crowd that packs its downtown Durango location. *Courtesy of Steamworks Brewing.*

"I think people understand that it's not just about making beer and getting people drunk, that you live in the community and you're trying to give back to the community," Oyler says. "We're responsible businesspeople. We live here. We play here. We raise our families here. We try to be a part of the fabric of the community."

Oyler and business partner Brian McEachron took over a 1920s-era auto dealership in a sleepy part of downtown, demolishing much of the interior but preserving its signature exterior.

In 1997, one year after opening the brewery, they produced Steam Engine Lager, an amber lager that has won six medals at the Great American Beer Festival. Steamworks quickly became known as a rare lager-heavy craft brewery, and its multiple honors for its Colorado Kolsch and What in the Helles? have enhanced that reputation.

But the lively brewpub that distributes throughout the state produces experimental ales too, from its Ale Diablo—an imperial-style blonde—to its spruce-infused Spruce Goose. Steamworks has sixteen taps, and though it features a number of southwestern Colorado guest beers, it has plenty of its own to offer.

When he wrote his business plan in 1994, Oyler looked across the country for a place to start his brewery. After visiting an uncle in Durango for just three days, he decided he had found a home. "At the time, people told me I was crazy to open here," he said, noting Steamworks became the fourth brewery in a town of twenty thousand people. "But more and more, we just keep focusing on our backyard."

UPSLOPE BREWING

1501 Lee Hill Road #20 www.upslopebrewing.com
Boulder (Map 4) 303-449-2911
Signature beers: Upslope India Pale Ale, Upslope Pale Ale,
Upslope Brown Ale
2:00 p.m. to 8:00 p.m. Tuesday–Thursday; 2:00 p.m. to 9:00 p.m.
Friday–Saturday

Matt Cutter drew up his first business plan for Upslope Brewing in 1996—and promptly put it on the shelf. He was focused on his kids and job then, and he didn't chase his dream.

When he dusted off the plan in 2007, his then-nine-year-old son encouraged Dad to go for it. Cutter took out a second mortgage to open the brewery as his wife proclaimed, "You'd better make this thing fly," and he built the business while working full time for a printing systems company.

A hiker and backcountry skier, Cutter wanted to brew beers that appealed to outdoor and environmental types like himself. So he packaged his products in recyclable cans. He bought a compressed-natural-gas van to make deliveries. He gave spent grain to a nearby farmer to use as feed. And his Upslope brewery uses less water than its counterparts. "That's all part of our efforts to be as green as we can," Cutter explains. "We make decisions as we go along…but if we can pursue a greener option at a similar cost, we'll do it."

He found his brewer at Argentina's Beagle Brewery—the world's southernmost brewery. In fact, Upslope had to order its first shipment of hops from Argentina in 2008 when it opened during a hop shortage in the United States. Those Patagonia hops remain a signature of Upslope's Pale Ale and IPA, the first two beers that rolled off its canning line.

Upslope Brewing founder Matt Cutter shows off his first shipment of cans that are just one of the many green features of the Boulder beer maker. *Courtesy of Upslope Brewing.*

Though Upslope cans just four beers—its Brown Ale and Craft Lager being the others—its taproom is an incubator of creativity. There, you can enjoy a Belgian Dubbel, a pumpkin ale made with 125 pounds of pumpkin or a Dunkelweizen that won a medal at the brewery's first Great American Beer Festival in 2009.

The brewery is in an industrial and small business center north of Boulder near a busy bike route along the foothills—an appropriate location.

"I see Upslope's position as being a great beer for the active Colorado outdoor enthusiast," Cutter says.

CHAPTER 4
EXPERIMENTAL BREWERIES

AVERY BREWING

5763 Arapahoe Avenue, Unit E www.averybrewing.com
Boulder (Map 4) 303-440-4324
 Signature beers: India Pale Ale, Hog Heaven (barleywine),
 Maharaja (imperial IPA)
 11:00 a.m. to 11:00 p.m. daily

GREAT DIVIDE BREWING

2201 Arapahoe Street www.greatdivide.com
Denver (Map 2) 303-296-9460
 Signature beers: Titan IPA, Yeti Imperial Stout, Hibernation Ale
 (English-style old ale)
 2:00 p.m. to 8:00 p.m. Sunday–Tuesday; 2:00 p.m. to 10:00 p.m.
 Wednesday–Saturday

Sometime in early 1993, it's very likely that Brian Dunn, on a plane heading to California for a job interview, flew over the Boulder-based sportswear company where Adam Avery was having his "young-life crisis."

Great Divide Brewing's bold beers have won it seventeen medals at the Great American Beer Festival and five World Beer Cup medals. *Courtesy of Great Divide Brewing.*

It's somewhat less likely—although not impossible—that both came to the realization simultaneously that their futures involved making beer. On that plane ride, Dunn began writing a marketing plan for Great Divide Brewing. And later that year, Avery found two investors to back Avery Brewing.

Both became leaders in making beer that was bigger and bolder than what other craft brewers were offering. And their early forays into new styles and higher alcohol strengths prompted competitors to make double IPAs, barrel-aged brews and other unique styles that furthered experimentation in beer making.

"I still don't really think about it being experimental, necessarily. I guess looking outside in, we definitely are," Avery says. "It's more about I was homebrewing on a bigger system. And in a lot of ways, I still am."

If Wisconsin brewers are masters of light lagers and those in Seattle are wizards with sharp northwestern hops, Colorado beer makers are pioneers in pushing limits with their ingredients and products. Boulder Beer kicked off the trend in 1979, when it introduced a stout and a pale ale. Today, new breweries like Crooked Stave make whole lines of products using only wild yeast.

But Avery Brewing and Great Divide, more than any other breweries in Colorado, played the role of Lewis and Clark, exploring deeper and deeper into unknown territory. And those breweries continue to push the envelope by churning out sour barrel-aged beers or infusing imperial stouts with espresso and chocolate.

"You take a chance," Dunn said while drinking a glass of Hibernation Ale, arguably the first widely distributed high-alcohol beer in Colorado. "I made this beer because I thought it would sell and people would like it...For the most part, people have responded well to it, to the more eccentric style."

Dunn graduated from Colorado State University with a degree in soils and plant biology. He worked for a company building farms in developing countries before heading to Europe, where he monitored soils in transatlantic fruit and vegetable shipments—and acquired a taste for locally made ales.

After earning a master's degree in environmental policy, Dunn flew to Fresno, California, for a job interview but decided on the way that he wanted to brew beer for a living. He wrote a marketing study, found investors and tapped into a City of Denver program that offered loans to set up businesses in high unemployment areas. Great Divide opened in an old warehouse just north of downtown in 1994.

Avery was several years out of college when he decided he didn't want the corporate life anymore. After he shopped around his business plan for a brewery, his father and an investing partner concluded that it had merit and stepped in with the cash needed to get the brewery off the ground.

Both breweries began by offering standard beers. And both stumbled out of the gate.

Dunn, as the only full-time Great Divide employee, worked from 3:00 to 11:00 a.m. brewing and bottling and then went out to sell the beer and work on the company's books. "We had a lot of years where we didn't think we could make it," he says.

Avery's brewery didn't make a profit during its first seven years.

But success came when the two brewers moved from making beers that everyone was brewing to inventing beers they wanted to drink, capturing the state and national imagination in the process.

In 1995, Dunn introduced his seasonal Hibernation Ale, an English-style old ale that measured in at a then-whopping 8.7 percent alcohol by

volume. It was one of the first big beers introduced in Colorado, and he was shocked at how quickly the drinking public took to it.

For Avery, the breakthrough began in 1996 with his India Pale Ale, the first IPA marketed in Colorado. Two years later, he rolled out Hog Heaven, the first dry-hopped barleywine to hit shelves in the state. "As soon as I started making the beers I really wanted to make is when the turning point came," Avery says.

But reaching the turning point took hard work. Joe Peters, manager of Wheat Ridge's Applejack Wine and Spirits, remembers both Dunn and Avery coming into the store on weekends, selling their beer personally and giving away decals and bottle openers.

"People, they were just like a sponge when it came to the knowledge of how this beer was crafted and how it tasted," Peters remembers of the reaction to Avery, Great Divide and some of the other edgier beers of the time. "You could see that once people started drinking these more flavorful beers, they were going to stick with them."

Avery Brewing has been a national leader in creating highly hopped, highly alcoholic and barrel-aged experimental beers. *Courtesy of Avery Brewing.*

After India Pale Ale, Avery concocted the "Holy Trinity of Ales" series—Hog Heaven, followed by The Reverend Belgian quadruple ale and Salvation Belgian-style strong golden ale.

Next came the dictators—Czar Imperial Stout, Kaiser Imperial Oktoberfest and Maharaja Imperial India Pale Ale, the latter a beer that sealed the brewery's reputation as the maker of the hoppiest suds in the state. Then there was the Demons of Ale, a trio that includes The Beast Grand Cru, a beer that typically hovers around 15 to 17 percent alcohol by volume and is the second-strongest beer ever made in Colorado, trailing only Bristol Brewing's XXX Warlock.

Avery's barrel-aging experiments, which were next in line, grew out of a trip he took to Belgium in 2006 with four other craft brewers. The first effort was a ten-gallon batch of sour ale that tasted like "poor-quality sewage water," in Avery's words. But the recipes evolved with bold and unique flavors to the point where the brewery invested in 220 barrels for souring and aging beers. These cutting-edge brews are made in limited batches, many of which are sold only at special tappings at the brewery.

Avery's creations have sometimes confused beer drinkers. For the brewery's fifteenth anniversary, he produced four hundred barrels fermented by the wild yeast Brettanomyces, making it the largest batch of Brett-fermented sour beer ever made. The beer got two reactions: love or hate. "I got some brutal e-mails: 'What are you doing?'; 'You suck'; 'This is the worst beer I've ever tasted,'" he recalls. "But others wrote, 'Thanks for having the balls to do something like this.'"

For a follow-up, Avery brewed something in 2010 that no one was expecting: a lower-alcohol pilsner. Joe's Pilsner is one of the most heavily hopped low-alcohol beers ever made in the United States.

Throwing a curveball is one of Avery's strengths, says Tomme Arthur of San Diego's Lost Abbey brewery, one of the friends who took the 2006 trip to Belgium with Avery. While Avery Brewing is best known for high-alcohol beers, its depth and variety of offerings is most impressive, he says. "Their legacy is built around so many different beers," Arthur says.

Great Divide, meanwhile, continues to build on its early provocateur reputation and to expand its boundaries every year. From Hibernation Ale, Dunn moved to Yeti Imperial Stout, a 9.5 percent ABV creation, and Hercules Double IPA, a 10 percent hop assault that is at the forefront of Colorado's push into that style.

"Brian Dunn was one of the early ones to try stuff that had personality, and they started drifting up on the alcohol content of some of their beers," recalls Ron Vaughn, owner of Argonaut Liquors.

The more Great Divide strayed from the mainstream, Dunn found, the more popular the beers became. In the mid-2000s, Great Divide introduced Samurai, the first unfiltered rice ale made in America. It doesn't have the kick of some buzz-worthy beers, but it is welcomed by taproom visitors who want a unique beer—and want to enjoy more than one glass without worrying about driving home.

Great Divide continues to experiment. In 2009, it introduced eight new beers, the most the brewery has done in one year. Those included

Great Divide ages its Yeti Imperial Stout with chocolate and espresso beans, pushing the taste boundaries of an already bold beer. *Courtesy of Great Divide Brewing.*

tweaks to the name brands. Espresso Oak-Aged Yeti and Chocolate Oak-Aged Yeti both took the classic envelope-pusher in different directions.

The 2009 and 2010 launches included more barrel-aged eye-openers, such as Rumble, an IPA aged on French and American oak, and derivations of Belgian (Colette farmhouse ale), Scotch (Claymore Scotch Ale) and northern European (Smoked Baltic Porter) styles.

"The landscape is changing a lot, and I think that people are embracing both craft beer and locally brewed craft beer much more than they used to," says Dunn, who now throws annual anniversary parties where he introduces an experiment in hopping and aging that typifies both Great Divide's past and its future. "And I don't think it's a fad. I think it's really going to grow a lot."

BIERWERKS BREWERY

121 East Midland Avenue www.bierwerks.com
Woodland Park (Map 5) 719-686-8100
Signature beers: Helles, Dunkel, Latzenbier (hopped German ale)
11:00 a.m. to 10:00 p.m. Monday–Saturday; 11:00 a.m. to 8:00 p.m. Sunday

Brothers-in-law Jeff Aragon and Brian Horton have spent more than a decade pushing the limits of Coloradans' palates. They ran Trinidad Brewing for ten years, serving well-known big beers along Colorado's southern border until the economy regrettably forced them to rethink their business plan.

In August 2010, they set up a brewery in a former tire shop in Woodland Park, a bedroom community in the mountains northwest of Colorado Springs. But rather than break out their old rotation of imperial porters and IPAs, they decided to serve traditional German-style beers such as their Helles, Dunkel and Altbier.

BierWerks also produces more innovative beers, such as its 10 percent alcohol-by-volume Doppelbock, its 8.5 percent springtime Maibock and its 8.5 percent Weihnachtsbier, a Bavarian winter seasonal. Its Latzenbier is a rare style of heavily hopped German ale that the brewers recommend for IPA fans. While some swear it off because it's not made like an IPA, others see it as a "breath of fresh air," Horton says.

"What's 'craft' mean? It means doing something homemade and different," Horton says of their effort to serve unique German beers. "I saw a lot of the brewing community doing something different in the same way, so we just kind of settled on this."

Outside the German scene is the Brewers Reserve, a series that reaches beyond the traditional offerings of a Bavarian brewery. Visitors to the brewery will find a Double Red, a Baltic Porter or a Double IPA on the menu.

Woodland Park's lone brewery had one hundred people sign up for its mug club before it opened. It draws a number of Colorado Springs' military members, who come for beers like the ones they enjoyed while stationed in Germany.

On summer and fall nights, crowds gather around the fire ring on BierWerks's patio. It doesn't have a kitchen but serves pretzels, cheeses and meats made by area businesses.

"It's kind of a tip of our hat to the brewing traditions of Germany. We kind of have an alpine setting here," Horton says, motioning to Pikes Peak, which can be seen from the patio.

CRAZY MOUNTAIN BREWING

439 Edwards Access Road, B-102 www.crazymountainbrewery.com
Edwards (Map 1) 970-926-3009
Signature beers: Crazy Mountain Amber Ale,
Old Soul Belgian Strong Ale
11:00 a.m. to 9:00 p.m. Monday–Saturday; 11:00 a.m. to 5:00 p.m. Sunday

Crazy Mountain Brewing made a big statement when it made its debut at the Vail Big Beers, Belgians and Barleywines festival in 2010. It offered just one beer—its Old Soul Belgian Strong Ale. But by the end of the festival, people had returned to founder Kevin Selvy's booth seven or eight times, and several said his beer was the best of show.

Selvy had made the juniper-laced golden ale at a California brewery and speedily driven three kegs across the western United States to Vail. The reception he got at the festival brought Crazy Mountain's final group of investors on board.

Crazy Mountain brewer Kevin Selvy's creations are available throughout the Vail Valley, but his most experimental beers are in the brewery's taproom. *Courtesy of Crazy Mountain Brewing.*

Today, you can find canned Crazy Mountain Amber Ale in stores. Bars and restaurants in the Vail Valley serve the brewery's Lava Wit Wheat, brewed with orange peel, coriander, chamomile and grains of paradise, a North African spice.

But to see the crazy side of the brewery, stop in at its tasting room in Edwards, where Selvy keeps ten beers on tap that go beyond year-round specialties like his IPA and black pale ale. You will find at least one tap of something aged ten to twelve months in oak barrels. You could find ale brewed with ponderosa pines next to one featuring fresh hops smoked with wood from fruit trees.

"People up here want approachable beers in bars and stores," Selvy says. "But in the tasting room, we can brew up something funky in twenty barrels."

Selvy was trading stocks and homebrewing in San Francisco when Anchor Brewing executives tasted one of his beers and gave him a job in the company's winery. He launched his own business in the Vail Valley after realizing there was not a brewery in the tourist-rich area that sold its beer to other bars and stores in the region.

Today, the brewery ties a nonprofit organization to each of its products and donates 1 percent of the revenue from that beer to the group. In doing so, Selvy hopes he's not just creating bold products but a new beer culture.

Then again, he also wants to make thought-provoking beer that people like. "I love when the beer I make makes somebody smile," he says. "The more people you can get your beer to, the more people you're making happy."

CROOKED STAVE

Temporarily housed at Funkwerks brewery www.crookedstave.com
Looking for a home in Denver (not on a map) chad@crookedstave.com
Signature beers: American Petite Sour series: Spring, Summer,
Fall, Winter
Available at Funkwerks brewery and select Front Range stores and bars

Crooked Stave brewer Chad Yakobson believes his collection of Brettanomyces yeast strains is the largest owned by an individual in the world. It should be no surprise, then, that beers from his brewery are almost uniformly sour, cutting-edge and challenging.

Yakobson fell in love with Brett, a wild yeast that lives on the skins of fruit, while studying winemaking in New Zealand. Vintners despise Brett because too much of it in a batch spoils the product. But he grew to love its wild fermenting characteristics, and he did his master's dissertation on the funky little yeast while a student at a brewing and distilling school in Scotland.

He came home to Colorado in 2009 to work with Odell Brewing before branching out on his own. He purchased a 660-gallon oak fermenter, bought a stash of barrels and set up shop at Funkwerks brewery in Fort Collins.

Crooked Stave launched in April 2011. Shortly thereafter, it created for Denver's Euclid Hall beer restaurant a simple Belgian ale made with lavender and kaffir lime leaves.

But then Yakobson rolled out his American Petite Sour series, creating a new style of beer in which he mixes sour wort with a saison-style wheat

beer to create a low-alcohol, tart product. He plans to make a different entry in the series for each season.

Crooked Stave also began work on a "Wild, Wild Brett" series, producing 100 percent Brett-fermented beers based on the seven tints of the color wheel. Those golden, red and dark sours will be available at Funkwerks and in a few beer bars and liquor stores along the Front Range.

By 2012, Yakobson hopes to be in his own place in Denver, where he'll have a taproom. He even plans a couple traditional beers like a double IPA or a Baltic porter, though he'll age those in oak.

Just don't expect him to deviate from his love of Brett and his desire to be a leader in the use of the yeast to make wild and sour beers. "I just love sour beer," Yakobson says. "If I went out at night I would prefer to drink all sour beer all night long...I brew what I want to drink."

LEFT HAND BREWING

1265 Boston Avenue www.lefthandbrewing.com
Longmont (Map 4) 303-772-0258
Signature beers: Sawtooth Ale (ESB), Milk Stout, Good Juju (ginger-
spiced ale)
3:00 p.m. to 8:00 p.m. Monday–Thursday; noon to 9:00 p.m. Friday;
noon to 8:00 p.m. Saturday; 2:00 p.m. to 8:00 p.m. Sunday

You might think one of the first breweries in Colorado to make an imperial stout, one of the first in the United States to create a fresh-hopped ale and a brewery that roared out of the gates with a ginger-spiced ale would consider itself an envelope-pusher.

But Left Hand Brewing founder Eric Wallace plays down that moniker, noting that Sawtooth Ale, his American-style ESB, remains the company's top seller. And his Polestar Pilsner has been named on lists of the top twenty-five beers in America, despite its lack of flashiness, he points out.

"I don't think [Left Hand] is perceived in the marketplace as being one of the cutting-edge innovators," Wallace says. "We brew one of the greatest ranges of high-quality beers of any brewery in the country."

Wallace grew up an army brat who spent his formative years in Germany and then toured the world as a U.S. Air Force officer. He and

Left Hand Brewing's eponymous logo rolls off the bottling line with its popular Milk Stout. *Courtesy of Left Hand Brewing.*

his wife returned to the United States as the microbrewery craze took off in 1993, and he knew he had to be involved in it.

Left Hand launched a year later with Sawtooth and a since-discontinued golden ale. Its third beer, and still one of its most popular, is Juju ginger-spiced ale. By 1995, it had produced an imperial stout—a revolutionary concept at the time—and later became a pioneer in organic and fresh-hopped beers.

The tasting room can feature as many as seventeen beers, and Left Hand isn't afraid to shake things up. In 2009, it replaced its popular Snowbound Ale, a spiced holiday beer, with Fade to Black, a foreign stout laced with licorice, molasses and espresso beans. Wallace heard howls from many drinkers, but they quieted after the big, bold new beer caught on.

The company itself is such a Longmont benefactor that one employee focuses full time on nonprofit donations. Wallace is a spokesman for Colorado craft brewing, having served as president of the Colorado Brewers Guild.

"It's always been our goal to remain a presence here in Colorado," he says. Indeed, nearly half of the company's revenues come from in-state sales, even though Left Hand is available in twenty-nine states and eleven countries.

PAGOSA BREWING

118 North Pagosa Boulevard www.pagosabrewing.com
Pagosa Springs (Map 1) 970-731-BREW (2739)
Signature beers: Poor Richard's Ale (colonial-style brown),
Powder Day IPA
11:00 a.m. to 10:00 p.m. daily from mid-spring to mid-fall; 3:00 p.m. to
10:00 p.m. Monday–Saturday the rest of the year

Pagosa Brewing churns out roughly forty-five beers per year, many changing by the season.
Courtesy of Pagosa Brewing.

In 2006, the Brewers Association held a nationwide search around the time of Ben Franklin's 300th birthday, looking for a beer that Ben would have drank. Some of the giants in U.S. craft brewing entered the contest. But the winner of the prestigious competition was Tony Simmons, owner of a brewery in tiny Pagosa Springs that hadn't even opened yet.

Simmons created a corn- and molasses-laden recipe for Poor Richard's Ale, suggesting that Franklin would have used corn when America was at war with its usual supplier of grains. After he won the contest, more than one hundred other breweries nationwide used that recipe. The winning entry—along with articles in *New Brewer*, *Paddler* and other publications— vaulted Pagosa Brewing onto the national scene.

Simmons's ensuing creations—roughly forty-five that can be found on tap throughout the year—have made Pagosa a brewing hotbed. Some visitors come for the Pack-It-In Coconut Porter, others for the Nipple Mountain Nip barleywine. Some products are timed by the season: Great Pumpkin Ale for Halloween, Chimney Rock Chocolate Stout for Valentine's Day or Honeymoon Ale braggot (part beer, part mead) each year for his wedding anniversary.

"We're getting people to get out of their shell and try new things," Simmons says.

Simmons first grew fascinated with the alchemy of fermentation as a teen and would brew in his locker and in his high school's rarely used closets. He was dragged in front of the headmaster's office when caught and asked if he had a drinking problem. With sincerity, he replied, "No, sir, I've got a fermentation problem."

He later got the taste for full-flavored beers while working in London as a worldwide account manager for Nestlé brands, took up homebrewing and, after leaving the corporate world, won a scholarship to a professional brewing school in Germany.

In 1996, Simmons moved to Pagosa Springs and opened a homebrew shop, and then the brewery in 2006. He always felt he'd have success but never imagined he would be one of three hundred people blowing out the candles on Ben Franklin's birthday cake as a reward for his winning recipe.

Today, he typically has twelve beers on tap—including Poor Richard's—as well as a menu of burgers, pizzas and wild salmon. And

he's happy to continue challenging palates in his 1,800-person town and winning awards.

"I'm the ale evangelist, you might say," he says. "I just had a real passion for creating a beer culture in our town, which I think we've actually achieved here."

STRANGE BREWING

1330 Zuni Street, Unit M www.strangebrewingco.com
Denver (Map 2) 720-985-2337
Signature beers: Strange Pale Ale, Le Bruit Du Diable (farmhouse ale),
Cherry Kriek
3:00 p.m. to 8:00 p.m. Monday–Friday; noon to 8:00 p.m. Saturday
(extended hours during football season)

When even their mistake batches became big hits, Strange Brewing founders Tim Myers and John Fletcher knew there were no limits to what they could do.

If you wander south of Denver's Invesco Field at Mile High and find this taproom brewery, you can get something hoppy, something Belgian, something on nitro or three different kinds of barleywine. It just depends on what Myers and Fletcher have dreamed up—or stumbled onto.

Take the Cherry Bomb Belgian Stout. Dark yet sour, it came about when Myers butchered a Belgian wheat recipe by using the wrong malt. Yet since Strange Brewing—and yes, the name comes from the 1983 movie—only makes its beers in one- or two-and-a-half-barrel batches, he figured he might as well serve it to get rid of it. And now it's here to stay. "I've been threatened with bodily harm if I don't keep the Cherry Bomb on tap," he says.

Strange Brewing inspires that kind of passion in its regulars, who quickly turned it from a four-day-a-week taproom to one serving beer daily during the NFL season.

Myers and Fletcher were homebrewing buddies and information technology workers at the *Rocky Mountain News* who found their lives upended when the 150-year-old newspaper closed in 2009. So they followed their dream of opening a brewery. After fits and starts involving

zoning permits and building codes, they started pouring beer a little more than a year later.

There are no golden ales, amber ales or pilsners on Strange's ten-tap menu, though you can find a farmhouse ale, an English barleywine and a honey coffee stout. "I never wanted this place to be a two-beer brewery or a three-beer brewery," Myers says. "And that wasn't from a lack of confidence in any specific recipe. It was more the homebrewer's mindset of 'OK, I made that; what do I feel like doing this week?'"

TWISTED PINE BREWING

3201 Walnut Street, Suite A www.twistedpinebrewing.com
Boulder (Map 4) 303-786-9270
Signature beers: Hoppy Boy (IPA), Billy's Chilies Beer,
Big Shot Espresso Stout
11:00 a.m. to 9:00 p.m. Monday–Friday; noon to 9:00 p.m. Saturday;
noon to 6:00 p.m. Sunday

Anyone can make the hoppiest beers around. In Boulder, you're an outcast if you don't. But Twisted Pine Brewing president Bob Baile is a trailblazer: he makes the hottest beer around, Billy's Chilies Beer. He says few other brewers produce beers like his bourbon-barrel-aged Scottish ale or Oak Whiskey Red. And he can count the experiments that regulars still talk about: a wasabi ginger beer, a vanilla chocolate porter, Twisted Pine's sour ales.

"Experimentation has always been an integral part of our business," Baile says. "It keeps the [brewers] excited…It gives our customers different beers to try."

Colorado brewing legend Gordon Knight opened Twisted Pine in 1995 and sold it one year later to Baile, who merged it with his Peak to Peak Brewing. Twisted Pine concentrated on bottling for a decade before moving into its current home and opening a taproom in 2006.

Its reputation as a taste gambler didn't began with that taproom, as the brewery was making Big Shot Espresso Stout and its chili beer, made with five kinds of chili, by then. But as the number of taps expanded to fifteen, Baile told the brewing crew to go wild.

Twisted Pine occasionally infuses a number of its less daring beers with hops, just to see how they'll turn out. And it has a new beer on tap roughly once a week.

"I make beer for *you*," Baile insists. "And that's one of the things I like about the experimental stuff."

Sometimes that "you" is a group of employees from nearby biotech companies, who come in monthly to mingle at Twisted Pine's "BioBeers" gathering. Sometimes it's what Baile calls "couples day" on Saturdays, when he sees first-time visitors tearing through samplers of everything on tap.

Twisted Pine began distributing outside the state in 2009, partly in response to the nagging of a former regular who moved to Texas. It plans to grow slowly and carefully. "I always want to be perceived as a mom-and-pop operation," Baile says.

CHAPTER 5
NICE NICHE

COLORADO'S MAKERS OF UNIQUE STYLES AND PACKAGES

OSKAR BLUES BREWERY

Brewery: 1800 Pike Road, Unit B,
Longmont (Map 4)
Also brewpubs in Longmont and Lyons
Signature beers: Dale's Pale Ale, Old Chub (Scottish ale),
Ten Fidy (imperial stout)
Longmont taproom: 3:00 p.m. to 8:00 p.m. Monday–Friday; noon to
6:00 p.m. Saturday–Sunday

www.oskarblues.com

303-776-1914

When Dale Katechis received an e-mail from a small Canadian business offering to sell him equipment to can his craft beer, he laughed. He passed it around to colleagues at Oskar Blues Brewery, and they laughed even harder.

And when the laughter died down, Katechis realized it might be the best idea he'd ever heard.

It was early 2002, and no one had dared to can craft beer. Cans were for light lagers, after all. But Katechis, the brewery's owner, took the leap, switching from the twenty-two-ounce bottles in which Oskar Blues had sold its beer for nearly three years and launching hoppy beer in a can.

Skeptics called Katechis an idiot.

Now the man is considered a genius.

Oskar Blues's Ten Fidy Imperial Stout won a 2010 World Beer Cup gold medal. At 10.5 percent ABV, it's one of the strongest canned beers. *Courtesy of Oskar Blues Brewery.*

"We created and pioneered the canned craft beer segment," Katechis said on the seventh "canniversary" of Dale's Pale Ale, a 6.5 percent alcohol-by-volume pale ale/IPA hybrid that hit stores in a twelve-ounce aluminum package. "So, what does that mean? Nothing. It's beer, right?… It was the unique package that drew us to it.

"Human nature teaches us to avoid risk," he continued. "I just have an extremely high tolerance for risk. I'm just dumb enough to not want to be safe."

Among Colorado's brewers are plenty of risk takers, people who cook up beers that market analysts dismiss as unmarketable. But Katechis and the crew at Oskar Blues took risk to a different level and watched a packaging technique catch fire nationally in the craft brew world.

Had you run into Katechis at the Oskar Blues brewpub shortly after it opened in 1997, you probably wouldn't have felt you were in the presence of a craft beer pioneer. Even Katechis's own brother, a banker, was skeptical and had turned down his request for a loan when the brewer pitched the idea of starting a restaurant in a mountain town of 1,400 people. Luckily, he found financing elsewhere.

Left Hand Brewing made the house beer. Katechis, who had been homebrewing since crafting what he called his first "horrible" beer seven years earlier, had nothing of his own on tap. A customer finally asked him when Oskar Blues, known for its Cajun menu and live blues music, was going to start serving its own suds. Katechis said he couldn't conceive of taking on another task but would be happy to let the patron brew if he'd like.

Soon, he and Katechis were making Dale's Pale Ale, a recipe much improved since that first disaster of a homebrew. People came from farther and farther away to try it.

So they made a second offering, a big Scottish ale lovingly named HYA, which stood for "Here's Your Ass." It was later renamed "Old Chub" when Katechis decided to market it.

The decision to can the beers came as Oskar Blues officials prepared to begin distribution. While the idea ran counter to conventional wisdom among craft brewers, Katechis saw several advantages. First was the portability of the container, shatterproof and small enough that drinkers could take it hiking, kayaking, golfing—wherever they wanted to have a hoppy beer. Second, aluminum actually helps keep beer fresher than bottles, which allow in ultraviolet light that can spoil the beer. The seal between the aluminum can and lid also allowed lower levels of oxygen, increasing the beer's shelf life. And third, aluminum has environmental benefits; it's recyclable like glass but is lighter to ship, leaving less of a carbon footprint.

"Once we were convinced it was the best package for beer, it was now, 'Do we really want to push this thing and be the first?'" Katechis remembers. "It was a no-brainer at that point. It was, 'We have to do it.'"

Knowing the skepticism he was about to face, however, Katechis told his salespeople who hand-delivered the beer to stores that they couldn't leave until the store owner or beer buyer drank Dale's Pale Ale, to prove that beer with big taste could be put into cans.

Dale's Pale Ale was the first canned craft beer, but other brewers soon followed. No microbreweries packaged beer in aluminum cans in mid-

Oskar Blues was little known when it became the first craft brewer to can beers in 2002. It's now the forty-ninth-largest brewery in America. *Courtesy of Oskar Blues Brewery.*

2002; by the end of 2009, more than fifty did so. Oskar Blues brought them together for the first "Burning Can" festival the next year.

Ska Brewing of Durango trailed Oskar Blues by a number of months in canning its beer, and cofounder Dave Thibodeau admitted that he was too scared to do it until he saw Katechis succeed first. "Kudos to him for having the balls to do it," Thibodeau said, seven years later.

Once those cans hit liquor stores, it was hard to keep them on the shelves. Dale's spread from Boulder County to the Denver area to the whole state. In 2003, Frontier Airlines agreed to sell the beer on its flights, and suddenly this crazy canned beer went national.

On average, Oskar Blues Brewery doubled its sales every year from 2003 through 2010. It went from a company making beer out of a Lyons restaurant to one that moved into a new plant in nearby Longmont in 2008. By 2010, it was the forty-ninth-largest brewery in America.

It also grabbed headlines. In 2010 alone, it made the *Inc.* magazine list of the five thousand fastest-growing companies in America, *Advertising Age* magazine's list of the fifty hottest brands in the country (specifically Dale's Pale Ale) and the cover of the industry trade journal *Market Watch.*

"Without a doubt, to this day, I wouldn't be in the beer business without the can," Katechis said.

Joe Peters, manager of Applejack Wine and Spirits in Wheat Ridge, recalls that craft beer in cans confused both customers and competitors at first. Then Dale's Pale Ale got a write-up in the *New York Times*, and suddenly everyone wanted to can. "I know some of the big microbrews, they kind of laughed at that when it was first introduced," Peters remembers. "[Oskar Blues] had a lot of gumption, a lot of guts."

Oskar Blues also made several moves to ensure it wasn't a one-hit wonder (though it does make a brewery-only offering called One Hit Wonder Imperial IPA). It canned Old Chub, G'Knight imperial red ale, Mama's Little Yella Pils and Ten Fidy imperial stout, whose unusual moniker is still a source of urban legends on the true meaning of the word "fidy."

Once it had the pilsner and other beers on shelves, it produced Gubna, a beverage that head brewer Dave Chichura calls a "smelly, alcoholic, big-ass IPA." The taprooms in Lyons and in Longmont—where both the brewery and the Home Made Liquids & Solids restaurant are located—from time to time offer exotics such as a smoked porter, a sour cherry stout or a red rye ale.

Though Oskar Blues has gotten far bigger than expected, it hasn't gone corporate. The brewery sells to local liquor stores before it supplies its beer to chain stores. And when demand grew to the point where the brewery couldn't make enough product in 2010, it decided to pull out of two states rather than rush through its processes and compromise its quality.

And if you tour the Longmont brewery, you'll notice a few things that you won't find in corporate breweries, such as a basketball court, a pitching machine and skateboards scattered around the floor. Oskar Blues leaders say Katechis is still known to lighten up meetings by shooting spitwads at his cohorts.

Oskar Blues may have spawned an environmentally responsible movement that has swept through craft brewing, but the enjoyment of the beer is what drives Katechis and his company.

"We got into this business for a reason, and we want to keep it fun," says Katechis. "So we owe that to the soul and the culture and the vibe of the company as we build it to let that remain intact."

AC Golden Brewing

300 Twelfth Street www.acgolden.com
Golden (Map 2) 800-936-5259
Signature beers: Colorado Native (amber lager),
Herman Joseph's Private Reserve
No public access to brewery; beers sold throughout Colorado

Few small breweries make only lagers, which take longer to ferment and hold less appeal to the majority of craft beer drinkers. But for the incubator brewery for the largest lager producer in Colorado, it's a family calling.

AC Golden Brewing launched in 2007 as the experimental brewery for Molson Coors. Tucked into a small, windowless space within the Coors brewery in Golden, its three brewers work on, well, whatever they want in the lager line.

Colorado Native, the signature beer of AC Golden Brewing, is made almost exclusively with ingredients from Colorado. *Courtesy of AC Golden Brewing.*

Unlike experimental brewing labs within Anheuser-Busch or Miller Brewing, AC Golden doesn't take orders from the parent company. Instead, its small staff dreams up the next style of beer that might be a big seller. Then it peddles it on its own, and if that beer sells enough, Molson Coors just might make it part of its line. "The idea isn't to be a cute little microbrewery. The idea is to hit a home run," President Glenn Knippenberg says.

AC Golden's first home run was Herman Joseph's Private Reserve, a German-style lager made from a recipe brought to the United States by Adolph Coors. Coors Brewing made a version of the beer in the 1980s and 1990s, but AC Golden's revival used four hops and four malts similar to what would have been found in Colorado in the mid-nineteenth century.

Its second batch was another Coors revival, the Winterfest lager that the big company put out in the late 1980s as one of America's first Christmastime beers.

The third effort really caught attention. Colorado Native is an amber lager that's made with 99.8 percent Colorado products (a few hops had to be imported). It not only introduced mainstream drinkers to a darker lager but also caught on with Coloradans who advocate local products.

In the thirty-barrel brewhouse, the AC Golden crew also crafts experiments you'll likely never see in bottles. In its first year at the Great American Beer Festival, its AC Dunkel won a medal; the next year, it repeated, with its German Pilsner and Schwarzbier—two beers only rarely available on tap.

You can't tour the sequestered brewery, though if you're lucky, you might be able to get on the volunteer crews that hand-bottle Herman Joseph's and other beers. But you can find AC Golden offerings at bars and on liquor store shelves near the beers of its patron company.

BLACK FOX BREWING

1647 South Tejon Street www.blackfoxbrewing.com
Colorado Springs (Map 5) 719-633-2555, ext. 15
Signature beers: La Noche Diablo (black saison with cayenne),
Debut (lemon saison)
Located at Bristol Brewing: 10:00 a.m. to 9:00 p.m. Monday–Friday;
9:00 a.m. to 9:00 p.m. Saturday; noon to 6:00 p.m. Sunday

Black Fox Brewing, the first all-saison brewery in Colorado, serves its Belgian-inspired beers from Bristol Brewing in Colorado Springs. *Courtesy of Black Fox Brewing.*

An unusual sight greeted customers of Bristol Brewing on Friday, March 13, 2009—posters of a fox wearing a serial killer–style hockey mask, daring people to try a new beer. But the artwork was bland compared to the beer, a citrus saison brewed with lemon zest and ground ginger root. Subsequent offerings from Black Fox Brewing cranked up the originality.

Colorado's first all-saison brewery is the brainchild of Bristol Brewing's John Davidson and operates as a separate entity within that Colorado Springs institution. Black Fox makes Belgian farmhouse–style ales with unique ingredients and places kegs in select beer bars on the Front Range and in Bristol's taproom.

"We call it 'Belgian-inspired.' We're not trying to do true Belgians. We're doing American bastardizations of Belgian style," Davidson says. "What we're really trying to do is brew one beer for each season."

So, in the spring, you may find Siempre Loco, a light saison brewed with lime zest, cumin seed and black peppercorns. In the fall there could be Automne, an Oktoberfest-inspired saison with Munich malts. And in the winter, bars might stock La Noche Diablo, a black saison aged on cherries and dark chocolate with hints of cinnamon and New Mexico red chilies.

Davidson began his brewing career at Bristol, left to run a pub in Arizona and came back in 2006. By the start of his second stint, he was dreaming of his own brewery, one where he would make small batches and change recipes each month.

A child of the punk-rock era—Davidson skateboards to work—he imbued Black Fox with influences from his favorite bands. The label pays homage to the skull logo of the band The Misfits, and several beer names, such as that of Gusto, a hopped saison, replicate names of his favorite songs.

People have been attracted to Black Fox for the daring of its ingredients and the cute image of the fox on its labels, Davidson acknowledges. But he hopes they also pick up the spirit with which he is running the company. "I would rather people just think our beers are fun and creative," he says. "We created this more for a fun and creative outlet…so I hope that people can feel that from us."

DEL NORTE BREWING

1390 West Evans Avenue, Unit 2-0 www.delnortebrewing.com
Denver (Map 2) 303-935-3223
Signature beers: Órale (Mexican-style light lager), Mañana
(Mexican-style amber lager)
Call to make appointments for tours

Co-workers Jack Sosebee and Joseph Fox enjoyed Mexican restaurants in the early 2000s but didn't care for the south-of-the-border beers served by many of them. Maybe the beers were delivered in trucks without refrigeration or got stuck at customs, causing them to warm up and degrade. Regardless, there had to be something better.

Fast-forward to 2011. Their Del Norte Brewing Company is the only American microbrewery producing exclusively Mexican lagers. "It finally dawned on me that if we didn't do it, nobody else was going to do it," Sosebee recalls. "Frankly, we've been surprised that niche hasn't been filled by others."

The brewery is in the back of an industrial warehouse complex in southwest Denver, and the only thing distinguishing it is a small sign on the door that reads "DNBC."

The going was slow at first. When Sosebee and Fox moved there in 2006, they had to cut a drain in the floor and spend a lot of time sqeegeeing water into it. They bought copper-clad fermenters from the

old Monte Carlo Brewery in Las Vegas, but they had to take off the labels and send those back to the hotel.

But the business came along. Two guys who had dedicated their lives to science—Sosebee is a chemist and Fox a chemical engineer—churn out just four styles of beers to keep things simple. Those include a Mexican-style lager, a Mexican-style light lager, a Mexican-style amber lager and a bock. They've done exhaustive research in historical styles, so their beers have more body and taste more like classic German lagers than those produced by more modern Mexican breweries.

Sosebee and Fox take heart in awards they've picked up. But they're prouder that the people who inspired them enjoy their beers. "When we run into Mexicans who drink our beer, they uniformly love our beer," Sosebee says.

Del Norte officials sell products in five states now and hope to distribute eventually to Mexico.

Few people visit the tucked-away brewery, and it doesn't have a tasting room. Sosebee and Fox, however, are happy to offer samples and tours to all visitors.

FORT COLLINS BREWERY

1020 East Lincoln Avenue
Fort Collins (Map 3)

www.fortcollinsbrewery.com
970-472-1499

Signature beers: Rocky Mountain IPA, Kidd Black Lager,
Z (smoked amber lager)
Noon to 6:00 p.m. Monday–Thursday; noon to 7:00 p.m.
Friday–Saturday

The namesake brewery of one of Colorado's best-known beer towns began as the lager house for the former H.C. Berger Brewery. H.C. Berger closed in 2002 and then reopened under new ownership as Fort Collins Brewery. A year later, when Jan and Tom Peters bought it, there were two lagers in its portfolio and a third still in the brewing process.

While they never envisioned owning one of the few lager-specialty craft breweries in the United States, the couple embraced that style and

has kept churning out unique beers, many of which are available only in their taproom. Fort Collins Brewery has expanded its repertoire, offering signature products like an IPA, chocolate stout and pomegranate wheat that complement longer-fermenting lager beers.

"We don't brew our beers for judges, so we're trying to brew it for the everyday person," Jan says.

Lagers, which typically feature a lighter body and are served at colder temperatures than ales, make up the vast majority of sales for companies such as Anheuser-Busch and MillerCoors. But as craft breweries came on to the scene in the early 1990s, many shied from making lagers like a pilsner or a helles to differentiate themselves from the mass market.

Fort Collins Brewery, however, built its reputation on making lagers with a twist. The Kidd Black Lager, a German-style schwarzbier, is made with chocolate and smoked malt, for example. Z is a smoked amber lager with caramel undertones.

The brewery's ten-table tasting area offers seasonals like its Rauchator smoked doppelbock or its popular spring Maibock.

The 1,200 or so members of the brewery's FCB Tap Club pay a nominal lifetime fee and get exclusive access to offerings like Scotch lager, dunkelweizen or eisbock. Jan calls the tap club one of the brewery's unique aspects.

The brewery moved into a new location just inside Fort Collins city limits in August 2010 and opened a restaurant, Gravity 1020, in an adjacent space. Jan hopes to find room for a local cheese or distillery company, too, in keeping with her goal of making the business "an oasis of all things wonderful."

FUNKWERKS

1900 East Lincoln Avenue, Unit B www.thefunkwerks.com
Fort Collins (Map 3) 970-482-FUNK (3865)
Signature beers: Saison, White (Belgian-style ale),
Māori King (imperial saison)
Noon to 8:00 p.m. Monday–Wednesday; noon to 10:00 p.m. Thursday–
Saturday; noon to 6:00 p.m. Sunday

Funkwerks, located in Fort Collins, is believed to be the only organic saison-specialty brewery in the world. *Courtesy of Funkwerks.*

There are saison breweries and organic breweries in Colorado and elsewhere. But an organic, saison-specialty brewery? Funkwerks may be the only one.

Owners Brad Lincoln and Gordon Schuck met as students at the Siebel Institute of Technology, a Chicago brewing academy, in 2009. After graduation, Lincoln got a call from his friend, whose Belgian Saison won a gold medal at the 2007 National Homebrew Competition. Schuck asked if he wanted to start an all-saison brewery. Lincoln knew saisons, which originated on Belgian farms centuries ago, were a less common style in America. And they agreed that a town like Fort Collins, which already had a Belgian beer palate, would be an ideal place for their brewery.

Moving into the former Fort Collins Brewery plant, they developed two signature beers for bottling—Saison and a Belgian-style White—and then began experimenting. Most beers in their taproom are saisons, though there are occasional forays with Biere de Gardes and other styles using yeast strains from Belgium or France.

"We're focusing on one style, doing it really well. And I think that's the sign of a maturing brewing industry in Colorado," said Lincoln, a few months after Funkwerks' late 2010 opening.

The name is a marriage of the hardworking "werks" tradition of German breweries and the "funk" that describes wild-yeast Belgian fermentation. A few people have told them the moniker is awful, but it always gets them noticed.

Funkwerks can be found in a growing number of specialty beer bars and liquor stores, but most of the business is done in the taproom. Visitors come in with odd looks on their faces at times when they see no IPA or stout on the chalkboard menu, but most find something to like in the Belgian selection.

"Saison's such a loosely defined style that it gives us a lot of leeway for creativity," says Schuck, noting that the brewery moved quickly into trying barrel aging and Brettanomyces souring yeast strains as well. "The attraction was this mysterious thing that I couldn't quite get a handle on."

GRIMM BROTHERS BREWHOUSE

547 North Denver Avenue www.grimmbrosbrewhouse.com
Loveland (Map 3) 970-624-6045
Signature beers: Snow Drop (honey wheat ale),
The Fearless Youth (dunkel)
1:00 p.m. to 7:00 p.m. Tuesday–Thursday; 1:00 p.m. to 9:00 p.m.
Friday; noon to 9:00 p.m. Saturday; 1:00 p.m. to 5:00 p.m. Sunday

When longtime homebrewing buddies Don Chapman and Aaron Heaton decided to open a brewery, they wanted to do something that no one else in Colorado had attempted. And so they turned not just to the niche of German beers but to somewhat obscure styles of those beers, designed both to delight beer geeks and to offer an easy-drinking option for people looking for refreshment.

Grimm Brothers Brewhouse has produced both rarely made types of German classics and some styles that had bordered on being extinct. Take, for instance, its Snow Drop, which brings back the long-dead style of koltbusser—essentially a honey wheat ale with eight different ingredients. Its Master Thief is a German-style porter that few other American breweries offer. Grimm Brothers also brews German styles that are more familiar, such as the Fearless Youth dunkel.

Grimm Brothers Brewhouse's fairy-tale logos, like Snow Drop Honey Wheat Ale and Little Red Cap altbier, adorn tap handles in its Loveland brewery. *Courtesy of Grimm Brothers Brewhouse.*

"Everybody and their mother does a pale ale or an IPA," says Heaton, the vice-president and business manager for the Loveland brewery. "Every beer that I've got is going to tell you a story."

Those stories are played out on the labels inspired by the nineteenth-century fairy tales of the namesake Grimm Brothers. While some are familiar—Snow Drop is Snow White, Red Cap altbier is Little Red Riding Hood—others are less familiar, a trait that Heaton thinks is fodder for taproom conversation.

Loveland seemed the perfect place to set up their brewery. The town didn't have one at the time, and many residents are of German descent, Heaton notes. The one-thousand-person crowd at the taproom's grand opening proved they had guessed right about the potential demand.

The Grimm beers have since spread to a number of restaurants in northern Colorado.

Heaton loves to tell visitors to the brewery about the origins of the beers they're buying. And from time to time on impromptu tours, he reveals that the brewery's fermenters are appropriately named Hansel and Gretel.

New Planet Beer

3980 Broadway, Suite 103 (business office) www.newplanetbeer.com
Boulder (not on a map) 303-499-4978
Signature beers: 3R Raspberry Ale, Tread Lightly Ale,
Off Grid Pale Ale
Contract brewed and distributed throughout Colorado

In 2003, a doctor told Pedro Gonzalez that he was gluten-intolerant. Gonzalez was relieved to know the source of his health problems but distressed that the diagnosis essentially meant the end of beer and pizza in his life.

But after discovering some gluten-free beers on the market, he asked a brewer friend to help him make such a beverage. That beer debuted to a small audience at the fortieth birthday party of his wife, Seneca Murley, in 2009. The reviews were glowing enough that Gonzalez decided to make a full go of it.

New Planet Beer is the only fully gluten-free brewery in Colorado and one of two in America (though several other breweries make one type of

New Planet Beer makes a full line of gluten-free products, such as its Tread Lightly Ale, and donates a portion of the sales to environmental causes. *Courtesy of New Planet Beer.*

gluten-free beer). It began distributing to other Rocky Mountain states in early 2011. While remaining focused on the gluten-free crowd, the brewery has gained fans who are gluten-tolerant but like its beers for their taste.

New Planet wants to be known for more than just gluten-free products, however. It donates a portion of sales of each beer to environmental causes. Tread Lightly Ale, a light ale, supports hiking trails; 3R Raspberry Ale backs nonprofits promoting recycling; and Off Grid Pale Ale helps groups promoting alternative energy education.

"I want to be recognized by my peers as a great gluten-free beer company that has their heart in the right place by giving to conservation in Colorado," says Gonzalez, a former regional financial manager for the Nature Conservancy.

The gluten-free brewing process bypasses the milling and mash tun operations and goes straight to the brew kettle, avoiding cross-contamination of grains. New Planet doesn't operate a brewery itself but contracts with Fort Collins Brewery, which does a weekly special cleanup of some of its equipment to keep it gluten free.

Growth of gluten-free markets is hindered by the lack of supplies. There are few gluten-free types of barley currently on the market, for example. But Gonzalez will look for ways to continue to grow New Planet's offerings. And eventually, he hopes to take his Colorado-bred idea nationwide.

PATEROS CREEK BREWING

242 North College Avenue
Fort Collins (Map 3)
www.pateroscreekbrewing.com
970-368-BREW (2739)
Signature beers: Cache la Porter, Stimulator (rye) Pale Ale,
Old Town Ale (kolsch)
Noon to 7:00 p.m. Tuesday–Sunday

Horsetooth was a known name in Fort Collins even before owner Steve Jones had finished his business plan and decided to call his brewery that. But there was one problem: "Horsetooth" was the trademarked moniker of another beer in town, so Jones had to come up with something else.

Pateros Creek Brewing, one of Fort Collins's newest breweries, specializes in lower-alcohol session beers. *Courtesy of Pateros Creek Brewing.*

This could have been a serious setback, especially since Jones's labels feature an image of Horsetooth Mountain west of town. But Jones turned a liability into an asset. A contest to rename the brewery received more than one thousand submissions. Jones picked Pateros Creek because it was the initial name of the Cache la Poudre River that flows through town.

In many ways, that no-problem spirit typifies the beer that Jones brews. While many Colorado beer makers push the limit on styles and alcohol content, Jones is content that Pateros Creek crafts lower-alcohol session ales.

"When I bring out a new beer, it's not always going to put you on your butt because we're trying to blast you with the amount of alcohol that we can throw at you," Jones says. "People can come here from a little farther away and they can have a couple of beers and not be at the point where they say: 'Whoa, I can't talk straight.'"

Jones grew up in Fort Collins as the city gained steam as a brewing capital. He caught the craft brew bug after his wife bought him a homebrewing kit. He even trudged up 14,065-foot Mount Bierstadt with friends to make one of the world's highest-elevation homebrews.

Pateros Creek put out its first beer eight months before its downtown Fort Collins taproom opened in June 2011, distributing its Cache la Porter, an English-style brown porter, to local bars. A rye pale ale and kolsch followed.

It's not that Pateros Creek won't do edgy beers; Jones plans a spruce-tipped beer as one of his regular offerings. But he intends to keep his products at around 5 percent alcohol by volume—an attribute he learned in homebrewing after his first child was born. "I wanted to have a beer when I got off work, but I didn't want to be buzzing when I was playing with my one-year-old son," he recalls.

CHAPTER 6
THEY HAVE A BREWERY IN THIS TOWN?

COLORADO'S SMALL-TOWN BREWERIES

COLORADO BOY PUB & BREWERY

602 Clinton Street www.coloradoboy.com
Ridgway (Map 1) 970-626-5333
Signature beers: Colorado Boy Irish Ale, Colorado Boy IPA,
Colorado Boy Best Bitter
4:00 p.m. to 8:00 p.m. Tuesday–Wednesday; 4:00 p.m. to 9:00 p.m.
Thursday; 3:00 p.m. to 9:00 p.m. Friday–Saturday; 4:00 to 8:00 p.m.
Sunday

Tom Hennessy had owned, operated and sold five breweries—including two in Albuquerque and one in Colorado Springs—when he got the itch to return to the business in 2007. Rather than seek out a big city, however, he found Ridgway—an 830-person mountain town and bedroom community of vacation hotspot Telluride that had never before been home to a brewery.

His demographic research was simple: he strolled around town and noticed a large number of Tibetan prayer flags on the porches of the laidback, nature-loving residents. And that was enough for Hennessy to know that the 1915 brick building on the "downtown" corner was where he wanted to open his sixth and, he hoped, final operation—Colorado Boy Pub & Brewery.

Colorado Boy Pub & Brewery is located in a town of fewer than one thousand people but teaches aspiring businesspeople nationwide how to open a brewery. *Courtesy of Colorado Boy Pub & Brewery.*

The fact that tiny Ridgway, located on the north end of one of the most scenic highways on Colorado's Western Slope, has a brewery is one thing. That it's run by one of the most influential brewers in the state is another.

Hennessy inspired countless small breweries in the mid-1990s with his *Frankenbrew* video, which explained how entrepreneurs could use old dairy equipment and Grundy tanks to start their own beer-making businesses. And he is teaching a new generation of small brewers from across the country by bringing them to his 1,200-square-foot brewpub for one-week classes.

Hennessy loves what he's doing at his "wee humble pub."

"It's just a corner pub. Every town should have one," he says. "We moved here and I was trying to think what I could do in this town. And I knew how to make beer. So, here we are."

Hennessy's story goes back to 1993, when he was running Il Vicino pizza restaurant in Albuquerque. A friend suggested it would be the perfect place for a brewery, and Hennessy, who'd never tried his hand at

making fermented beverages, spent the next six months crafting what he called "bad beer."

Then he brought in a professional brewer to spend a few days with him, and things changed dramatically. He expanded Il Vicino to a second restaurant in Albuquerque and then opened two Colorado Il Vicinos in Colorado Springs and Salida.

It was as he was cobbling together various equipment (for $20,000, as opposed to investing in a $200,000 brewing system) that he envisioned his *Frankenbrew* video, named as such because other brewers would walk in and ask how he created his Frankenstein of a system. He made money on the eighty-minute tapes, but demand tapered off by the late 1990s.

It was about this time that Hennessy and his wife, Sandy, decided to get out of the brewing business and become park rangers. They moved from park to park, loving the outdoors, until they relocated to Colorado's Western Slope and opened Palisade Brewery in 2003.

Palisade introduced Hennessy to the bottling and shipping side of the business, and it's where he developed balanced but malty British-style ales, including Farmers Friend Irish ale and Red Truck IPA, that garnered statewide fans. The brewery has sold, shut down, sold again and reintroduced a completely different line of products, but current brewer Danny Wilson says rarely a day goes by that someone doesn't walk in and ask for a now-retired Farmers Friend or Red Truck.

But after two years of bottling and shipping beers, the man who loved nothing more than interacting with customers tired of that end of the business. So it was back to the national parks again, only to realize a couple years later that he missed the Colorado mountains and living in one spot.

Ridgway is an old mining and ranching town that hasn't seen a lot of growth in the past eighty years. Its original cattle exchange sits a few blocks from Colorado Boy, and typical residents, Hennessy says, "live off the grid and climb mountains."

But Ridgway has a surprising trove of character for its size. Billings Artworks, across the street from Colorado Boy, makes the statuettes given at the Grammy Awards. One of the town's residents is a mountain climber who also serves as the Rolling Stones' physician during their American tours.

Colorado Boy is the heart of this local scene. On some winter days, it may get only three or four customers. But in the summer, when tourists

Having started and sold several other breweries in the state, Colorado Boy founder Tom Hennessy moved to Ridgway for the small-town sense of community. *Courtesy of Colorado Boy Pub & Brewery.*

rediscover Ridgway, the brewery becomes a standing-room-only place whose twenty-five seats go fast.

The mayor occasionally tends bar, and town council members, the majority of whom were homebrewers when Hennessy looked to open in 2008, also frequent the pub. Heady discussions on governance and politics (Hennessy's idea of mandatory voting, punishable by fine, nearly made it onto the Ridgway ballot in 2010) are encouraged at the brewery. TV is not. In fact, Colorado Boy has neither television nor live music. Food is limited to a half dozen types of pizzas Hennessy makes.

That's also about how many beers you'll find, typically of British descent, in addition to the Colorado Boy Irish Ale—a Great American Beer Festival silver medal winner on its first try that Hennessy tries to keep on tap at all times.

Hennessy brews a stout, a blonde, a dark mild and a best bitter. He brews an IPA, but it is a balanced product with hops that are relatively silent compared to most of its Colorado brethren. And there's almost always some form of cask ale on tap.

Hennessy was a "hophead" in the 1990s, he admits, preferring beers with high hops tastes and bitterness. But a trip to Scotland with his wife changed his thinking about balanced and cask-conditioned ales. "I want a beer that just accompanies the conversation," he says. "I want to bring it back down to what it is. It's a beverage that you enjoy with your friends."

And, in Hennessy's case, it's a beverage that you teach a lot of new friends to make.

As he was first getting ready to open Colorado Boy, he went online and found a number of bootlegged copies of *Frankenbrew*. He realized that the video he put together on a shoestring more than a decade earlier had gained a cult following.

That inspired him to take the concept further and offer weeklong, one-on-one brewery startup courses at Colorado Boy covering brewing, bookkeeping, business operations and equipment sourcing. Students are responsible for bringing their own notepads and rubber boots. He's taught Coloradans and out-of-staters alike. Some have gone on to start their own breweries.

"Our feeling is if you can do it in a town of eight hundred, you can do it in just about every little town in the state of Colorado," Hennessy says.

Some of the state's small-town brewers are testament, and they credit Hennessy.

Erin Eddy, co-owner of Ouray Brewery, says Hennessy encouraged him when others said eight-hundred-person Ouray wasn't big enough for a second brewery and gave him valuable feedback on the size and design of his business.

Similarly, when Tony Simmons wavered on starting a brewery in 1,800-person Pagosa Springs, "Tom Hennessy assured me over and over again: people will find good beer."

Mic Heynekamp remembers walking into Il Vicino in Albuquerque back in the 1990s and nervously telling Hennessy that he didn't want to step on his toes but that he wanted to open a brewery about an hour away in Socorro Springs, New Mexico, and was hoping to get advice. Hennessy told him the only secret was working hard and then walked him through everything from brewing to equipment purchasing. "He's helped a lot of people," says Heynekamp, who has opened two breweries, including Eddyline Brewery in Buena Vista.

Hennessy's legacy is certainly that, but more important to him is the idea that people will have the same gumption he's had—several times—to open their own "wee humble pubs" with conversation and approachable beer and a spirit to building community, no matter the size of the town.

"I've helped a lot of breweries open over the years," he acknowledges. "And I'm glad about it."

AMICAS PIZZA & MICROBREWERY

136 East Second Street
Salida (Map 1)

amicassalida.wordpress.com
719-539-5219

Signature beers: Headwaters IPA, Loyal Duke Scotch Ale,
Green Chile Ale
11:30 a.m. to 9:00 p.m. daily

Amicas Microbrewery, tucked in a brick building on a quiet downtown street with free two-hour parking out front, is the kind of place you'd expect to walk in and meet the locals. Chances are you'll also find the place teeming with tourists.

That's because Salida is not your average town of 5,500. Situated between world-class rafting areas and Monarch ski area, the town whose name means "exit" in Spanish is a gateway to all sorts of Colorado pleasures.

Amicas is a small-town pizza joint with a flair for bold flavors and a crop of loyalists who keep the place jammed.

"I'm trying to brew something that is unique, flavorful and isn't super-challenging to drink," head brewer Mike LaCroix says of the roughly twenty-four beers that appear on Amicas' seven taps each year.

Anyone wondering how that philosophy fits in with both the quaint downtown and the adventure-sport crowds need only watch LaCroix stir the mash with the same rafting paddle used since the brewery opened in 1994. Amicas then was part of the Il Vicino brewpub chain. But when chain officials told local owner Kathie Younghans in 2002 that the small town didn't have enough potential customers, she went independent.

While many of the pizza recipes have remained the same, LaCroix revamped the beer selection, adding pumpkin and ginger beers and

barleywines throughout the year to the regular lineup of IPA, amber and blonde ales. The ambitious menu comes with a caveat, LaCroix notes. "We have to brew beers that can be ready pretty quickly because we don't have the time or the room to let beers sit around very long," he says.

Indeed, the "brewery" is a small side room tucked behind the wood-fired pizza ovens. Amicas bottles a few beers and sells them at local liquor stores and the nearby ski area, but for the most part you have to go to the restaurant to try the product.

And when you do, know that Younghans has taken steps to ensure the locals are treated right, like eliminating happy hours that used to draw drinking-only crowds, forcing pizza customers to stand in lines outside. It's part of how a small-town brewery manages big expectations.

CARBONDALE BEER WORKS

647 Main Street
Carbondale (Map 1)
www.carbondalebeerworks.com
970-704-1216
Signature beers: Langer Irish Stout, Little Tinker ESB,
Off-Beat Lemon Wheat
4:30 p.m. to 11:00 p.m. daily

Carbondale is near the tourist magnets Aspen and Glenwood Springs, but in many ways it may as well be on the opposite end of the state. Few tourists visit Carbondale; rather, its 6,300 residents make up much of the labor force for the town's two high-profile neighbors.

Life happens at a relaxed pace in Carbondale, says Jeff Dahl. So when he opened Carbondale Beer Works in late 2010, he made sure it was a place where the locals could kick off their shoes, bring the kids and enjoy hot dogs and brats. (The establishment is the only Colorado brewery that also calls itself a "wienery.")

"We want this to be a pub in the English sense of the word, a place where people come to chill," Dahl says.

Dahl is an architect by trade but developed the homebrewing bug while living in New Orleans. He moved to Snowmass, just down the road from Carbondale, for a job. When the economy tanked in 2009 and his

workload as an architect slowed, he felt it was the right time to pursue his long-held goal to start a brewery.

Carbondale Beer Works doesn't specialize in one particular beer. Dahl's Off-Beat Lemon Wheat won him numerous homebrewing awards, but he is equally excited about the reaction to his Little Tinker ESB and his Langer Irish Stout.

If the atmosphere and beers have a certain UK character, it's because, as he was preparing to open the brewery, Dahl rushed to England to get a formal brewing education. The most lasting influence is the constant presence of cask-conditioned beers on tap.

The community, which had gone ten years without a brewery after the previous one closed, was very supportive, so Dahl looks constantly to give back. He hosts First Fridays to support local artists and offers a Founders Club to reward loyal customers with merchandise and credits. He also tries to buy the vast majority of his sausages and hot dogs from area vendors.

It's part of being the brewery that thrives because of locals rather than tourists and why Dahl proclaims Carbondale "the coolest town in the valley."

DILLON DAM BREWERY

100 Little Dam Street www.dambrewery.com
Dillon (Map 1) 970-262-7777
Signature beers: Sweet George's Brown, McLuhr's Irish Stout,
Dam Straight Lager
11:30 a.m. to 11:30 p.m. daily

The bustling outlet malls and winter sports resorts surrounding it belie the fact that the town of Dillon is home to only eight hundred year-round residents. And while Dillon Dam Brewery draws out-of-town shoppers and skiers, it relies on those locals to build its customer base and its reputation.

Located just off Interstate 70, the brewpub with the giant green grain mill has been open since 1997, offering eight to nine beers on tap, local bands and crowds of regulars eager to advise newcomers on which beers to try.

The Dillon Dam Brewery sits at the foot of Dillon Reservoir and near several ski resorts but relies on locals as its main customer base. *Courtesy of Dillon Dam Brewery.*

"There is a great community feeling here. I think that's what all of us would like to be a part of is a good community," owner and general manager George Blincoe says.

Blincoe wanted a pub where the brewers were as accessible as the beer and where happy hours were—and still are—as packed from 3:00 to 6:00 p.m. on weekdays as they are on weekends.

Dillon Dam is one of the rare Colorado craft breweries to make a light beer, a nod to the southerners who ski and buy second houses in the area. But its regular taps range from a hefeweizen to a brown ale to an Irish stout.

Brewer Cory Forster also sets aside a little bit of nearly every batch and ferments it with a twist. He may add peaches and cream to the Wildernest Wheat. Or he could brew raspberry and vanilla into his seasonal porter, creating his Neapolitan Porter. "The great thing about these side batches is they keep people excited," he says.

Dillon Dam's family-friendly restaurant has an extensive menu, and if there's a line when you get there, you can take a sign-guided tour of

the brewery upstairs. Or you can entertain yourself with the imaginative monikers on the beer menu: Dam Straight Lager, Sweet George's Brown, Yo Han Bock. If the brewers can create an inside joke with locals or elicit a smile from visitors, they've created the community they always sought.

DOLORES RIVER BREWERY

100 South Fourth Street www.doloresriverbrewery.com
Dolores (Map 1) 970-882-HOPS (4677)
Signature beers: Sweet Jamaican Brown Ale, ESB,
Liquid Sunshine (hoppy ale)
4:00 p.m. to close Tuesday–Sunday

Mark Youngquist lived the life of a beer-industry rock star, helping found the Rock Bottom chain and flying around the country to set up breweries. But after seven years, he missed the process of actually making a beverage.

Dolores River Brewery is located in an eight-hundred-person town, but its forty-five-seat taproom is often packed with many of the town's leaders on Friday nights. *Courtesy of Dolores River Brewery.*

So he settled in Dolores, a town of eight hundred in southwest Colorado that attracts tourists on their way to Mesa Verde National Park and residents who've left the big-city rat race. In 2002, he opened his "dream"—the Dolores River Brewery, a forty-five-seat brewpub that offers musical acts, quirky beers and a community gathering spot.

Youngquist can point out most everyone in the pub on a Friday night—the town manager, the police chief, one of the guys who helped build the local McPhee Reservoir. He can tell you who keeps bugging him to make a smoked beer (he won't do it) and who gave him directions for a six-day backpacking trip.

The brewery, a remodeled 1930s telegraph office building, is regularly jammed on weekends. "Being in a small town presents a load of challenges," Youngquist says. "But I wouldn't have it any other way. I mean, I know damn near everybody sitting in here right now."

The regulars come for the ESB or the Pale Ale. But Youngquist—who is adamant that he never brews to a particular style—will also foist upon them his Jamaican-spiced brown ale or his Liquid Sunshine, an ale thick with Mount Hood hops that's not quite an IPA.

"I'd love to be able to brew really esoteric, bizarre beers," he admits. "But this is a small market. I need people to drink more than one."

Youngquist, who learned to homebrew on his stove in high school and worked in the microbrew industry's early days at institutions such as BridgePort Brewing of Portland, Oregon, hopes now to be the center of a close-knit town. He doesn't travel to beer festivals or enter contests, and he doesn't want to live the hectic life he once did.

"The testimonial of an empty glass and a smile on somebody's face— that's better than any [award] I could put on a *Rolling Stone* ad or on the side of my six-pack...if I had one."

ELDO BREWERY AND TAPROOM

215 Elk Avenue www.eldobrewpub.com
Crested Butte (Map 1) 970-349-6125
Signature beers: Secret Trail Ale (amber), Sock-it-to-me Scottish Ale,
King's Kolsch
3:00 p.m. to close daily

They Have a Brewery in This Town?

When the Eldo Brewery opened in 1998, half the streets in Crested Butte were unpaved. But residents did have Internet access, one of the seeming contradictions about this rustic-yet-sophisticated world-class ski destination.

For a town that thrives off international skiers who come each winter for its renowned technical terrain, CB, as it's known, keeps a remarkably local feel to it. During the spring and fall slow seasons, you can find dogs lying on Elk Avenue, the main drag. And one big event in a neighboring town can be enough to shut down businesses along that road.

"Around here, if there's a funeral or a wedding, half your crowd's out of town," says Fred Orndorff, Eldo's head brewer. "And if there's a powder day, everyone's too tired."

That makes it all the more remarkable that the Eldo, a dark, second-floor bar accessible by a narrow stairway off the street, can pack 170 people around its concert stage when it hosts national touring bands like the Reverend Horton Heat (earning it the nickname "The Smelldo.")

When Orndorff took over brewing duties in 2007, the brewery side of the Eldo was a distant afterthought. He set out to change that. First, he embraced its reputation as the rare malt brewery in a state full of hop stars. Yeah, there's an IPA on the menu. But there's also the flagship Beckwith Brown Ale, a mild ale, and the King's Kolsch, brewed with an English ale yeast.

And he made sure there are always options. Orndorff makes about sixteen beers on a regular basis and rotates them when the spirit moves him—the joy, he says, of being a small brewpub with only one off-premises account.

"My favorite part is making new recipes," he says, remembering how the OPG Smoked Ale evolved through several iterations. "We have the ability to be able to experiment."

Eldo is a local-friendly place. One regular made its bar stools, another created its custom tap handles and a third designed its website. But it's welcoming also to the après-ski crowd that packs its porch overlooking Elk Avenue.

If you head there in April or October, you may have the place to yourself. Or you may have to compete for a stool at the bar with the "same eight guys" Orndorff has come to appreciate always being there.

Grand Lake Brewing

915 Grand Avenue www.grandlakebrewing.com
Grand Lake (Map 1) 970-627-1711
Signature beers: Wooly Booger Nut Brown Ale,
Super Chicken (barleywine)
Summer: 11:00 a.m. to 9:00 p.m. Sunday–Thursday; 11:00 a.m. to
10:00 p.m. Friday–Saturday; Winter: noon to 7:00 p.m. Sunday–
Thursday; noon to 8:00 p.m. Friday–Saturday

Boardwalks line the main drag in Grand Lake, and snowmobiles are welcome everywhere in this town of 450 on the western edge of Rocky Mountain National Park.

And, thanks to Grand Lake Brewing, the high-altitude hamlet can boast of being the smallest town in Colorado with a brewery. Its tasting room features two tables, ten bar stools, ten taps and a small pub

Grand Lake Brewing holds the double distinction of being the highest-elevation packaging brewery in America and the brewery located in the smallest town in Colorado. *Courtesy of Grand Lake Brewing.*

menu, but the heart of Grand Lake Brewing's business is bottling and distributing beers.

Owners Richard and Karen Wood bring ingredients to the brewery themselves and transport six-packs to sell to liquor stores one hundred miles away in Denver.

"We're hare-brained enough to be a distributing/packaging microbrewery in the middle of nowhere," brewmaster Eric Kohl says of the highest-elevation packaging brewery in the United States, at 8,369 feet above sea level. "Nobody else is ambitious enough or stupid enough...to do this in such a remote area."

The Woods opened Grand Lake with two partners in early 2003 and bought them out three years later.

One of their biggest challenges has been limited space. They've had to move equipment out of the brewery to set up the bottling line there. For a while, they parked kegs on the sidewalk until the city said they had to move them by 10:00 a.m.

Wooly Booger Nut Brown Ale is the brewery's top seller. But the regulars plead most often for Super Chicken, an 11 percent alcohol-by-volume barleywine (marketed at beer festivals by people in chicken costumes), and Plaid Bastard, a strong Scotch Ale.

It's a family operation. Karen embroiders clothing with the brewery's logo. Their teenage son, Warren, helped design the bottle labels.

The Woods, who live in Golden ninety-five miles away, fell in love with Grand Lake in 1970, when they first camped there. For one thing, the water quality is outstanding. "Nobody's had a chance to pee in it before we get it," Kohl jokes.

They also like the altitude. It gives them lots of opportunity to use the company's motto: "It's all downhill from here."

OURAY BREWERY

607 Main Street www.ouraybrewery.com
Ouray (Map 1) 970-325-7388
Signature beers: San Juan IPA, Box Canyon Brown Ale,
Camp Bird Kolsch
11:00 a.m. to 9:00 p.m. daily

Driving south on Highway 550, you pass through a steep canyon whose red cliffs seem almost to envelop the roadway. If it feels like you're entering a place sheltered from the world, you know you're in Ouray.

The town of eight hundred year-round residents, with gravel streets leading to its one paved road, seems an unlikely place to support one brewery, let alone two. Yet there on the east side of that paved street sits Ouray Brewery, the second beer maker in town and the only restaurant with a rooftop patio staring into the San Juan Mountains.

Founding partner Erin Eddy had been in Ouray fifteen years before he opened the place in August 2010, his résumé dotted with stints as a motel operator, fishing guide and organizer of the Ouray Ice Festival, an international gathering of ice climbers.

Eddy, who also dabbles in real estate, sold 607 Main Street to a Texas oilman whose daughter planned to open a dine-in movie theater there. When she and her dad had a falling out, Eddy swooped in with a brewery plan, and the agreement was written on a napkin.

He wanted something that catered to residents but also grabbed summer tourists. (Ourayle House, located just 228 yards northwest, caters more to locals.) So he brought in a Cajun chef, put tables on the patio and, instead of bar stools, set up bar swings. Yes, bar swings. The chairs hang from a cable that used to hold the sightseeing gondola in Moab, Utah. "This rooftop and those chairs have really kind of saved us," Eddy said after his first summer in operation.

Brewer Jeff Lockhart's contributions didn't hurt, either. Lockhart was looking for a new gig about the time Eddy's first brewer—his wife—got into nursing school. He signed on and created a spate of approachable beers, including a signature IPA, a rye ale and an Irish stout. The menu tends to change with the seasons.

Running a brewery in a town where 40 percent of the businesses close in the winter is not easy, but the locals have taken to it. That's important, as this is a Main Street full of independent businesses in a town full of fourth- and fifth-generation residents.

Says Eddy: "It's a town rooted in tradition and strongly resistant to change."

A taster of Aspen Brewing Company beers rests against the mountainous background in the tourist magnet town. *Courtesy of Aspen Brewing.*

The New Belgium Brewing tasting room, or "liquid center," offers specialty Belgian-style beers that are not sold elsewhere. *Courtesy of New Belgium Brewing.*

Equinox Brewing owner Colin Westcott taps a special cask ale of his beer, which is typically made in a classical style with a unique twist. *Courtesy of Equinox Brewing.*

Colorado Boy Pub & Brewery is a "wee humble pub" in an 830-person town whose owner, Tom Hennessy, has taught many people how to open breweries. *Courtesy of Colorado Boy Pub & Brewery.*

Great Divide Brewing's hip tasting room just north of downtown Denver is just a couple blocks away from Coors Field and numerous restaurants. *Courtesy of Great Divide Brewing.*

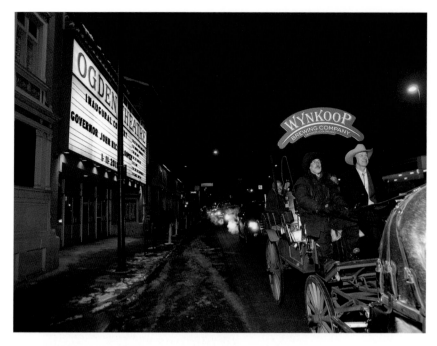

Wynkoop Brewing cofounder John Hickenlooper rides to his inaugural celebration in the brewery's horse-drawn beer wagon after being sworn in as Colorado governor in 2011. *Courtesy of Wynkoop Brewing.*

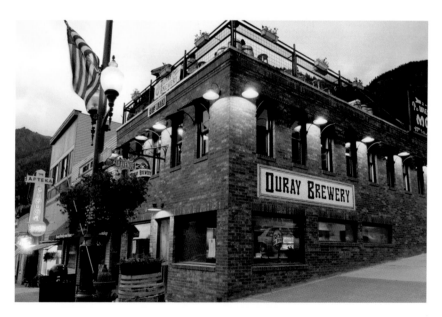

The rooftop patio at Ouray Brewery stares into the San Juan Mountains, and the brewery offers bar swings suspended from a sightseeing gondola cable. *Courtesy of Ouray Brewery.*

Pagosa Brewing founder Tony Simmons pops out of a kettle used to make Poor Richard's Ale, a colonial ale served for Ben Franklin's 300th birthday. *Courtesy of Pagosa Brewing.*

Breckenridge Brewery has three locations around downtown Denver, including a brewpub opposite the right field gates at Coors Field that is a popular pre-game stop. *Courtesy of Breckenridge Brewery.*

Avery Brewing founder Adam Avery tastes Depuceleuse, one of the barrel-aged wild ales that has furthered the brewery's experimental reputation. *Courtesy of Avery Brewing.*

CooperSmith's in downtown Fort Collins boasts an expansive list of beers, a full pub menu and an active billiards room. *Courtesy of CooperSmith's.*

Dillon Dam brewer Cory Forster displays his award-winning beers, including Sweet George's Brown Ale, a gold medalist at the Great American Beer Festival. *Courtesy of Dillon Dam Brewery.*

Customers pack Trinity Brewing in Colorado Springs for its envelope-pushing beers and glass-top bar, composed of shards of the bottles of beer drunk during construction. *Photo by Mike Laur/*Beer Drinker's Guide to Colorado.

Left: Bill Eye, head brewer for Dry Dock Brewing of Aurora, mills grain for his award-winning beers. *Courtesy of McBoat Photography.*

Below: Before its fourth anniversary, Dry Dock Brewing won the Great American Beer Festival's prestigious Small Brewing Company of the Year award with its wide beer selection. *Courtesy of McBoat Photography.*

Right: The taproom of Durango Brewing, one of Colorado's oldest breweries, pays homage to the historic Durango-Silverton Railroad. *Courtesy of Durango Brewing.*

Below: The taproom of Aspen Brewing is a mix of the rustic and the refined, with shining stainless steel and wood-hewn tap handles. *Courtesy of Aspen Brewing.*

Upslope Brewing founder Matt Cutter packages his beers in cans that can be taken on a bike ride, a hike—or a mountain climb. *Courtesy of Upslope Brewing.*

Oskar Blues workers pour samples at their popular booth at the Great American Beer Festival in Denver. *Courtesy of Oskar Blues Brewery.*

Oskar Blues launched the "Canned Beer Apocalypse" with Dale's Pale Ale in 2002. Cans are lighter to ship and protect beer from light and oxygen. *Courtesy of Oskar Blues Brewery.*

Pump House Brewery in downtown Longmont is known both for its assertive Shockwave Scottish Ale and a variety of experimental fruit beers. *Courtesy of Stephanie Whitehill.*

Above: Strange Brewing Company of Denver doesn't serve golden or amber ales, but it makes a variety of Belgian-style and highly hopped products for adventurous drinkers. *Courtesy of Strange Brewing.*

Left: Jake O'Mara, brewer for Odell Brewing of Fort Collins, mills grain for the company that's grown a national reputation for barrel-aged and experimental beers. *Courtesy of Odell Brewing.*

Twisted Pine Brewing of Boulder may look gentle, but it makes the hottest beer in Colorado and a variety of envelope-pushing experiments. *Courtesy of Twisted Pine Brewing.*

Left: Equinox Brewing of Fort Collins not only serves beer but also encourages visitors to write down each recipe and to try brewing it at home. *Courtesy of Equinox Brewing.*

Below: Wynkoop Brewing, the oldest brewpub in Colorado, began canning its flagship Railyard Ale for distribution in 2009. *Courtesy of Wynkoop Brewing.*

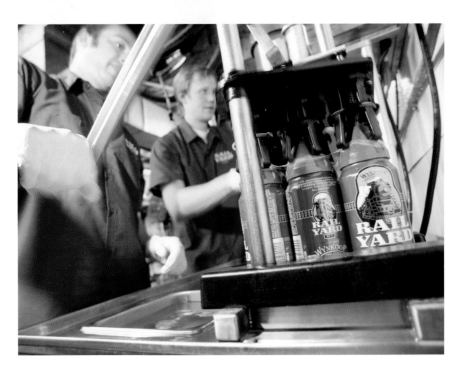

SILVERTON BREWERY

1333 Greene Street
Silverton (Map 1)
www.silvertonbrewing.com
970-387-5033
Signature beers: Ice Pick Ale (English-style IPA), Bear-Ass Brown
(English mild)
May 1–November 1: 11:30 a.m. to 9:00 p.m. Monday–Saturday;
11:30 a.m. to 7:00 p.m. Sunday

Never mind that San Juan County, with its 550 year-round residents, is the smallest county in the United States with a commercial beer maker. That doesn't tell you what you need to know about Silverton Brewery.

Know instead that the town of Silverton once was cut off from the world for twenty-three days when snow closed the two passes to the south

Silverton Brewing's Red Mountain Ale depicts the nearby "Million Dollar Highway" crossing Red Mountain Pass, which becomes impassable in the winter months. *Courtesy of Silverton Brewery.*

and the infamous Red Mountain Pass to the north. Red Mountain Pass, after all, is part of the "Million Dollar Highway," so named because an early traveler exclaimed: "I wouldn't go that way again if you paid me a million dollars."

Only then will you understand what brewers here go through to make their beer.

Yet, since 2005, Silverton Brewery has been a mainstay, offering six taps and, starting in 2009, sales of six-packs of its most popular beers. It churns out locally brewed beer in a town where supplies sometimes show up and sometimes don't. "We're kind of on our own," said former assistant brewer Ian Hendry. "I love the place, but it's really secluded."

Silverton is a classic Colorado mining town that, in the 1880s, boasted a brewery that turned out five thousand barrels a year. Prohibition killed that business, but current owners Joel and Kate Harvie loved the town when they visited and decided the brewery needed to be revived.

Originally a producer of big beers—its lightest offerings were in the 6.5 percent alcohol-by-volume range—Silverton now makes a spectrum from a German helles to a thick and pungent barleywine. Once a year it serves up a Presidential Porter loosely based off one of George Washington's molasses-and-brown-sugar homebrew recipes.

Inside the brewpub, decorated with old mining tools and 1890s-style newspaper ads, are a few locals and, in the summer, lots of tourists who come in via the Durango & Silverton Narrow Gauge Railroad. It's a seasonal place: Silverton Brewery doesn't open from November through April.

But in that downtime, brewers perfect their recipes in the basement and dream up cheeky names, like their Bear-Ass Brown or Barley Legal Barley Wine.

Eventually, Silverton Brewery's owners would like to see their company become a household name in Colorado. But for now, they're happy accommodating anyone who can get through to town, sit on the saddle seats at their bar and enjoy a brewing tradition that started when the mountains around them sparkled silver and gold.

THREE BARREL BREWING

586 Columbia Street
Del Norte (Map 1)

www.threebarrelbrew.com
719-852-3314

Signature beers: Black Copter Stout, Bad Phil (pale ale),
Hop Trash Ale (IPA)
8:30 a.m. to 5:30 p.m., Monday–Friday; by appointment on Saturday

As you drive into Del Norte on a Friday night, the storefronts and restaurants are so dark you almost wonder why the town's lone stoplight hasn't rolled up and gone home as well. Yet half a block off the main drag, tucked between a post office and a title company, in the back room of a brick building, a man toils over a wet-hopped Scottish ale or a Brettanomyces-infused sour Belgian ale. And here you've found John Bricker, owner of the elusive Three Barrel Brewing Company.

The brewery is through a door in the back of his insurance office, where he'd be happy to sell you a policy for your pickup or a party pig full of his Trashy Blonde ale. A few customers come in to request both. Those who come for the refreshment discover that small town doesn't mean small beer. And every label on Three Barrel's twenty-two-ounce bombers tells a story.

Bad Phil, Three Barrel Brewing's pale ale, was named for a rebellious rooster that lived next to owner John Bricker in Del Norte. *Courtesy of Three Barrel Brewing.*

Bricker honors the surrounding San Luis Valley's history with his Penitente Canyon Ale, a Belgian Biere de Garde named for the self-flagellating Spanish settlers who confessed to a priest on his once-a-year trips through town. And he sings his own story with Bad Phil, a Cascade- and Centennial-hopped pale ale dedicated to his neighbor's rooster, known to attack those who turn their backs.

You can get those at a few bars and stores in the sparsely populated valley known for its migrant farmers and UFO sightings (which inspired his Black Copter Stout). Or, in the summer, you can stroll past the certificates of insurance education and licensing on Bricker's wall to the patio area behind his office.

Three Barrel isn't the first brewery in this old cattle town of 1,700. In 1878, Del Norte Brewery—not to be confused with its contemporary namesake in Denver—operated about a mile south of town.

One hundred twenty-eight years later, homebrewer Bricker sunk some of his savings into a three-and-a-half-barrel system—and made his wife question his sanity. But he's still producing a range of experimental beers and is happy to show anyone who can find the brewery, from Continental Divide bikers to cross-state travelers, some small-town charm.

"I wanted to bring out the culture of the San Luis Valley," he says. "The adventure of it is part of the journey."

WILD MOUNTAIN SMOKEHOUSE & BREWERY

70 East First Street www.wildmountainsb.com
Nederland (Map 1) 303-258-WILD (9453)
Signature beers: Hop Diggity IPA, Redemption Oatmeal Stout, Big Ned Red
11:30 a.m. to 8:30 p.m. Monday–Thursday; 11:00 a.m. to 9:00 p.m. Friday–Saturday; 11:00 a.m. to 8:30 p.m. Sunday

Located between the gambling town of Central City and the mountain gateway of Estes Park, Nederland is a town of bohemian characters that didn't put in sidewalks until a few years ago. But down its main street is a new building—the first new structure in more than a decade when it opened in 2006—owned by a former partner in Avery Brewing. And

Wild Mountain Smokehouse & Brewery delights its small-town regulars with bold brews like the Hop Diggity IPA. *Courtesy of Wild Mountain Smokehouse & Brewery.*

Tom Boogaard has turned Wild Mountain Smokehouse and Brewery into his own little kingdom.

Boogaard serves smoked barbecue and wings to a crowd of regulars that include the Nederland Curling Club. His patio overlooks a creek and Eldora Mountain Resort. And he whips up balanced but often-big beers that harken to his days from 1998 to 2001 at Avery Brewing when he created The Reverend quadruple Belgian ale. His regulars know those beers well enough to question him when he tweaks his recipes.

Many of them walk from their homes for the bold Hop Diggity IPA, which has a rabid following. "If it's off tap for a day, it's a crisis," Tom's wife, Cori Boogaard, says.

They come, too, for a red ale and an oatmeal stout that approach 9 percent alcohol by volume, as well as for a cherry wheat. Boogaard created a Belgian golden ale for his bar manager's wedding; locals liked it so well that he put it on tap and named it "Consummation."

Nederland features a solar-powered "Carousel of Happiness" and draws huge crowds every March for its Frozen Dead Guy Days, a festival that features coffin races and celebrates the bizarre, ongoing effort to keep a deceased grandfather in a frozen state in a Tuff Shed in town so he can be brought back to life at a future time.

Wild Mountain does its part to advance the town's earth-loving personality by heating its brewing water with solar panels.

The restaurant walls are adorned with 1960s psychedelic rock posters. Tickets from Grateful Dead and Lynyrd Skynyrd concerts are inlaid on its tables, and upstairs are two tickets to an Elvis Presley show that was canceled due to his death.

If you can't decide what to drink, order the BrewSki, a small ski full of four-ounce samples. Or try menu items that go with the Texas barbecue sauce or homemade mustard, both cooked with beer.

But be warned: some people, like Boogaard, have a hard time leaving the town. "I love living away from civilization a little bit," he says.

CHAPTER 7
AGAINST THE GRAIN

COLORADO BREWERIES THAT RUN COUNTER TO THEIR SURROUNDINGS

TRINITY BREWING

1466 Garden of the Gods Road www.trinitybrew.com
Colorado Springs (Map 5) 719-634-0029
Signature beers: TPS Report (Flanders sour ale),
Nocturnum (black saison), Flo IPA
Noon to 9:00 p.m. Monday–Thursday; noon to 11:00 p.m. Friday–
Saturday; noon to 8:00 p.m. Sunday

Customers lucky enough to make Trinity Brewing's first anniversary party in August 2009 were greeted by a man in a dress banging a tambourine and a flutist stomping around the room to the beat of a Jethro Tull cover band. Many, no doubt, had to remind themselves of where they were—in a strip mall surrounded by chain restaurants in the suburban area of the most conservative city in Colorado. The culture clash would have been confounding.

Yet Jason Yester—a dreadlocked hippie who serves slow food and makes thirty-eight types of saison—has found a way for his brewery to not just survive but thrive in this seemingly unlikely atmosphere. A crowd ranging from bike-riding vegetarians to tech-company executives in three-piece suits packs the brewpub seven days a week, making it one of the most popular draws in the area.

Trinity Brewing anchors a strip mall in Colorado Springs but gets decidedly countercultural with its bold, experimental beers, including thirty-eight styles of saisons. *Photo by Mike Laur/* Beer Drinker's Guide to Colorado.

Yester is aware that this shouldn't work, that cities like this typically don't support places where you can get vegan buffalo wings but not a Budweiser. Yet he sees the success of Trinity Brewing as a testament that good beer crosses cultural and political lines.

"I would not expect a bar like this in Colorado Springs. It's like you took something from Boulder and transplanted it here," he admits. "But it is what it is, and we've tried to stay true to it."

While Trinity might be an anathema in its own community, it is representative of a Colorado phenomenon—thriving countercultural craft breweries. Whether such breweries are located in a white-tablecloth restaurant, a Nepalese eatery, an outlet mall or a city that's home to one of the largest breweries in the world, these ventures have found a following in customers who accept beer making in unlikely venues.

Trinity's story starts with Yester, the son of an artist and a biology teacher who, as a student at Colorado College, fell so in love with emerging beer styles that he and his friends had a kegerator in their dorm

room. Yester made his first beer, a stout, with a homebrew kit he had bought for a roommate. After that, there was no going back.

As a sophomore, he gave a presentation on yeast and beer to his microbiology class. The professor liked it so much that he suggested Yester go into brewing. So, two years before it was legal for him to drink, Yester began making beer for Colorado Springs' Bristol Brewing, refining recipes and learning the art.

After completing a senior thesis entitled "A Microbial Analysis of Bristol Bottled Beer," Yester went to work full time there. Just one year later, in 1998, he developed the recipe for Old No. 23, the first barleywine made in Colorado.

"I started doing a lot of experimenting on homebrews," he recalls. "After that, it just was natural to throw my artistic curve at beers."

Over ten years, Yester expanded Bristol's beers to include sours, double IPA and XXX Warlock—an 18.4 percent alcohol-by-volume version of the brewery's oatmeal stout that remains the strongest commercial beer ever made in Colorado.

But by 2008, he was ready to start his own brewery. Yester and a business partner found investors largely through the efforts of John Boddington, a Colorado Springs lumber company owner descended from the British beer-making family of the same name. Boddington met Yester through Bristol and grew to love his beer, figuring that Colorado Springs drinkers would follow him to a new venture.

Boddington now concedes that he underestimated that following. The day Trinity opened, a line of 150 people had formed by 10:30 a.m. for the 11:00 a.m. event. The brewery's beer sold out in less than two days. "It was too successful right from the start," Boddington says in retrospect. "We were packed right when we opened the door."

While Yester had become known at Bristol for pushing the style envelope, he introduced a whole new approach at Trinity. After debuting with beers like an IPA, stout and horkey—an English genre that encompasses a range of brown ales—Yester dived into saisons with a passion.

The saison is a historic Belgian farmhouse style—slightly tart, often made with a variety of spices and typically consumed in spring or summer—that went out of favor for centuries. Pushing a brewery to specialize in such an ancient art required not only an open-minded customer base but also a brewer who wasn't looking to break sales records.

Yet Yester kept coming up with new ideas, spicing saisons with sarsaparilla, pie cherries, cocoa nibs or hemp seed. By early 2011, he had developed recipes for thirty-eight different saisons, and he kept looking to go to places that Belgians perhaps feared to tread.

Take the Double Rainbow, a saison inspired by a viral YouTube clip that included ingredients representing colors from caramelized eggplant to blue agaves to green peppercorns. Trinity brewed the 14 percent ABV experiment in collaboration with Black Fox Brewing of Colorado Springs as the first of what it hopes will be a ten-year series of beers documenting the evolution of pop culture.

Yester also launched the Saison and Farmhouse Ale Festival at Trinity in 2009, an event that grew to include more than a dozen participants by its third year.

In February 2011, he set up the Buddha Nuvo Collaborative Saison Project, a joint venture of some twenty breweries to make a saison as a fundraiser for the Colorado Brewers Guild. Created with five distinct yeasts, six varieties of Brettanomyces, pumpkin, several types of peppercorns and the rare Asian fruit Buddha's Hand, the experiment was meant to entice everyone in the state who had jumped on to the saison bandwagon or even was thinking about it.

"I don't think 'boundaries' is in his vocabulary," says Tim Myers, cofounder of Denver's Strange Brewing. "Doing stuff like this, it goes back to the club homebrew days of: 'What are you doing?'"

Buddha Nuvo was not Yester's first collaborative project, however. The man who has always tried to define brewing by its cultural relevance and group spirit had, eight years earlier, set up the Warning Sign Eisbock team brew. This annual collaboration of fifteen to twenty breweries creates a highly alcoholic but rarely made style of beer served at the Craft Lager Festival in Manitou Springs and designed to show what brewers can do when they work together.

In fact, one of the things visitors to Trinity notice right away is the number of guest taps it offers—typically twenty-five to twenty-seven. The guest taps were a godsend in the days when the brewery couldn't produce its own beer fast enough to meet demand, but they're also an indication that Yester isn't intimidated by having the best beers in America—plus, of course, a tap of Boddington's from England—in competition with his.

"What I really like about it is it pushes me," he says. "I have all these great beers we tap up…and it keeps me on my toes. I like to have that kind of drive." Little else about Trinity Brewing tries to keep up with the Joneses, though.

The menu specializes in slow food—wraps, sliders or soup bowls that take time to come to fruition in the kitchen and inspire you to drink a second glass of the TPS Report Flanders sour ale or Farmhouse saison while you're waiting.

Aside from its fascination with saisons, the brewery also pushes boundaries with its sour ales, including Old Growth, a Flemish-inspired wild brown ale that makes even Belgian beer fans pucker. Yester also has experimented with a series of Sans Hop Lagers that create unique tastes out of barley and spices without hops.

He counts as a blessing the fact that brewers from across the state and country call him to talk about experimental beers. But he does not ignore the fact that the residents of Colorado Springs stuck with him as he tested his beers and have continued to support his brewery.

Boddington believes the boldness of Yester's creations speaks to the town's willingness to trust a known brewer as he delves deeper into the craft. "Colorado Springs may be conservative in terms of its reputation,

Customers who arrive at Trinity Brewing by human power—bike or feet—receive a 10 percent discount on their bills. *Photo by Mike Laur/*Beer Drinker's Guide to Colorado.

but it's made up of half a million people, and they're not all conservative," he says. "And they're looking for different experiments."

Yester reaches out to that more liberal crowd by offering 10 percent discounts for anyone who arrives by human power—bike or foot. The metal and wood in his lighted bar come from two old barns, and the bar top is composed of shards of glass from containers of beer he and his compatriots drank while constructing Trinity.

Trinity's laidback vibe extends to its couches in the back—testaments to Yester's philosophy that his business is also about helping customers relax. It won't serve shots of hard alcohol, and it welcomes a number of mothers with small children who come by in the afternoon.

But he's not trying to make a statement so much as to introduce people to a unique style of beer. And that's why his motto—"Who wants to make a boring beer?"—may be as essential to the success of Trinity Brewing as any of its countercultural cachet.

"We thought it was good to give people an opportunity to go to a place with its own personality," Yester says. "What I like to do is brew a beer that is provocative for a brewer or a connoisseur to drink but also craft it in a way that a pub drinker can drink it."

DOSTAL ALLEY BREWPUB

116 Main Street
Central City (Map 1)

www.dostalalley.net
303-582-1610

Signature beers: Pub Ale (English-style bitter), Shaft House Stout,
Jacob Mack (mild ale)
10:00 a.m. to 2:00 a.m. daily

Buddy Schmalz and his Dostal Alley Brewpub hold two distinctions in Colorado. First, Schmalz was the first brewer/mayor in the state, elected in Central City in late 2002. Second—and more key to the success of his business—Dostal Alley is the only Colorado brewery located in a casino. It may not seem countercultural to combine drinking and gambling, but very few gaming halls in the United States make their own beer.

Above the din of some seventy slot machines that ring 24/7 in Dostal Alley's basement and a few more near the brewery on the ground floor, Schmalz toils at a craft he fell into by accident in 1998.

Schmalz and his sisters dreamed up the idea of the brewery as they were taking over the casino from their parents. The first brewer left after a couple of months, and Schmalz was planning to hire someone else. But after a couple days of serving as the caretaker brewer, he realized there was nothing he would rather do.

For more than a dozen years, Dostal Alley has churned out English-style ales, including Shaft House Stout, a silver-medal winner at the 2008 Great American Beer Festival. It also makes Jacob Mack, an American-style mild ale whose hops come from Central City—grown on fences and in the yards of many of the town's 515 residents, including Schmalz's and his sisters'. Locals trade him bags of hops for beer.

Though the casino is largely packed with tourists, Dostal Alley's local traffic is so brisk that Schmalz gathered all the signatures he needed to make the mayoral ballot without leaving his perch behind the bar. He's still there much of the time. Or he's downstairs in the casino restaurant making pizza and wings and talking with players.

Central City is the second-smallest town in Colorado with a brewery, but Schmalz has done pretty well. "People say, 'How can you still be in business?' And I can probably come up with a dozen different reasons," he says. "But certainly luck is part of it too. We're in the right spot."

FALCON BREWING

19751 East Main Street, Suite R1 www.falconbrewingco.com
Parker (Map 1) 303-805-1133
Signature beers: Hog Daddy Amber, Broadwater Blonde,
Strawberry Basil Blonde
11:00 a.m. to 10:00 p.m. Monday–Thursday; 11:00 a.m. to 11:00 p.m.
Friday–Saturday; 11:00 a.m. to 9:00 p.m. Sunday

Falcon Brewing faced some tough obstacles from the start, including its location in a bedroom community known for chain restaurants and early nights.

It opened in September 2008, the month the bottom dropped out of the stock market. And as soon as it debuted, construction began on the street in front of it and lasted six months.

Falcon Brewing Company has set its sights on bringing craft beer culture to the Denver suburb of Parker. *Courtesy of Falcon Brewing.*

Then, as the brewery was finally getting its feet under it, owner and U.S. Air Force member Jason Deese was reassigned to Arkansas. Deese and his wife, Gina, maintain their ownership from afar, but he had to bring in a new brewer. And Falcon Brewing had to remake itself again.

Yet through all this, the Parker brewery survived, turning out just two or three beers at a time to serve to the crowd that wanders in off Main Street. Here, you might find customers drinking mass-market light lagers or taking part in a homebrewing class taught by brewer Aubrey Hall.

Above all, the restaurant with the giant mural of a Bavarian-outfitted falcon opening the door to a cellar continues to evolve and to introduce craft beer to a community that is not naturally drawn to it. "We were the black sheep of Parker," recalls Hall of the initial reaction. "Once you talk to people and you soften them up and get through their hard cowboy edge, people are pretty open about it."

Hall often graduates new drinkers from easy beers to more challenging ones. His most popular offerings are the Hog Daddy Amber, Broadwater Blonde and Strawberry Basil Blonde, a summertime experiment that produced rave reviews. But he also will offer Imperial Stout, Coffee

Smoked Porter and Imperial Red on nitrogen. And Fridays usually feature a firkin barrel of experimental nature.

If it's not beer drinking that brings people in, it's beer talk. Hall is happy to critique homebrews, and he'll teach both big-group and individual classes.

Month by month, the brewpub began to win over more drinkers. Customers now include people from a number of the surrounding Denver suburbs.

GOLDEN CITY BREWERY

920 Twelfth Street · www.gcbrewery.com
Golden (Map 2) · 303-279-8092
Signature beers: Clear Creek Gold (pale ale), Legendary Red Ale, Oatmeal Stout
11:30 a.m. to 6:30 p.m. daily

Sitting literally in the shadow of the Coors brewery—as most of Golden does—Golden City Brewery never had aspirations of going head-to-head with the giant four blocks east of it.

So what do you do if you're the other brewery in a town synonymous with a different beer?

You milk it for all it's worth.

On every bomber or piece of literature that bears Golden City's name is the phrase "Handcrafted at the second largest brewery in Golden." When people stop by, head brewer Jeff Griffith encourages them to take the thirty-five-minute Coors tour, sup up the free beers and come back to Golden City for the "two-minute" tour. "We're not in competition with Coors," Griffith says. "I think Coors spills more beer in a day than we make in a year."

Once that point is clear, you realize Golden City is not just the little brewery that runs counter to its corporate townsman but the essence of the neighborhood brewery.

Owners Charlie and Janine Sturdavant turned the old machine shop behind their frontier-era home into a brewery in 1993 and began selling growlers out of their sunroom. The carriage house became a tasting room. Their backyard became a beer garden.

On sunny weekends, the beer garden at Golden City Brewery is packed with hikers, locals and the occasional bluegrass band. *Courtesy of Golden City Brewery.*

That backyard now holds 150 to 200 people on summer weekends, and families are known to pack a lunch and come for the day. Bluegrass bands show up to play unannounced.

The inside tasting room fits just six tables, filled usually by regulars ranging from students at the nearby Colorado School of Mines to workers at the National Renewable Energy Laboratory. Serious cribbage players show up the last Saturday of each month for tournaments.

For all it can pack them in, however, Golden City closes each day at 6:30 p.m. out of respect for the historic residential neighborhood around it.

Its beer offerings also run counter to that other brewery down the street. The pale, red, brown, oatmeal stout and IPA almost always are available, and a rotating sixth tap has featured everything from a jalapeno-infused stout to a traditional German Gose sour beer.

Outside of the carriage house, Golden City beer can be relatively hard to find, as it's sold at only a few Denver-area bars and stores.

No, this isn't Coors. But the second-biggest brewery in town has a first-class group of loyal regulars.

Palisade Brewing

200 Peach Avenue www.palisadebrewingcompany.com
Palisade (Map 1) 970-464-1462
Signature beers: Dirty Hippie (dark wheat), High Desert Red,
S'O.B. Pale Ale
Noon to 10:00 p.m. daily

The official tourism website for Palisade uses the word "wine" seven times on its front page. Only under the heading "wineries and spirits" does it mention the town's lone brewery.

Yes, it's tough to be the beer guys in a Colorado town that's home to sixteen vineyards. But after several starts and stops over its first decade, Palisade Brewing has found its niche. With its barrel fermentation program and a forty-gallon experimental pilot system, it is making beers for people whose palates aren't satisfied by old standards. Co-owner Pat Moe and brewer Danny Wilson can be seen around the small town offering beer-pairing dinners and convincing pinot noir devotees that their pale ale will also excite taste buds.

"We are the only brewery in Colorado's wine country," Moe says with both resignation and enthusiasm. "It's just a matter of getting in front of people and letting them know what it could be."

Palisade Brewery was opened in 2003 by Colorado brewing legend Tom Hennessy, who eventually sold the business. The next owners had bottling distribution problems, and the brewery's reputation suffered. Moe, a salesman for several breweries and distributors, saw potential. He came in, cleaned the menu even of popular beers like Farmer's Friend Irish ale and Red Truck IPA to give it a new start and reopened it in 2010.

The brewery, located near the railroad tracks and across the street from a bourbon/vodka/gin/brandy/grappa distillery, is as chill as the laidback wine valley that surrounds it. Visitors gather on a spacious concrete patio in the summertime, and jam bands play on weekends.

The beer, however, can be aggressive. Bestselling Dirty Hippie is a wheat beer brewed with chocolate and caramel malts. High Desert Red is highly hopped for its style.

Wilson spent his first year steering visitors to the six beers typically on tap, including an IPA, a blonde and a brown ale. All the while, he

experimented with recipes for everything from an apricot saison to a Belgian imperial stout.

"We don't care if people like the beer or not. We're making the beer that we love," Moe says.

And he's found that even a few wine lovers can find a side dalliance with his products.

PUG RYAN'S STEAKHOUSE BREWERY

104 Village Place www.pugryans.com
Dillon (Map 1) 970-468-2145
Signature beers: Morning Wood Wheat, Pallavicini Pilsner,
Over the Rail Pale Ale
4:00 p.m. to 2:00 a.m. Monday–Thursday; 3:00 p.m. to 2:00 a.m.
Friday; 11:30 a.m. to 2:00 a.m. Saturday–Sunday

Pug Ryan's Steakhouse has been known as one of Dillon's finest restaurants since its 1975 opening. So when owners Travis and Annie Holton decided to open a brewery there in 1997, frequent diners were skeptical. "That was a big change. And especially in that '96–'97 era, there was a lot being thrown in people's faces," recalls head brewer Dave Simmons of the time when brewpubs were opening—and closing—faster than you could chug a beer.

But nearly fifteen years later, Simmons has earned the right to say, "Obviously, we were doing something right." In that time, Pug's has established itself as one of Colorado's most innovative mountain breweries, winning medals at the Great American Beer Festival or North American Beer Awards from 2005 to 2010.

It began canning its Morning Wood Wheat back in 2003, and it built a tiki bar on Lake Dillon to entertain boaters, who are the lifeblood of the town's economy each summer.

The restaurant features bacon-wrapped filet mignon and salmon oscar. But in the sprit of brewpubs, it is also known for its buffalo burgers and slider plates.

The brewing style is, as Simmons describes it, "fly by the seat of my pants." The wheat, pilsner, Scottish ale and pale ale will always be on tap,

but at various times you can also stumble onto a sweet helles bock, coffee-heavy breakfast porter or saison.

The beers' names tell stories of the brewery and of the area. Pallavicini is one of the ski runs at nearby Arapahoe Basin. Over the Rail Pale Ale got its moniker from a near disaster involving a brew kettle and a less-than-smooth installation process. The steakhouse is named after an outlaw whose gang held up the nearby Breckenridge Hotel in 1888.

The trick to maintaining a brewery in a fancy restaurant is to keep things consistent, meaning you're not likely to find a large number of beers on tap but are likely to recognize the brew from your last vacation. "I often hear people come in and say: 'Damn, this is my last day of vacation, I wish I'd found it earlier,'" Simmons says.

Regardless, Pug Ryan's is open 364 days a year (closing once a year for a private party). It has two-for-one beer specials in slow seasons. And it has seven-dollar burger Tuesdays.

It's a fancy steak joint. It's a neighborhood hangout. It's a brewery. Just take your pick.

RIFLE BREWING

412 Park Avenue www.riflebrew.com
Rifle (Map 1) 970-625-8008
Signature beers: Rifle Creek IPA, Anvil Point Amber Ale,
Black Sunday Porter
5:00 p.m. to 9:00 p.m. Monday–Thursday; 5:00 p.m. to 9:30 p.m.
Friday–Saturday

Rifle is filled with ranchers and oil-and-gas workers, and its main source of tourism comes from hunters flooding it during elk season. So, seeing a white-tablecloth restaurant like Sammy's on Park Avenue can be a surprise.

But Todd Malloy takes the curiosity one step further, running the brewery within the tony restaurant. And yet, Rifle Brewing has found its place in this town.

Sammy's debuted in 1997 as a place where Rifle residents went to find prime rib, lamb chops and lobster tail. After an ownership change, it reopened in February 2010 as Colorado's fanciest brewpub.

Rifle Brewing has brought a shot of the craft beer scene to a town full of roughnecks and one-time light beer drinkers. *Courtesy of Rifle Brewing.*

Malloy describes his beers as an "English-American hybrid," a mix of classic styles like his Anvil Point Amber Ale and those with obvious U.S. characteristics, such the Rifle Creek IPA with an aggressiveness accented by late-addition hops.

When Rifle Brewing opened, Malloy also offered a blonde ale to wean American light lager drinkers off their well-known brands. But he found there were two kinds of beer drinkers in the town of seven thousand people: those who stuck to their bottles and those who jumped straight to the IPA.

"It's an ever-changing place: a lot of roughnecks, a lot of pickup trucks, a lot of blue collar," Malloy says. "But they like their beer…And I think it takes just a little bit of coaxing to try to get them to drink something better."

Malloy began brewing all-grain creations while still in high school. He spent time assisting at Glenwood Canyon Brewing and at Firestone Walker Brewing in California before returning to Colorado to open his own place.

In time, Malloy plans to experiment more with his beers. He believes this town will take to it.

"It's always been a goal of mine to take a brewery to a community you think would never have a brewery and to try to make it succeed," Malloy says. "Once you've done that, that's when you're really making some headway on the craft brewing scene."

ROCKYARD AMERICAN GRILL & BREWING

880 Castleton Road www.rockyard.com
Castle Rock (Map 1) 303-814-9273
Signature beers: Redhawk Ale (amber ale), Double Eagle Ale (wheat), Oktoberfest
11:00 a.m. to 9:00 p.m. Sunday–Thursday; 11:00 a.m. to 10:00 p.m. Friday–Saturday

Animal visages grace Rockyard's beer labels, including this muscle-bound bunny meant to show how brawny the hops are in the Hopyard IPA. *Courtesy of Rockyard American Grill & Brewery.*

The Outlets at Castle Rock has a Nike Factory Store, an Eddie Bauer shop, a Gap—every chain you could imagine. Across the road is a family-owned brewery that sticks out like a fresh-hopped IPA.

Five siblings opened Rockyard American Grill & Brewing in 1999 next to an office building they own. Their hangout now attracts shoppers' spouses, nearby hotel guests and anyone wanting to find an oasis of originality in a sea of brand names.

"Something we pride ourselves on is being an independent operation," says Jim Stinson, Rockyard's brewmaster since 2002. "It's a Colorado family: four good ol' boys and a good ol' sister."

Stinson specializes in amber ales and German-style beers. His Oktoberfest is the bestselling product each year.

Since most of the crowd is drive-up, the offerings at Rockyard are lower strength; even the Bourbon Barrel Stout weighs in at only 6.2 percent. That doesn't mean you won't see an occasional barleywine or doppelbock. It's just that Stinson prefers his customers hang out for a while without needing a cab home.

The five year-round beers share animal themes on their labels. From the proud bird on the Double Eagle Ale to the rattlesnake on Lightning Strike Stout to the muscle-bound, angry bunny on the Hopyard IPA, the characters are a tribute to indigenous wildlife.

Pigtail Cream Ale was made for creatures of a different sort: the local roller derby team, which gets a portion of the proceeds from its sales.

The second Thursday of each month, Rockyard hosts an active homebrew club whose members created the recipe for the brewery's barleywine.

Castle Rock's only brewery has a great relationship with the nearby outlet shops, working trade-out promotions of its beer and warmly greeting the weary husband who can't look at any more shoes.

There are always seven or eight house specialties on tap, and you can also find bottled Rockyard products in a few surrounding liquor stores.

Just don't get it mixed up with the Rock Bottom chain—something Stinson has heard all too often. And don't expect a loud late-night crowd. This is a family joint, through and through.

SANDLOT BREWERY AT COORS FIELD

2161 Blake Street no website
Denver (Map 2) 303-298-1587
Signature beers: Barmen Pilsner, Most Beer Judges Are Boneheads
(European-style lager)
Open only during Colorado Rockies games

Strolling around Coors Field, the astute beer drinker will note two things. The first is that there are a lot of Budweiser taps in a stadium named after that brewery's primary competitor. The second is that tucked behind the right-field foul pole is the only brewery in a baseball stadium in America.

This is the SandLot, an experiment owned by MillerCoors Brewing. Brewmaster Tom Hall says the brewpub flies a bit under the radar of the company, comparing its status to that of a U.S. protectorate. "We're kind of like Puerto Rico," Hall muses.

On the wall of Hall's basement "office" is a list of more than thirty Great American Beer Festival medals and awards the SandLot has won, including 2005 Small Brewery of the Year. Most of those honors have come for German-style beers. From European pilsners to marzens to helles lagers, the SandLot creates brews you'd expect to find in a soccer stadium in Munich.

Actually finding them in Denver can be somewhat of a trick, as the stadium bar has only two to three of the brewery's many beers available at a time. SandLot accounts are scattered at a few other watering holes around town. The easiest way to know you're drinking a SandLot product is to look for the beers with the oddest or most offensive names.

These include Clueless Beer Writer and Most Beer Judges Are Boneheads, the latter of which caused the crowd at the GABF to erupt in laughter when the European-style pilsner nabbed a silver medal in 2005. "It was probably my second or third step to being the most hated brewer in America," Hall recalls.

Hall also has built a following with Move Back Oktoberfest, dedicated to the local Chicago Cubs fans who take over Coors Field when their team is in town and boast that Chicago is better than Denver.

The beers are created in a basement brewery in a turn-of-the-century brick warehouse, the only area building not demolished when the stadium

was built. Hall swears it's haunted, particularly an elevator that travels to random floors where no one awaits it.

Hall's creations are available to some thirty thousand Colorado Rockies fans on warm summer afternoons. But there's a slight downside for the beer drinkers off the street.

"There's a cover charge to get in," he notes.

SAN LUIS VALLEY BREWING

631 Main Street www.slvbrewco.com
Alamosa (Map 1) 719-587-BEER (2337)
Signature beers: Hefe Suave (hefeweizen), Alamosa Amber
Summer: 11:00 a.m. to 10:30 p.m. daily; Winter: 11:00 a.m. to 9:30
p.m. daily

Scott Graber received a graduate degree in theology from the University of Notre Dame in 2001 and moved to Alamosa for what he thought would be a short time to clear his head. But he and his wife, Angie, loved the remote town in the San Luis Valley and decided to stay—he working as a youth pastor and she for a campaign to keep kids off drugs and tobacco. They also homebrewed until it became, as Scott put it, a "hobby out of control."

In 2006, the Grabers went in with Angie's parents and opened San Luis Valley Brewing, the first brewery to operate in the rural, low-income valley in at least half a century. While their ministerial and community-service backgrounds may have seemed like an odd fit with brewing, they made sure to incorporate those influences. On certain Thursday nights, customers are welcome to attend Theology Pub, a discussion of religious issues over a pint of beer and a plate of barbecue. "Some people might say that God and the restaurant business don't mix, but we're trying to integrate faith into what we do," Scott says. "We've been blessed."

The brewpub gained a reputation as a top downtown restaurant. It's not pretentious, though: the menu comes on a newspaper dubbed the *Barley Chronicle*, which explains the history of the building and the brewing process.

In an area better known for farming than brewing, the San Luis Valley Brewing Company has created a community atmosphere in its downtown Alamosa brewpub. *Courtesy of San Luis Valley Brewing.*

Angie, who has a background in pharmacology and microbiology, was the brewer for the first two years. The duties now rotate between the couple as they take time to care for their small children.

Five year-round beers and a few seasonals are on tap. The offerings tip their cap to the heritage of the local Hispanic population, both in styles (Mexican lager) and names (the "Hefe Suave" unfiltered hefeweizen). But they also reflect original homebrewing recipes, especially Grande River IPA and Alamosa Amber.

One thing you'll notice is that one of the owners is almost always in the 1879 former bank building and happy to talk beers. Another is the item hanging over the bar—a five-thousand-pound vault door originally installed in 1912 and hoisted into its current position to honor the history of the structure and the town.

Tommyknocker Brewery

1401 Miner Street www.tommyknocker.com

Idaho Springs (Map 1) 303-567-2688

Signature beers: Maple Nut Brown Ale, Butt Head Bock,
Vienna Amber Lager

11:00 a.m. to 2:00 a.m. Monday–Saturday; 11:00 a.m. to midnight
Sunday

Idaho Springs is a mountain town of one square mile. When it's not prime hiking or skiing season, the place is pretty subdued. Except for its brewery—which distributes to more than half the states in the country.

Tommyknocker Brewery is a study in contrasts, a small-town business with big ambitions that exploded during an era of hop-centric beers while refusing to make a product that could be called bitter or citrus-heavy.

"We're only twenty miles away from Denver, but it seems like we're twenty years behind," brewmaster Steve Indrehus says—a statement that describes both the town, a former gold mining center, and the way Tommyknocker makes beer.

Maple Nut Brown Ale is the beer "that built the brewery," as Indrehus says, and most of the subsequent hits also fall into the malt-heavy category. Butt Head Bock, Vienna Amber Lager and Imperial Nut Brown Ale tend to stray from the hopped.

Tommyknocker's signature oak flavors are not derived from barrel aging. Instead, oak chips are actually used in the brewing process—the mash tun, the kettle boil, the fermenting vessels—to imbue the beers with that taste.

A Tommyknocker is an elf-like creature that Cornish miners who settled the region believed lived in the crevices of mines. The mischievous ones blew out lamps and knocked over lunch pails; the kind ones tapped on walls to point out the richest veins. Those little guys decorate the bottles and walls of the brewery and harken to the building's 1859 origins as the Placer Inn. The building and the town of 1,800—once the last stagecoach stop before explorers had to hire Indian guides to travel farther west—went through a lot of changes.

Tommyknocker Brewery opened in 1994 as a late-night watering hole before expanding its product slowly to surrounding states. (Closing time

Tommyknocker taps emerge from a mine-door mural at the Idaho Springs brewpub. The brewery is named for the legendary imps who taunted or helped miners. *Courtesy of Tommyknocker Brewery.*

is still listed as 2:00 a.m. except Sunday, but you'd be hard-pressed to find many souls imbibing past 10:00 p.m.)

The brewery is still defined by its mountain culture and by its place in Idaho Springs. But more and more, Idaho Springs is becoming known largely as the home of Tommyknocker Brewery.

YAK AND YETI

7803 Ralston Road www.theyakandyeti.com/arvada
Arvada (Map 2) 303-431-9000
Signature beers: Himalayan IPA, Chai Milk Stout, Namaste Pilsner
11:00 a.m. to 9:00 p.m. daily

Nepalese food and hoppy American beers may seem as unlikely a pair as buffalo wings and chai tea, but the Yak and Yeti restaurant has married

them well. The combination came about when restaurateur Dol Bhattarai purchased the Cheshire Cat, a British brewpub, after it closed in 2008. The spot was a meeting and drinking ground for Arvada residents, so there was never talk about tearing out the brewery.

But where former owners had stuck to British-style beers, new brewer Chris Kennedy decided to brew beer that he wanted to drink and that would go well with the Indian, Nepalese and Tibetan food on the menu.

Some Yak and Yeti offerings are wholly American. The Himalayan IPA is big and hoppy, and the Namaste Pilsner is light with a grassy backbone. Some are blended with culture in mind, such as the popular Chai Milk Stout. And some are just blended—one of the traditions passed down from the Cheshire Cat to the Yak and Yeti. Regulars put two types of beer together, often to reduce the alcohol level so they can drink more. Popular combinations include pilsner/IPA, IPA/American wheat and the Doctor's Blend: 90 percent ESB, 10 percent milk stout. "I thought it was kind of weird and funny at first," Kennedy admits. "But I'm all about 'You drink what you like.'"

Yak and Yeti was once a house, built in 1863, which a number of wealthy and well-known residents called home. One still does, says catering manager Troi Cardynal. Cora Vanvoorhis was elderly when she fell down the stairs in the 1940s and died. In recent years, workers have reported her knocking on closet doors and dumping water on them, and a paranormal team told a local television station that a ghost appeared to be in the house.

Maybe she's just confused about the cultural crossovers the pub has created. For instance, the Yak and Yeti hosts Irish music on many Tuesday nights.

Regardless, Kennedy says the beer he brews is an ever-changing blend offering something that appeals to those who like hops, malt or spices. And it all should feel natural when dining on curry or Tibetan noodles.

"The beer in general goes well with Indian food," he says, noting the fiery spices are offset by the hops in the IPA.

CHAPTER 8
AMATEUR DREAMS

FROM HOMEBREWER TO PROFESSIONAL BREWER, OVERNIGHT

DRY DOCK BREWING

15120 East Hampden Avenue www.drydockbrewing.com
Aurora (Map 2) 303-400-5606
Signature beers: HMS Victory E.S.B., Paragon Apricot Blonde,
Urca Vanilla Porter
Noon to 9:00 p.m. Sunday–Thursday; noon to 11:00 p.m.
Friday–Saturday

Kevin DeLange was sitting outside the World Beer Cup awards ceremony in Seattle in 2006, just six months removed from cutting the ribbon on his own brewery. He couldn't afford the eighty-dollar ticket to attend the dinner ceremony, so he and a friend hung out near the ballroom, drinking beer left over from a reception, hoping that one of two beers he'd entered into the competition might win a medal.

Officials announced the first category he'd entered with no mention of Dry Dock Brewing. The second category, special bitter or best bitter, came up, and the emcee announced the bronze and silver medallists. Again, no mention of a Colorado winner. DeLange got up and told his friend that it was time to end this charade and to grab dinner.

Then he heard the emcee say, "Gold medal: HMS Victory E.S.B...." His first reaction, as he recalls it, was, "Wait, who took the name of

Dry Dock Brewing founder Kevin DeLange (right) stands with head brewer Bill Eye in the company's nautical-inspired tasting room, opened in 2009. *Courtesy of McBoat Photography.*

my beer?" Slowly, though, it sunk in. Out of a cramped, eight-hundred-square-foot industrial space in Aurora that its small cadre of regulars referred to as a "hallway brewery," DeLange had produced the top special bitter on the planet.

It took another six months, as word got out about this underdog story, for Dry Dock to capitalize fully on the honor and find itself the host of a tasting room so full that people couldn't make it in the door. DeLange had come a long way since 2002, when he opened a homebrew shop in Aurora and for the next three years saved all his earnings to launch a tiny brewery in the space next door.

By mid-2009, Dry Dock's draft-only business needed a bigger home. And later that year, the four-year-old brewery was named Small Brewing Company of the Year at the Great American Beer Festival.

The story of DeLange and Dry Dock is inspirational. But even he admits that what makes it special is that it's not unique. While few start-up breweries have risen as quickly as his, tales are not uncommon of Coloradans who tinker on makeshift brewing systems in their basements

one year, only to find themselves hoisting a medal or staring out into an overflow crowd in their tasting room the next.

But if there is a poster child for this movement from amateur brewer to successful professional, it is Dry Dock, the first brewery in the third-largest city in Colorado—and the kind of business many other beer makers aspire theirs to be.

"Since I've opened, I've probably sat down and scheduled an appointment and chatted with people about how to open a brewery and things I've learned and given advice to at least thirty people," DeLange said in September 2009, two weeks before winning his GABF small brewing company award. "I try to be generous with my time to those people, because people were great to me when I opened."

Colorado homebrewers are estimated to be in the thousands, men and women who start out with a kit that includes malt extract and work their way up to producing barleywines and ginger saisons and other intricate styles in their homes. Dozens of clubs support their efforts, and from those clubs come a few brave souls who invest in their own breweries or leave their professions to work with other beer makers.

Colorado laws encourage that entrepreneurship. Brewers can make, distribute and sell their own beer. They're free to sell directly to local liquor stores and deliver their beer from the backs of their pickups, saving themselves the expense of a professional distributor.

And, unlike in many professions, brewers who watch competitors develop are usually supportive of their efforts. Jim Koch, founder of the Boston Beer Co., maker of the Sam Adams line, holds an annual competition in which he chooses two homebrewed entries from around the country to be made at his brewery and sold in six-packs with his beer. "I've always believed that the line between a talented homebrewer and a practicing professional brewer is completely arbitrary and imagined," Koch said at the GABF brunch celebrating the 2010 honorees.

DeLange received his first homebrew kit from his mother, a Christmas present after he turned twenty-one. He started brewing in his apartment at Iowa State University before moving west with his wife to get his PhD in medieval history at the University of Colorado. After realizing that he didn't want to leave Colorado—but that he had little chance of landing a job in the state with his specialty degree— DeLange moved to for-profit college administration. Then, in 2002,

when the owner of The Brew Hut homebrew shop wanted to sell the business, DeLange snatched it up.

There he befriended homebrewers and invited regulars to bring their beers to a monthly tasting he hosted. And when the little space next door opened up in 2005, DeLange built his brewery.

It wasn't rocking right away, remembers Greg Baker, a longtime Brew Hut customer and one of the original Dry Dock patrons. Its crowd was basically a select group of homebrewers who would come in to support DeLange. Then, after the *Rocky Mountain News* and *Denver Post* ran stories about the World Beer Cup medal, Dry Dock grew. Strangers nudged their way into the industrial space where the water heaters, mash tun and boil kettles were all exposed, and patrons could chat with DeLange as he brewed.

Dry Dock initially concentrated on English-style beers, and the HMS Victory was one of a collection of products, including the SS Minnow Mild Ale and HMS Bounty Old Ale, that went on to capture medals early on.

But DeLange began getting raves for some of his nontraditional styles, such as his Urca Vanilla Porter and his Paragon Apricot Blonde, as well. And the crowds became so great at the little space with twelve bar seats and five tables that some would-be customers would leave rather than wait to get in.

So, in 2009, DeLange landed a federal stimulus loan and recruited about 110 friends to move the Brew Hut and Dry Dock into a bigger space. It took exactly one hour and three minutes to move all of the equipment, recalls John King, another homebrewer and regular who participated in the relocation. And then it took the crowd an hour and a half to drink the four kegs that DeLange provided as thanks.

Dry Dock has never guarded its secrets like a big brewery. DeLange shares his recipes online and encourages homebrewers to try to replicate the beers. Occasionally, amateurs bring in their creations and ask the Dry Dock brewers for a critique. That has helped to make Dry Dock's crowd one of the most knowledgeable and inquisitive groups of beer drinkers in the state. "A lot of people you find in here are homebrewers. As a matter of fact, they're serious homebrewers," Baker said, pointing out several people in the taproom who won awards in homebrewing competitions.

The brewery offers fifteen taps and has expanded its original English focus to include a healthy selection of German beers, Belgian offerings and experimental beers. It offers a new cask beer each Friday and has rolled out recipes such as a cherry ale and coconut porter that appeal to an increasingly diverse crowd.

In late 2010, Dry Dock, with a staff of four brewers, began bottling a few of its beers—including its Hefeweizen and Dry Dock Double IPA—in twenty-two-ounce bombers, taking the brewery to its next phase. "This is starting us down a path that I'm not sure I want to be on, frankly," DeLange said then.

But rather than sign the brewery over to a major distributor, he decided to self-distribute, a tack usually taken by smaller breweries that have received fewer accolades. DeLange said in early 2011 that he wanted to do this to control the brewing process and to make sure Dry Dock stayed true to its roots.

DeLange's influence continues to be felt in new breweries around the state. Tom Bell went from being a Dry Dock regular to owner of Elk Mountain Brewing in nearby Parker in 2010. DeLange was a "huge influence" on his plans and helped when Bell found himself short on hops and other materials in the opening months, Bell says.

And the guy who couldn't even bring himself to go to the World Beer Cup awards ceremony in 2006? He's now making presentations at brewers' gatherings, gobbling up medals like they're dots on a Pac-Man board and providing hope to homebrewers aiming to perhaps be the next Kevin DeLange.

"Everybody helped me so much getting started that I'm happy to help other people as well," he says.

COPPER KETTLE BREWING

1338 South Valentia Street, Unit 100 www.copperkettledenver.com
Denver (Map 2) 720-443-CKBC (2522)
Signature beers: Bavarian Helles, Mexican Chocolate Stout,
Saison Savoureux
3:00 p.m. to 9:00 p.m. Wednesday–Friday; noon to 9:00 p.m.
Saturday–Sunday

Copper Kettle Brewing, opened by the husband-and-wife team of Jeremy Gobien and Kristen Kozik, does brew in copper-lined kettles. *Courtesy of Copper Kettle Brewing.*

Jeremy Gobien was completing his doctorate in materials science, on his way to a high-paying career, and all he could think about was beer. The North Carolina State University student had learned to homebrew in 2007, and by 2010, he was making forty gallons a month and keeping a six-tap kegerator in his town home. He and his wife, Kristen Kozik, would throw parties and have guests vote on the beers, so they knew what they were doing right.

After graduation, when Dr. Gobien's cohorts joined international corporations, he moved to Colorado, where he'd skied as a child, to find a neighborhood that needed a brewery. And in April 2011, he opened Copper Kettle Brewing in southeast Denver, in a tucked-away strip mall near a couple of residential areas.

Copper Kettle aims to be the "Cheers" of its neighborhood, a place where Gobien and Kozik work as the only full-time employees

and personally serve everyone who comes in. They offer comfortable couches, a copper-top bar and a dues-free mug club to their most frequent customers.

"If I could have my way, I would get to talk to every person who ever drank my beer—not just to meet you, but to talk to every person and get to know you," Gobien says. "We just want to have fun with it and really enjoy coming into work and get to meet people—and have regulars."

Gobien gained loyal followers by launching a homebrew contest before he opened—and putting the winning Saison Savoureux recipe on tap when he debuted.

Copper Kettle's beers are largely German-inspired—Gobien proposed to Kozik at Munich's royal palace during Oktoberfest—but also feature some of the daring he displayed as a homebrewer. His Mexican Chocolate Stout, for example, is brewed with chocolate, red chili peppers and ground cinnamon.

His taps include everything from an altbier to a German rye beer to a double IPA. Copper Kettle is a small place that aims to be the neighborhood hangout—without food but with the reputation of being "a little wild in trying new things," Gobien says.

CRABTREE BREWING

625 Third Street #D www.crabtreebrewing.com
Greeley (Map 1) 970-356-0516
Signature beers: Serenity Amber Ale, Boxcar Brown, Oatmeal Stout
1:00 p.m. to 8:00 p.m. Monday–Saturday

Jeff Crabtree has never gone into anything half-assed. When he took up golf, he invested in custom-made clubs and shoes. When a restaurant served him a bad calzone, he responded by going home and perfecting a recipe for an Italian turnover the size of a baking tray.

So when he told his wife, Stephanie, in 2003 that he wanted to brew, she made him study the subject before going overboard. Jeff invested in a $475 homebrewing kit and made two batches. Then he began brewing in half barrels. And when the Union Colony Brewery closed in Greeley the next year, Jeff took out a second mortgage and bought its equipment.

"One day he came to me and said, 'Honey, I want to open a brewery,'" Stephanie recalls. "I said, 'Uh, OK.'"

That equipment sat in their garage for two years as Crabtree finished his bachelor's degree at the University of Northern Colorado. In every class from accounting to business law, he turned in papers and case studies that analyzed how a local craft brewery could succeed.

Upon graduation in 2006, Crabtree took a job in corporate finance and opened the brewery on the side in a fifty-year-old former concrete factory. In Greeley, a city of industrial and farm workers, it did not catch on right away. But after several years of studying the market and getting frustrated with brewing, Crabtree had a revelation. He was just going to make beer the way he wanted.

That means brewery visitors may see Crabtree's bestsellers, such as Boxcar Brown or Serenity Amber Ale, on tap. Or they may see his latest experiments, ranging from his Braggot to his Dearfield Ale, a strawberry blonde ale whose proceeds are donated to help preserve one of the state's first African American agricultural communities. One of those experiments, the high-alcohol Oatmeal Stout, is now one of his more regular recipes in rotation.

By 2009, Crabtree had expanded distribution to Nebraska and Kansas, selling six-packs and twenty-two-ounce bottles. And the brewery developed followers.

It remains a low-overhead operation, with Jeff and Stephanie's two preteen sons helping them to bottle or stir the mash. But unlike his now forgotten golf habit, Jeff feels this is one investment he's made right.

"We kind of go in our own direction," Jeff says. "We're that classic no-directions-needed, we'll-find-our-own-way-there brewery—no Tom Tom, no navigation, let's just do it."

CRYSTAL SPRINGS BREWING

876 Sunshine Canyon Drive www.crystalspringsbrewing.com
Boulder (Map 4) 303-884-5602
Signature beers: Doc's American Porter, Crystal Springs
Summertime Ale (kolsch)
Brewery in a home garage; beer sold in select locations in Denver
and Boulder

Up a gravel driveway in the Sunshine Canyon west of Boulder sits an unassuming garage where Tom Horst operates one of the smallest breweries in America. In a back corner of that structure, next to a tool cabinet, is the two-thirds-barrel brewery, the fount of Crystal Springs Brewing's elixirs.

Though Horst's operation is small, his beers are true originals. One of the top restaurants in Boulder, The Kitchen, keeps his beer on tap, and every once in a while, Horst fields calls from tourists insisting on visiting his "tasting room"—a small table where he'll pour a sample if you make the trip up the canyon.

"I don't think there's anybody who's doing quite what I'm doing. And I'm not sure quite what I'm doing," says Horst, who is also a band director and music teacher at Boulder High School. "I think I'm unique because I'm very small—and I'm crazy."

Horst began homebrewing with his son in 1988. By 2009, he had written a business plan for a seven-barrel brewery. But when he discovered that Boulder County allows home businesses in some areas, he built a cold-storage room in his garage and went to work there.

His first beer and most widely sold product was the robust Doc's American Porter. Summertime Ale, a kolsch-style beer, followed that. Horst continued to roll out challenging beers, from his Black Saddle (imperial) Stout to Tic Wit, a Belgian wit for which he and his wife hand-zest all the orange peels that are thrown into the brewing.

The name Crystal Springs is a tribute to the first brewery in Boulder County, a beer maker that was selling its products in seven states as the twentieth century began. It did not make it through Prohibition, however.

Horst hopes his iteration has more staying power, and he plans one day to move out of his garage. But for now, he's happy with the exposure he's getting as the little guy who is doing something different.

"I can try anything, and if it doesn't work out, I don't have to release it," he says. "But I would like to make beers that are notable."

Dad & Dudes Breweria

6730 South Cornerstone Way, Suite D www.breweria.com
Aurora (Map 2) 303-400-5699
Signature beers: Liquid Résumé Pale Ale, Buzzed Weasel Coffee Stout
11:00 a.m. to 10:00 p.m. Sunday–Thursday; 11:00 a.m. to 11:00 p.m.
Friday–Saturday

Dad & Dudes is the smallest brewery in Colorado, if not the United States, concocting its products in a half-barrel system identical to the one Dogfish Head uses to make pilot batches, says Mason Hembree, the "Dude" part of the business. The "Dad" part is Mason's father, Tom Hembree.

The "breweria" is a cross between the pizzeria that Tom, a restaurant industry veteran, wanted to open and the brewery that his son wanted to start. The name "Dad & Dudes" comes from the days Tom spent with his sons at baseball or football games.

The Aurora storefront's décor and menu celebrates the end of Prohibition, from 1933 protest photos on the wall to a bar designed like a barn where bootleggers made moonshine to pizzas bearing names like Tommy Gun and Bootlegger.

To find brewers, Mason put an ad on Craigslist specifying that he was looking for homebrewers wanting to go professional. He got more than 350 responses and brought on two award-winning backyard brewers.

"What we have is a brewery that's made for homebrewers," Tom says. "It's not microbrew. It's nanobrew." Every once in a while, in fact, homebrewers are invited to come in and make a beer for the restaurant with the brewmaster.

The beer itself is creativity in motion. As brewer Justin Baccary explains, the brewers can think of recipes in the morning and make them by the afternoon. That encourages experimentation. Brewer Bard Nielsen decided shortly after the business opened in November 2010 to toss basil into a honey ale. Tom thought it was a horrible idea, but the beer sold out in three hours.

And therein lies the downside to small-batch freedom: beers, especially popular creations like the Buzzed Weasel Coffee Stout, fly out of the taps faster than brewers can make them. Dad & Dudes can put six beers on

tap, but it has a hard time having four ready, with patrons drinking them temporarily out of existence.

But if a favorite beer isn't on tap, it might be in the pizza. Tom uses spent grains from brewing in his signature dish's crust.

ELK MOUNTAIN BREWING

18921 Plaza Drive, Unit 104 www.elkmountainbrewing.com
Parker (Map 1) 303-805-BREW (2739)
Signature beers: Ghost Town Brown, Mine Shaft Kolsch, Puma IPA
3:00 p.m. to 9:00 p.m. Monday–Thursday; noon to 11:00 p.m.
Friday–Saturday; noon to 9:00 p.m. Sunday

Tom Bell made the transition from heavy equipment mechanic to professional beer maker in July 2010 when he opened Elk Mountain

Elk Mountain Brewing is named for the wilderness area where owner Tom Bell has hunted for much of his life. *Courtesy of Elk Mountain Brewing.*

Brewing. It's not a career path taken by many, but Bell says it makes perfect sense. "You almost have to be a mechanic to be a brewer," he says, shrugging. "There's so many things that, at the last second, you have to figure out…So, they go together."

The career move was a long time coming. Bell had wanted to open his own place in the mid-1990s, but at the time he was a single dad with two small kids who knew he had other priorities. So, he fixed everything from weed whackers to earth movers and waited.

When Bell finally opened Elk Mountain, it was an immediate hit in Parker, a bedroom community that rolls up its streets by 8:00 p.m. He sold out of three different beers in the first three weeks.

Happy hour is peak time at the brewery, with locals stopping on their way home to grab a beer or two and cart off two growlers—one of beer and one of Bell's homemade root beer for the kids. Elk Mountain's food is limited to a corner popcorn machine, but the brewery stocks a good supply of local delivery menus.

Its libations are largely descendants of German styles, a reflection of Bell's introduction to the world of beer while visiting his brother in Germany in the early 1980s. Some are time-tested creations, such as the Rock Slide Amber Ale he started making in 1992 and the Wild Wapiti Wheat, a hefeweizen that garnered him national homebrewing awards in the late 1990s. Others, such as the Puma IPA, were first made when he was getting ready to open the brewery. Bell wasn't an IPA drinker before 2010, but he found the balance of hops and malt he sought. And Puma became his bestseller.

Each of Elk Mountain's beers is named after local wildlife or natural features. An elk-antler chandelier hangs above the bar made of beetle-kill pine from the area around Elk Mountain, where Bell has hunted for more than twenty years.

GUNNISON BREWERY

138 North Main Street
Gunnison (Map 1)

www.gunnisonbrewery.com
970-641-2739

Signature beers: Gunnison Pub Ale (ESB), Summertime 69
(English summer ale)

11:00 a.m. to close Monday–Saturday; 4:00 p.m. to close Sunday

Most brewers can tell you the basic chemistry of beer. Kevin Alexander can write the equations that explain the fermentation process—and then quiz you on it.

Alexander is a biology professor at Western State College whose father-in-law bought a vacant downtown Gunnison shop and asked him what kind of business the town was lacking. The one-time homebrewer thought only briefly before replying: a brewery and a family-friendly restaurant. And Gunnison Brewery, which opened in 2003, is both.

The beer is, as one might expect from an academic, a matter of constant experimentation. Gunnison is one of the few Colorado breweries with open-fermentation tanks.

You can always find Gunnison Pub Ale, an extra special bitter, on tap. About twenty-five other creations can be found on the brewery's menu over the course of a year. Those rotators include Evil Rabbit, a 12.5 percent alcohol-by-volume Belgian-style golden ale that's inspired fans to draw their visions of the harrowing hare on coasters displayed behind the bar. It's on tap once or twice a year.

Summertime 69, an English-style summer ale with coriander and lime zest, nabbed the two-and-a-half-barrel brewery a gold medal at the 2007 Great American Beer Festival.

While a diverse crowd including college professors, pitcher-purchasing students and outdoor-adventure-seeking tourists populates the brewery now, Alexander admits his debut as a professional brewer nearly doomed the business. Unprepared for the excitement that Gunnison's first brewery since Prohibition would generate, he sold out in three days and had to shut down immediately for a weeklong "fermentation vacation."

"The night we opened, I cried. I said, 'We're not ready!'" recalls Lori Alexander, Kevin's wife and brewery co-owner.

The warmth of the pub, which often features college bands, is appealing in a town where the temperature hits twenty degrees below zero several times a winter. In summer, the back patio is popular. Nothing draws people to Gunnison Brewery, however, like Taco Tuesdays, when the place can sell eight hundred to one thousand one-dollar fish tacos in a day.

Alexander gives a guest lecture to a biochemistry class each year, ending with a lesson in how to brew.

"This isn't my real job," he'll still say occasionally, expounding on his specialty area of aquatic insects.

But Gunnison Brewery has had so much success that, by now, it kind of is.

Horsefly Brewing

846 East Main Street www.horseflybrewing.com
Montrose (Map 1) 970-249-6889
Signature beers: Scottish Heavy, Porter, India Pale Ale
11:00 a.m. to 9:00 p.m. Monday–Thursday; 11:00 a.m. to 11:00 p.m.
Friday–Saturday; noon to 8:00 p.m. Sunday

A motel owner and a cop walk into a bar…and then decide to start one themselves.

It may sound like a joke, but that is the short version of how Nigel Askew and Phil Freismuth decided to open Horsefly Brewing in Montrose.

Askew, the outgoing owner of the nearby Blue Sky Inn, and Freismuth, the quiet police officer, had been homebrewing buddies for years when they visited a tiny, one-barrel brewery up the road in Paonia. The owner explained to the pair that they just needed equipment and a few licenses, and they suddenly had a goal.

The 1.0 version of Horsefly was, to put it kindly, rustic. Friends gave them a vacant tractor dealership on the highway heading into town, and they set up three tables and offered board games and peanuts.

But people came. On winter nights, they had to turn some away. And fifty-one weeks later, Horsefly relocated to a three-thousand-square-foot former restaurant near downtown.

The newest location could be an Americana museum. From the lighted Blatz beer sign to the Battleship game on a corner table to the cow skull on the wall, it is, as Askew says, "farmyard meets Western meets beer paraphernalia."

The beer is more serious. English-style ales reflect Askew's upbringing as a Zambian citizen reared in a Scottish boarding school before moving up through the ranks of hotel management in London. That lifestyle grew boring, however, and it wasn't until he discovered brewing in the

early 1990s that he found a new passion. Many Horsefly offerings are old recipes of Askew's or amalgamations of his and Freismuth's recipes.

The menu includes a couple of hoppy American-style creations but also ambers, porters, stouts, reds and lighter beers like a blonde or altbier. Askew, who is descended from Norman knights, is proudest of the Scottish Heavy, for which he uses peat-smoked malt.

The names of regulars are burned into the bar. Melanie Freismuth—who plays a more active role in the business than her husband because of his job in law enforcement—notes that the most common thing visitors say is: "I feel at home."

Horsefly, named after a nearby mesa, is no longer just the side project of two homebrewers but a five-barrel brewpub that's quite abuzz.

OURAYLE HOUSE BREWERY

215 Seventh Avenue www.ouraylehouse.com
Ouray (Map 1) 970-903-1824
Signature beers: Whatever Hutch feels like brewing
4:30 p.m. to whenever Hutch feels like closing daily

Tired of working as a tourist-town cook, James Paul Hutchison sold his Ouray condo in 2007 and dumped everything he had into a brewery.

Right before he was ready to open Ourayle House, he brought in his parents, who were not regular bar-goers. What they saw pleased them, however, and they told their son Ourayle House was the kind of place where they could hang out.

As soon as they left, "Hutch" grabbed a hammer and destroyed the bar. It looks much less refined now.

That's life at Mr. Grumpy Pants Brewing Company—the business's unexplained other name—where you can take your every expectation of a craft brewery and toss it on the wood stove used to heat the place. That stove, by the way, was the donation of a regular patron who got tired of freezing in the brewery in the winter.

Ourayle House, located half a block off the one paved road in Ouray, may open at 4:30 p.m., like its sign says. Or if Hutch had a particularly good day kayaking, it may not.

Mr. Grumpy Pants—"I figure it's fair warning," says the not-at-all-unpleasant owner—may have the right ingredients to make a classic hefeweizen or stout. If he doesn't, eh, he'll just wing it and rename the beer.

Want to know what's on tap? The chalkboard listing his selections has a column labeled "About it," which explains the origins of each beer. That's how you find that 3 Nurses Dush Munke Nut Brown Ale was named after a trio of healthcare professionals who spent one evening drinking and trying to come up with a clever profanity.

Hutch began homebrewing in the 1980s and gave six-packs as Christmas gifts to friends, who leaned on him to open his own brewery.

At one and a half barrels of capacity, Ourayle House (pronounced "your-ale house") is one of the smallest breweries in the state. There is no live music, no food (though you can bring your own and cook it on the grill outside) and no way Hutch can get lost walking home. He lives in a room above the brewery.

No cash? No problem. Hutch doesn't take credit cards, but a friend once traded him the meat of a mountain elk he'd cleaned off the highway for some growlers. "I traded beer for roadkill. I'm officially mountain trash," Hutch says.

Want to get his attention? Ring the bell on the bar. He'll slide down on a swing attached to an old barn door rail running the length of the ceiling above the bar.

You'll never get rich with that set-up, other brewers told him. Hutch believes them. He's just not worried. "If I wanted to make more, I'd probably work more," he says. "But that's just a theory I'm not willing to try out yet."

Rocky Mountain Brewery

625 Paonia Street www.rockymountainbrews.com
Colorado Springs (Map 5) 719-528-1651
Signature beers: Da' Yoopers (cherry ale), Smoked Hefeweizen
10:00 a.m. to 7:00 p.m. Monday–Tuesday; 10:00 a.m. to 9:00 p.m.
Wednesday–Thursday; 10:00 a.m. to 11:00 p.m. Friday–Saturday

The story starts in a familiar way: homebrew storeowner Duane Lujan takes the next step, opens a brewery and develops a following. But there is nothing else about Lujan and his Rocky Mountain Brewery that goes by the book.

Nestled on an industrial back road, Rocky Mountain introduced itself by brewing thirty different beers in its first year. There was a curry wheat, a jellybean tripel and a chai porter—and, in the spirit of diversity, both a green chili lager and a red chili ale.

That was the start. Lujan went on to produce an award-winning cherry ale and a blueberry ale that tastes like pie. He poured what he believes was the nation's first smoked hefeweizen. And for the man who can't choose, he tapped a Rocky Mountain Redhead, a Rocky Mountain Blonde Lager and a Rocky Mountain Brunette. "We're just maybe a little bit more adventurous and a little too stupid to know we can't do that," he says.

For twelve years, beginning in 1996, Lujan owned and operated My Home Brew, a shop where Colorado Springs residents came to buy hops. But when he found that Blicks Brewing was closing, he decided, almost on the spur of the moment, to buy its equipment and space. My Home Brew moved there, and Lujan started experimenting. The shop is in the front of the building and the brewpub is in back.

Most everyone who ventures in knows Lujan, and he treats them less like customers than old pals. Want some food? If Lujan isn't grilling burgers, or the local rib truck isn't serving, you're on the honors system for the jar of locally made jerky. He also may give you a rib to go with his smoked hefe.

Chances are good that the person behind the bar isn't an employee but instead a volunteer covering for Lujan while he waits on a customer in his store. And if you think he's keeping a tab, think again: he expects you to remember what you've drunk and tell him as you pay at the end.

Lujan is sure he'll have something you like. "We just keep inventing new stuff to make you come to the brewery," he says.

CHAPTER 9
BEER HERE, THERE AND EVERYWHERE

MULTIPLE-LOCATION BREWERIES

ROCK BOTTOM RESTAURANT AND BREWERY

Seven locations along Front Range www.rockbottom.com
Headquarters: Louisville (Denver location on Map 2) 303-664-4000
Signature beers: Molly's Titanic Brown Ale (Denver),
Red Rocks Red (Westminster)
Hours vary by location but are most typically 11:00 a.m. to
midnight daily

The founder of the Rock Bottom brewpub didn't start out thinking his business would be cloned in locations across the country one day. Frank Day didn't realize he was going to revolutionize the brewpub industry and introduce a whole new genre to the chain restaurant scene. Nor did he realize that his ventures might serve as people's gateway experiences into the world of craft brewing.

But today, more than twenty years later, thirty-four Rock Bottom brewery restaurants are open across the United States, including seven in Colorado. And they've spawned a handful of other brewpub and brewery bar concepts also run by Day and his company.

"I can't say we were responsible for the brewpub movement. That thing was bubbling away and ready to explode when we got into it," Day says. "But I think one thing Rock Bottom has done is given

The Rock Bottom Restaurant and Brewery chain began as a single brewpub in downtown Boulder and has grown to include locations in sixteen states. *Courtesy of Rock Bottom.*

credibility to the idea that a chain can really have high-quality beers and be as successful as or better than anyone...And with that, we were influential, I think, in people building brewpubs—or at least one strain of them."

It was 1990 and Day, the entrepreneur who had launched his first Old Chicago restaurant in Boulder fourteen years earlier, had gotten to know the American beer scene pretty well. The 110 beers he'd offered on tap at his pizza restaurants had morphed from mostly imports and products from regional domestic breweries to a steady stream of microbrews from around the country.

Then he discovered brewpubs popping up in California and down the road in Denver and decided he needed to get into the business. He put together a group of partners, snatched up some prime real estate on Walnut Street in downtown Boulder and debuted the appropriately named Walnut Brewery that year.

It was a "howling success," in Day's words, and before long he was gearing up to put his second brewpub on Denver's 16th Street Mall. This one was on the bottom floor of the Prudential Building—the company known as "The Rock"—so it seemed only appropriate to name it "Rock Bottom."

The same Realtor who set up that deal had property in downtown Minneapolis, where he thought the concept would be a hit. The street the property fronted (LaSalle Plaza) lacked an interesting name, so company officials went with the second in the line of what would become a fleet of Rock Bottoms across the country, recalls Tom Moxcey, senior vice-president in charge of the brewery group.

In the middle of Denver's 16th Street Mall, Rock Bottom's downtown restaurant and brewery is a hub of activity year round. *Courtesy of Rock Bottom.*

And this is where things got interesting, because Minneapolis's Rock Bottom patrons included investment bankers from Piper Jaffray who thought the idea was so good that Day and his crew should take it public and make big money. And Day did just that, leading the company through an initial public offering in 1994 and then stepping back to let it grow.

The next five years brought about conflicting results, depending on who tells the story. Rock Bottom grew like crazy and set up roughly thirty locations by the end of the decade, some of them eye-popping. The restaurant in Houston was surrounded by a moat populated with ducks, recalls Mark Youngquist, who headed up installation teams for the new breweries.

But the concept was competing with the great rash of breweries that developed locally in the mid-1990s, and not every site succeeded. In 1999, Day stepped back in, taking the company, which by this time was headquartered in the Boulder County town of Louisville, private once again to assert more control over its development.

Rock Bottom continues to grow, and its parent company also owns the ChopHouse concept in four cities (including Denver), two Sing Sing piano bars and one Rock Bottom Gold Medal Tap location. Few know that it also owns Boulder Beer, a company it helped to bring out of deep trouble in the early 1990s.

But just as the offerings at Rock Bottom and Boulder Beer are vastly different, so are the selections that can be found at the Rock Bottoms in, say, Denver or Des Moines or King of Prussia, Pennsylvania. That is because Rock Bottom, unlike some national brewery chains that dictate recipes to scattered brewmasters, gives its beer makers almost complete autonomy.

Rock Bottom officials lay out to each location the range of beers they'd like it to serve: something light, usually a lager; something pale; something red or amber; and something brown. But even in those areas, explains national director of brewing operations Kevin Reed, there is flexibility.

The 16th Street Mall location in Denver, for example, usually substitutes IPA for a pale ale because that's what its customers prefer. The IPA you'll find in San Diego will come from a different recipe than the one in Portland or Denver, because the palates of beer drinkers in different states have evolved in different ways, Reed says. "Our theory at this point is that we can do a better job of servicing what the guest at the bar wants if we are mindful of getting out and talking to them," he says.

As of mid-2011, there are seven Rock Bottoms in Colorado: the pioneer in downtown Denver, two in Westminster and one each in south suburban Denver, Colorado Springs, Loveland and the Denver International Airport. Even in that spectrum, you'll find differing levels of aggressiveness in the beer—strong in downtown Denver, where beer drinkers take their brew seriously, and less so in Loveland, where the restaurant is in a suburban mall.

In addition to the general lineup that each location is asked to put out, brewmasters tend to make between fifteen and twenty-five specialties a

year, Reed says. Wheats and dark beers are highly recommended for the rotations, but much of what comes out of the taps otherwise is up to the local brewers.

John McClure, brewmaster at the downtown Denver location, has used that leeway to start up a barrel-aging program. Hang out at his place around the time of the annual Great American Beer Festival and you'll find an assortment of whiskey-tinged high-alcohol beers that won't bring the term "chain restaurant" to mind.

In fact, it wasn't until April 2011 that Rock Bottom officials introduced to the chain a line of four beers that would be served at every restaurant nationwide: Kolsch, White Ale, Red Ale and I.P.A. Still, a number of locations offer a second style of some or all of those brews. So you can still find local legends like the Red Rocks Red at the Westminster Promenade and Molly's Titanic Brown Ale on the 16th Street Mall.

With those locally brewed recipes, Rock Bottom has amassed an impressive set of honors. Stores from throughout the national chain racked up forty-six medals through the end of 2010 at the GABF and World Beer Cup—more than any other brewery in America, Day points out.

"We have an admittedly large chip on our shoulder because we feel we don't get credit as brewers sometimes because we are a chain," Reed says.

Yet, for all the expertise that such a number may signify, the goal at Rock Bottom locations remains the same: drinkability. Many customers aren't beer aficionados, Reed admits. They're people who want to catch a drink for happy hour or celebrate a small occasion or just grab a bite to eat with friends.

So, while all of the Rock Bottoms offer mug clubs for loyalists and special beers for more refined palates, Reed is mindful that the restaurants also introduce novices to craft brews. Thus, the beers have to be crafted for a wide range of palates. And the restaurants even have wine lists, he notes.

"Brew it for the folks. Don't get too tied up about getting exotic, because most folks don't drink exotic," Reed reminds his brewmasters. "I hope that we're making beers that are highly accessible to most people and that there's a selection of beers that will challenge most folks as well."

As of late 2010, the company that began with Frank Day's desire to get on the brewpub bus was valued at $300 million. Start-up brewers come

in to study its operations, and it has produced brewers who've moved on to such nationally admired sites as Oskar Blues in Longmont, Three Floyds Brewing in Munster, Indiana, and Surly Brewing in Minneapolis.

In November 2010, a private equity firm bought both Rock Bottom and Gordon Biersch Brewery Restaurant Group, bringing the two national brewpub chain pioneers—and longtime friendly competitors—under the same umbrella. Day took over as board chairman.

But Day still has never brewed beer himself. Not even once. He's shoveled grain and done other odd jobs around Walnut. But oddly enough, the man who spawned more than forty breweries directly and countless competitors indirectly has never mixed up a batch of stout or IPA.

Rock Bottom founder Frank Day says he's proud his chain of brewpubs has grown to be a gathering place for friends to celebrate special occasions. *Courtesy of Rock Bottom.*

Day got into the food-service industry by setting up concession stands in an old Chicago-area chain of discount stores called Shoppers World. There, in the early 1960s, the man with an MBA from Harvard sold nineteen-cent hot dogs, nine-cent Cokes and nine-cent popcorn. The operation was absurdly simple. And he made, as he will now say, "a hell of a lot of money."

So maybe when he set up that first brewpub in Boulder in 1990, people should have taken more notice, anticipating the kind of success it would achieve. And regardless of whether people think the beer is too light, too heavy or just right, he's happy that folks want to come in to try it.

"One of the reasons that people come to Rock Bottoms is they've become places where they meet friends and get together…They're social places," he says.

ANHEUSER-BUSCH

2351 Busch Drive www.anheuser-busch.com
Fort Collins (Map 3) 970-490-4691
Signature beers: Budweiser, Bud Light, Shock Top Belgian White
Tours 10:00 a.m. to 4:00 p.m. Thursday–Monday (October–May);
10:00 a.m. to 4:00 p.m. daily (June–September)

Before there was the Wynkoop or New Belgium, before brewpubs had popped up in towns across Colorado, there was Anheuser-Busch.

The third-oldest brewery in the state opened in June 1988 in Fort Collins. And while Anheuser-Busch is more associated with St. Louis, the amount of beer the plant makes compared to most breweries in the state is mind-boggling.

At full capacity, the 130-acre plant can roll out 7.8 million cans of beer, 5.1 million bottles and 7,680 kegs per day. Employees work around the clock to brew twenty-five kinds of beer, including specialty seasonals that the company's eleven other U.S. plants haven't produced in some years.

The maker of the Bud and Michelob lines built a plant in Colorado to deliver beer quicker to the Rocky Mountain West, as well as parts of the Midwest and West Coast, says plant general manager Kevin Fahrenkrog. The Fort Collins plant is on a rail line and very close to an interstate highway.

Some ninety-four thousand visitors each year take the tour of the massive Anheuser-Busch brewery in Fort Collins. *Courtesy of Anheuser-Busch.*

Some of Anheuser-Busch's more craft-style creations have come out of its Colorado plant. Shock Top Belgian White was developed and is still made there. And while they're now made elsewhere, Budweiser American Ale and Michelob Dunkel Weisse were conceived at the Fort Collins plant as well.

But Anheuser-Busch's business in Colorado is not limited to making beer. It operates a barley research facility that works with Colorado State University to develop disease-resistant and high-yield varieties of the crop. It has its own can-making facility in the town of Windsor. And it has a company-owned distributorship in Denver.

But the main attractions are the beer and the Budweiser Clydesdales—the majestic draft horses featured in Anheuser-Busch commercials—which train in Fort Collins for one to two years. Roughly ninety-four thousand people a year visit the plant for a free tour or a paid behind-the-scenes tour, both of which end in the tasting room.

Though Anheuser-Busch, the largest seller of beer in America, has stiff competition in Colorado, it still does a significant chunk of business here. Its beers hold about a 40 percent market share, and specialties like Shock Top and Jack's Pumpkin Spice Ale sell better in Colorado than in other markets, Fahrenkrog says.

And the brewery tries to make itself an integral part of the community, hosting regional Master Brewers Association meetings and working with more than twenty charitable organizations.

BJ's RESTAURANT AND BREWHOUSE

Four Front Range locations www.bjsbrewhouse.com
Colorado brewery: 1125 Pearl Street, Boulder (Map 4) 303-402-9294
Signature beers: BJ's Jeremiah Red, BJ's Brewhouse Blonde,
Piranha Pale Ale
Hours vary but typically 11:00 a.m. to 11:00 p.m. weekdays; 11:00 a.m.
to midnight weekends

For a brewpub chain as centralized and controlled as BJ's Restaurant and Brewhouse, its decision to open its second location in Boulder was uncharacteristically spur-of-the-moment.

Original brewer Alex Puchner was in Denver for the 1995 Great American Beer Festival when a friend told him he'd found a vacant bar in Boulder that was perfect for a brewpub. BJ's was a Huntington Beach, California–based pizza chain still six months from opening its first brewpub at the time and had no plans to expand off the West Coast.

But Puchner loved the Pearl Street Mall location, and he summoned the chain's owners to see it. They bought it, and in February 1997, the second BJ's brewpub in America opened.

Today, there are several notable differences between most of the one hundred BJ's across America and that Boulder hot spot. Much of the brewery in Boulder, for instance, extends into the bar and dining area, so brewers can talk to customers. But it's notable too because the Boulder brewpub—unlike the BJ's restaurants in Aurora, Westminster and Colorado Springs—is the only Colorado site that makes its own beer. The other three are supplied by the Boulder brewery and by a BJ's in Reno, Nevada.

BJ's popular location on Boulder's Pearl Street Mall is the only one in Colorado that brews its own beer. *Courtesy of BJ's Brewhouse.*

The chain's philosophy is consistency, consistency and consistency. Eight standard beers are on tap at every BJ's in the United States, and local brewers get no freedom to bend the recipes. "It takes control, but we pride ourselves in how consistent our beer is across the country from one brewery to another," says Puchner, senior vice-president of brewing operations.

Those nationwide products include Jeremiah Red, an Irish ale that emphasizes malt rather than hops, and Brewhouse Blonde, one of the first kolsch-style ales brewed in America. In recent years, BJ's, now in thirteen states, has begun aging beers in wine and whiskey barrels.

In Boulder, it is a Pearl Street institution, with its bar-food menu and ten house taps popular with University of Colorado students. But beer geeks may find its other three locations even more interesting. Those spots contain a signature of the chain not found in Boulder: roughly forty other breweries' beers on tap, plus some twenty Belgian bottled options. It's the chain's way of offering the best of all beer worlds.

BRECKENRIDGE BREWERY

Locations in Denver (3), Breckenridge,
 Grand Junction
Main brewery: 471 Kalamath Street,
 Denver (Map 2)
 Signature beers: Avalanche Ale (amber), 471 IPA (double IPA),
 Vanilla Porter
 Closing hours vary, but all locations open at 11:00 a.m.

www.breckbrew.com

303-623-BREW (2739)

Opened in 1990 in the town of its namesake, Breckenridge Brewery quickly became the beer maker most associated with Colorado skiing. But founder Richard Squire had bigger ambitions, so he expanded in 1991 to a bottling facility in a then-dilapidated neighborhood of Denver. Luckily, Coors Field moved in across the street three years later, and the Breckenridge Ball Park Brew Pub hasn't slowed down since.

Its brewing facility did move in 1995 to an old manufacturing facility south of downtown. Visit there today and you'll find sixteen taps of

Breckenridge Brewery started in Breckenridge in 1990 and expanded to Denver in 1991. The brewery now has five locations throughout Colorado. *Courtesy of Breckenridge Brewery.*

Breckenridge beer—including several you can't find elsewhere—and the constant smell of barbecue (especially on all-you-can-eat ribs nights).

Then, a decade later, the brewing company began its current phase, opening casual alehouses featuring food and taps of other craft breweries. In early 2011, there was one west of downtown Denver and one in Grand Junction.

The beer from brewery director Todd Usry begins with Avalanche Ale, an amber ale available in seemingly every bar in Colorado. "Avalanche pretty much pays our paycheck. The rest are just for fun," marketing director Todd Thibault likes to say.

For a decade and a half, "the rest" were drinkable but very mainstream beers—Oatmeal Stout, a wheat, a brown—but in 2005, Usry realized that the beer pioneer had fallen behind. It was then that he came up with the beers that now define Breckenridge.

There's 471 IPA, a double IPA with a strong malt backing to balance out the upfront citrus bitterness. It's been called one of the best IPAs in America. And there's Vanilla Porter, a beer Breckenridge first made in 2000 but resisted packaging until 2007, when demand grew too loud.

Breckenridge looks to put out one or two new beers a year, along with its small-batch series and seasonals.

The goal is to open more alehouses, expand to more states and be the local beer, as well as the one waiting for skiers at the bottom of the slopes. It formed a joint venture with Wynkoop Brewing in 2011 to help it do just that.

"We are still big on being the brewery that makes a wide portfolio, from authentic English bitters to American hefeweizens, that are super well balanced and highly drinkable," Usry says.

C.B. & POTTS

Six locations along Front Range www.cbpotts.com
Regional headquarters: 1427 West Elizabeth, 970-221-1139
 Fort Collins (Map 3)
Signature beers: Buttface Amber Ale, Big Horn Hefeweizen,
Big Horn Blonde
Hours vary but typically 11:00 a.m. to close daily, with weekend
breakfast at 10:00 a.m.

C.B. & POTTS™

RESTAURANT & BREWERY

C.B & Potts serves its signature brews and a full menu at six Colorado locations. *Courtesy of C.B. & Potts.*

C.B. & Potts may be a chain, but you'll notice big differences in the beer at its six Colorado locations. Stop into the South Fort Collins brewpub and you'll find an emphasis on German styles. In the Denver Tech Center, that focus shifts to Belgians. And if you like beers that incorporate coffee, Highlands Ranch is the place for you.

The regional differences are brewmaster-driven. While the Lakewood, Washington–based chain has six standard beers at all twenty-three locations nationwide (including seventeen in other states that go by the name Ram Brewery), it gives local brewers leeway in how they make those standards and what else they create.

C.B. & Potts also is the only national brewpub chain in Colorado that bottles its beer, though you can find six-packs of offerings like its Big Horn Blonde in only a few liquor stores in Fort Collins and north Denver. And it's the only chain that proudly serves major domestic beers; others either don't do it or do it quietly. "We don't want to alienate a group…We want to be able to offer what they want," regional brewer Kirk Lombardi says. "We just try to be your neighborhood bar."

The first of the chain's locations moved into Fort Collins in 1974, when it served beer but didn't make its own. C.B. & Potts started brewing in 1995.

Its brewpubs are chock full of TV screens showing sports, and the menu is laden with foods cooked in beer. The testosterone quotient goes up further if you buy a Big Red IPA T-shirt that reads: "Big Red will kick your Dad's ass too."

The Colorado locations—which also include Broomfield, Westminster and the Collindale neighborhood of Fort Collins—feature some ten house-made beers on tap. The styles are what Lombardi calls drinkable, and he notes that some creations, such as the bestselling and lighter Butthead Amber Ale, are "gateway" beers for people not accustomed to drinking craft brew.

But he also notes that his Total Disorder Porter won a Great American Beer Festival gold medal. And the beer selection at each stop attracts homebrew clubs.

And in case you are tempted to buy a brand-name beer over a C.B. & Potts offering, know that house beers come in mugs that are two ounces bigger for the same price.

DENVER CHOPHOUSE & BREWERY

1735 Nineteenth Street, Suite 100 www.denverchophouse.com
Denver (Map 2) 303-296-0800
Signature beers: Wild Turkey Barrel Conditioned Stout,
Dark Munich Lager
11:00 a.m. to 11:00 p.m. Monday–Thursday; 11:00 a.m. to midnight
Friday–Saturday; 11:00 a.m. to 10:00 p.m. Sunday

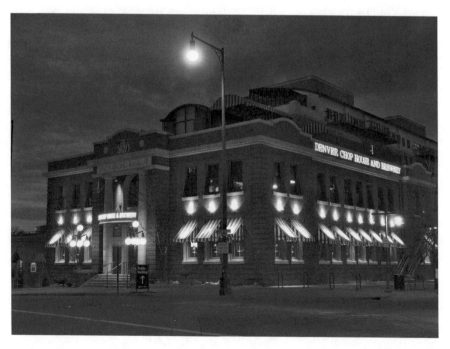

One of Denver's most elegant steakhouses is also a brewery. The Denver ChopHouse & Brewery is located in LoDo, just outside Coors Field. *Courtesy of Denver ChopHouse.*

If the Rock Bottom chain is where average Coloradans are introduced to microbrew beer, then the Denver ChopHouse is a similar portal for people who don't mind shelling out thirty-four dollars for a steak.

Located in the old Union Pacific Railroad roadway nexus in Lower Downtown Denver, the Denver ChopHouse is part of the Rock Bottom franchise. It boasts four sister chophouses around the United States, including a tavern in Boulder, but its story is unique in the redevelopment of LoDo.

In 1995, Rock Bottom mastermind Frank Day renovated what then was a dilapidated structure "full of rats and homeless people." Aiming to reflect the heyday of the railroad, he opted for a turn-of-the-century chophouse theme—a meat-filled, fine-dining experience complete with lengthy wine lists and wood-paneled walls and bars.

So famous is the place for its steaks that Kevin Marley, ChopHouse brewmaster since 1995, admits he still sees customers who don't realize the restaurant makes its own beer—despite its name: ChopHouse & *Brewery*.

The ChopHouse's specialty is Wild Turkey Barrel Conditioned Stout, for which Marley diverts half of each batch of his oatmeal stout into four fifty-five-gallon whiskey barrels. But while it's the most requested beer, he likes creations that are a little more balanced.

So the ChopHouse, unlike many small breweries, set aside room to make lagers in 2005. The Dark Munich Lager, a dunkel, replaced the brown ale at that time. The Dortmunder Lager took the place of the golden ale. And a house-made light lager substitutes for mass-made American lagers.

Rock Bottom expanded the ChopHouse concept to Washington, D.C., and Cleveland, but each location features its own brewer and unique selection of beers. There is also a ChopHouse on Concourse A at Denver International Airport, where Australians rave about the hop-subdued Pale Ale.

Back at the ChopHouse in Denver's LoDo, upscale carnivores mingle with T-shirt-clad Colorado Rockies baseball fans on game days. Coors Field is one block away. And it even offers a bit of nostalgia to the longtime Denver crowd—its walls are lined with pictures from the Union Pacific library. Some old-timers still come in and point out relatives in the photos, Marley says.

GORDON BIERSCH BREWERY RESTAURANT

Broomfield: 1 West Flatiron Circle (Map 4) www.gordonbiersch.com
Colorado Springs: Airport Broomfield: 720-887-2991
Signature beers: Czech Pilsner, Altbier, Schwarzbier
Broomfield: 11:00 a.m. to midnight Sunday–Thursday; 11:00 a.m. to
1:30 a.m. Friday–Saturday

The chain restaurant may be an all-American concept, but Gordon
Biersch Brewery Restaurant brings a little German influence to the
table as well. Its two Colorado locations—among thirty free-standing
brewpubs and twelve airport locations nationwide—brew only German-
style beer. Want a pilsner, hefeweizen or marzen? No problem. If you
want a pale ale or a barrel-aged stout, however, this may not be the
place for you.

Tom Dargen, the chain's director of brewing operations based at its
Flatiron Crossing mall location in Broomfield, says the beer menu attracts
a mixed crowd. Some are true beer geeks wanting to see how successful
a brewery can be making old-world lagers, and some are first-timers on
the craft-brewing scene.

"It's a different way of brewing. It's very challenging because there's
not a whole lot of roasted malt or a whole lot of hops that we throw into
the beers," Dargen says. "So the beers have to be made very cleanly or
the flavor is horrible."

The Gordon Biersch chain—which in 2010 merged with Rock
Bottom Restaurants—is headquartered in Chattanooga, Tennessee, with
locations from Hawaii to Florida. The company bottles beer for limited
distribution in the West.

Dargen coordinates recipes nationally and processes purchasing orders
from his office at the Broomfield location, which he opened in 2000 after
turning down a job as a congressional aide.

Gordon Biersch has five flagship beers, as well as a variety of all-
German seasonals. It uses German specialty hops and German yeast
for an authentic taste. And if you're looking for seldom-made German
styles, such as a Berliner weisse or a keller bier, they will pop up in the
rotation every once in a while. "If it's a German style of beer, we've done
it," Dargen says.

The Broomfield location offers menu items such as lobster and Chilean sea bass, making it, as Dargen says, an appropriate place for football watching or for a "serious date."

The Colorado Springs location is in the airport, making it a nice place to grab a beer on the run.

HOPS GRILL & BREWERY

Golden: 14285 West Colfax Avenue (Map 2) www.hopsrestaurants.com
Littleton: 8026 West Bowles Avenue 303-216-2469 (Golden)
Signature beers: Hoptoberfest, Thoroughbred Red, Clearwater Light
11:00 a.m. to 11:00 p.m. Sunday–Thursday; 11:00 a.m. to midnight
Friday–Saturday

Walk into either Hops Grill & Brewery location in the Denver area and you'll notice the brewery enclosed in glass in the middle of the restaurant. If brewmaster Steven Oliver is there—he oversees both breweries—the door will likely be open, and he'll be happy to give you the five-minute tour.

As the oldest brewery chain in America, Hops knows a thing or two about educating the public in the basics of craft brewing. When the first store opened in Clearwater, Florida, in 1988, it took great pains to explain the concept of a restaurant brewing its own beer.

At its peak, Hops had seventy-six restaurants. It is significantly smaller now, with the two Colorado restaurants representing half of the four Hops Grills left in the United States after its parent company went through bankruptcy.

But it still sees itself as a teacher, says Oliver, who develops the recipes for the four locations. Because both suburban Denver restaurants sit amidst a sea of other chains—and the Golden location is just a few miles from one of America's largest breweries—many customers remain unfamiliar with craft brewing.

"When you think of Golden, you only think of one brewery, and a lot of people have only ever drunk that one style," Oliver says of Coors beer. "For the most part, we want to make a beer that everybody can have—a good crisp, clean product that falls into line with what Americans view as a microbrew."

There's no barrage of hops, no wild yeast strains. Hops offers four year-round beers: Clearwater Light, Lightning Bold Gold, Alligator Ale porter and an amber ale whose name changes depending on its location. It brews six seasonals throughout the year, from a pale to a bock to a summer wheat, and two are likely to be on tap at any given time.

The crowd in Golden includes a lot of families on their way to the movies, as well as former Coors employees stopping by to talk beer. Education at Hops is a lifelong experience.

Mountain Sun Pub and Brewery

Boulder: 1535 Pearl Street (Map 4); www.mountainsunpub.com
 627 South Broadway (Southern Sun)
Denver: 1700 Vine Street 303-546-0886 (Mountain Sun)
 (Vine Street Pub)
 Signature beers: Colorado Kind Ale (dry-hopped amber ale),
 FYIPA, Isadore Java Porter
Hours vary, but open as early as 11:30 a.m. and close at 1:00 a.m. daily

Walking off Boulder's Pearl Street Mall into Mountain Sun, a visitor eyeing the Grateful Dead concert posters, tapestries and twenty taps of homemade ale would never assume the place was a chain.

And in truth, Mountain Sun and its sister hangouts, Southern Sun and Vine Street Pub, aren't a chain in any corporate way. It's just that the crowds got so big and the lines so long at the flagship location that owners had to expand to fit all of their fans.

The three locations have developed unique personalities. Mountain Sun, opened in 1993, is packed with University of Colorado students and tourists who go strong until 1:00 a.m. Southern Sun, a 2002 creation in southern Boulder, is more family oriented. Vine Street, opened in uptown Denver in 2008, is a respite for people wanting a more laidback atmosphere than many nearby restaurants offer.

Still, the three siblings share basic family traits—scads of hoppy and stout beers, slow-cooked menus, board games and the distinct possibility that someone with an acoustic guitar could play there that night.

"This pub is Boulder," says head brewer Brian Hutchinson. "You have a ton of freedom, and you can experiment a lot."

Those experiments have produced eight standard beers at each location, including the bestselling FYIPA and styles from a blackberry wheat to a java porter. As for the other twelve taps at each place, they're filled by creations drawn from an ever-growing reservoir of sixty recipes.

That list is highly populated by darks, giving birth to the yearly tradition of February as Stout Month, when everything on tap is dark (with the exception of the eight standards) and employees grow sideburns and muttonchops.

The license for creativity also has led to one-time beers ranging from a spearmint wheat to a red ale brewed with sage and rosemary, with customers buying multiple samplers to be able to try them all.

What you won't find at any of the pubs is a TV, as the atmospheres are hippie and conversational. You'll still find a packed house at Mountain Sun, despite the two new locations. But by now, that's because it's an institution more than a chain.

SMUGGLERS BREWPUB

Telluride: 225 South Pine Street (Map 1) www.smugglersbrew.com
Grand Junction: 2412 Highways 6 and 50 Telluride: 970-728-0919
Signature beers: Rocky Mountain Rye, San Juan SkyHop (hoppy red
ale), Strong Scottish Ale
11:00 a.m. to 10:00 p.m. daily

It's pretty easy to tell that Mike Metz is a sports fan. Check out either Smugglers Brewpub location owned by the Chicago native and you'll see a dozen games on myriad big screens—or catch the Smugglers softball team scarfing down wings in a corner.

That competitive spirit also fuels Metz's goal of opening new iterations of his brewpub in towns throughout Colorado's Western Slope. Eight years after turning an old mining warehouse in downtown Telluride into the town's first brewpub in 1996, he expanded north into Montrose (though that location has since closed). Then, in late 2008, he opened

in the Slope's largest city, Grand Junction; it closed temporarily but is scheduled to reopen in August 2011.

Smugglers Brewpub isn't bent on world domination: Metz's original goal was five. But as a guy who loves beer, the Chicago Bears and ribs slathered in barbecue sauce made with his Powder Night Espresso Porter, he thinks everyone should have access to such pleasures.

"Microbrewing's a big industry. People don't go out to eat quite as much these days, but they do drink," he says. "It's what we do. We make beer and make food."

The busy brewery in Telluride, located half a block from a ski lift, kicks out enough suds to supply the Smugglers there sixteen of its own beers on tap and twelve taps at its satellite in Grand Junction. Metz espouses a philosophy of "light, drinkable beers," including Smugglers' signature Rocky Mountain Rye or its Wildcat Wheat.

But the brewery has grown decidedly more experimental in recent years, introducing bourbon-barrel-aged concoctions and barleywines. Among Smugglers' signature creations are its Strong Scottish Ale, weighing in at 6.8 percent alcohol by volume, and its Imperial San Juan SkyHop, a big red ale.

Metz insists his places are just as much about the food: steaks and seafood mingle with wings on the menu, and the Telluride brewpub features a gyro machine.

Telluride is Colorado's summer music festival capital as well as a ski destination of the rich and famous, so Smugglers attracts both visitors and locals, particularly mountain bikers.

The Smuggler-Union was the biggest mine near Telluride, and the brewpub's wood-paneled walls are still stamped with the names of other area claims.

CHAPTER 10
INDEFINABLE BREWERIES

SKA BREWING

225 Girard Street
Durango (Map 1)

www.skabrewing.com
970-247-5792

Signature beers: Pinstripe Red Ale, Modus Hoperandi (IPA),
True Blonde Ale
9:00 a.m. to 8:00 p.m. Monday–Friday; 11:00 a.m. to 6:00 p.m.
Saturday

When Bill Graham and Dave Thibodeau rented the tiny warehouse on
the outskirts of Durango where they would begin developing recipes for
Ska Brewing in 1995, one feature stood out: the space had a shower. "I
really thought that in starting this company, we were probably going to
fail," Graham recalls. "But because it had a shower, we knew that if we
failed, we'd probably live at the brewery until the landlord finally would
evict us. I'm pretty sure we verbalized this."

Failure didn't happen. In fact, today, Thibodeau and Graham have the
largest brewery in southwest Colorado. Housed in a $5 million, twenty-
four-thousand-square-foot, all-wind-powered facility, Ska Brewery
employs forty and ships its award-winning beer to nine states.

The company's success owes at least partially to the fact that the
founders are the same free spirits they were in college, when they cooked

Ska Brewing co-owners Bill Graham, Dave Thibodeau and Matt Vincent have taken a less-than-by-the-book approach to making their business the largest brewery in southwest Colorado. *Courtesy of Ska Brewing.*

up beer for their friends and created the original comic book characters featured to this day on Ska's now-iconic labels. In an industry known for its colorful personalities, dreamers and out-of-the-box thinkers, Graham, Thibodeau and co-owner Matt Vincent stand apart.

In 1985, Graham and Thibodeau were buddies at Wheat Ridge High School in suburban Denver. Hanging out one day, they stumbled upon Thibodeau's father's homebrewing notebook. It dawned on the underage boys that they had discovered the key to getting drunk anytime they wanted—cheap—with ingredients they could find in the grocery store.

The friends brewed through college and, after graduation, moved to Durango. Thibodeau worked as a courier for the Durango Mountain at Purgatory ski area, while Graham did temp work for a construction company. But they were not exactly the high-level careers the men had envisioned in school, and in 1995, they felt the time had come to take up professional brewing.

The pair started by driving up and down the rural Western Slope— the west side of the Rocky Mountains that runs the north–south length

of Colorado—buying old tanks from dairies and creameries. Next, they got a small loan from Graham's father to rent the corner space in the warehouse, set up shop and began experimenting.

True to form, the budding entrepreneurs—or "punk-ass kids," as they now recall—crafted their business plan on the back of a napkin in a bar. When a bar mate asked what kind of beer their new brewery would make, they were stumped. Thibodeau suggested True Blonde Ale, not because he liked the style so much as he loved the name.

The early brewing sessions were, like their high school experiments, fueled by a loud dose of ska music, the pulsating, Jamaican-born reggae precursor that stormed England in the 1960s and mid-1980s and inspired the company's name. They would get off their courier and construction jobs around 5:00 p.m. and then make beer and invite friends over to try it, as their warehouse didn't have a public tasting room yet.

The room they did have was interesting, the pair recalls. The makeshift brewery was next door to a laboratory where police officers would test the blood-alcohol levels of intoxicated drivers. The cops and suspects had to walk through Ska's space to get to the bathroom. Thibodeau, Graham and friends would often watch—as they sat and knocked back beer.

While the way they made their beer would be vital to the future success of the company, arguably the most important decision that Ska's founders made involved labeling. For that, they turned to a comic book that they and a former roommate created and used characters from that unpublished story on the first beers—and on every beer they've made since.

In the story, the CEO of Rotgutzen International imposes Prohibition to wipe out small craft breweries in the world. Then the guys from Ska move to town, begin selling their beer speakeasy-style in bars throughout Durango and do battle with the Rotgutzen goons.

The "True Blonde" of bottle-label fame is Lana, the heroine. The evil Rotgutzen CEO is Pinstripe, the skull-headed fellow who stares out from the label of Ska's flagship Pinstripe Red Ale. He and his goons are on the Modus Hoperandi IPA cans. And new beers mean new characters, such as Carlos Javier, the chainsaw-wielding protagonist whose sleeping visage is on their Mexican Logger Mexican lager.

Drinkers took to the characters, and the hook expanded. Thibodeau and Graham set up Rotgutzen.com so that fans can go to the site to see the character of the evil beer that is "hand-crafted by robots." They even

Ska's unique labels all stem from a comic book that its founders developed in college. Modus Hoperandi labels feature the bad guys from that story. *Courtesy of Ska Brewing.*

shot a "World Beer Summit" video, viewable on YouTube, of Thibodeau and a Rotgutzen "official" discussing beer. "We just had our comic book that was like our marketing plan," Graham remembers. "And that, of course, is the Ska way."

The Ska way was also heavy on old-fashioned word-of-mouth advertising. Those friends who'd drunk a lot of free beer before the brewery officially opened in the warehouse in 1995 spread the word throughout Durango. Their message: beer drinkers didn't have to find Ska—Ska would find them.

That, as it turns out, is how they met Vincent. Graham and Thibodeau had heard of a young homebrewer in town who was serious enough to be kegging his creations. So one night before the brewery officially opened, they showed up uninvited at one of his homebrew parties—and brought their own keg.

Vincent was with Durango Brewing at the time, and the offer to come work for Ska for free just wasn't that appealing, he says. But once Ska was up and running, Vincent persuaded his mother to let him buy into the business with the college funds that had gone unused since he dropped out to work at a ski resort at age nineteen. "My first investment was to buy actual tanks that were made for making beer, not tanks that were made for making milk," Vincent remembers.

For all its quirkiness, Ska's original beers were traditional English-style offerings: the blonde ale, the red ale, a brown ale, a porter. By the time it got around to making an IPA in early 2009, the company was following a trend rather than setting one. And these are the Ska products that you'll find in most liquor stores.

But get down to Durango or to selected stores and you'll discover the creativity dwelling in the comic-drawing brewers, especially with their use of spice. Ska has brewed beers with peppercorns, coriander, kaffir lime leaves and organic chocolate. It's created a double cream ale with cherries.

Every winter, Durango hosts its Snowdown Festival, and Ska is there brewing to theme. For "Snowdown in DaNile," it brewed an Egyptian lager with dates, figs and honey. When it was "Surf's Up Snowdown," Ska produced a blonde ale with a wheat yeast strain brewed with pineapples and toasted coconut.

And Ska has begun making high-alcohol versions of some of its bestsellers, creating a Decadent Imperial IPA, Nefarious Ten Pin imperial porter and True Blonde Dubbel Belgian-style golden ale.

Where it really pushed boundaries, however, was in canning its product, following Oskar Blues's innovation by a couple of months. As Thibodeau tells the story, the Canadian company that produces the

aluminum containers actually came to Ska first, and he thought the idea sounded crazy. After Oskar Blues's success, he offered Ska's beer in cans and found them very popular with Durango's outdoor crowd. By 2009, sales of Ska's canned beers had equaled sales of its bottled beers.

All the while, the little brewery that started on a shoestring has ingrained itself in the community. Ska promoted ska concerts early on and continues to partner with the local arts and concert scene. It hosts fundraisers galore. One philanthropic effort—Pints for Pints, in which each blood donor received a free pint of Ska beer—earned a mention in Jay Leno's monologue.

"Locally, the people can tell that we come from them," Graham says. "I think there's genuineness in our products that crosses over."

While Ska Brewing has built its reputation around not taking itself too seriously, it also built a $5 million eco-friendly facility in Durango. *Courtesy of Ska Brewing.*

In 2008, Ska moved out of that first warehouse (after having expanded subsequently throughout the structure) and opened its new environmentally friendly four-story headquarters two blocks away. The bars and tables were made of materials from old Denver bowling lanes, and 75 percent of building materials came from within fifty miles of Durango. And while the brewery still doesn't have a kitchen, it's made room in its beer garden for a local taqueria to make and sell food.

In 2010, Ska produced more than fifteen thousand barrels of beer, vaulting it from the category of microbrewery to regional craft brewery. In a show of just how (not) serious the beer makers had grown, their news release announced that new signs in the parking lot would read "Regional Craft Brewer Parking Only" and noted that Ska had gone from being the nation's largest microbrewery to its smallest regional craft brewery.

"It's amazing how much your life can change in the course of a day," Thibodeau wrote. "Just yesterday we were the king of the 'micros' at 14,957 barrels, ruling the land with an iron-clad brew glove, and now here we are 20 hours later scraping the bottom of the regional barrel."

Comic books and good times still define Ska Brewing, though co-owners Bill Graham, Dave Thibodeau and Matt Vincent have forty employees and their own families. *Courtesy of Ska Brewing.*

Multimillion-dollar facilities and newfound respect from academia aside—the men who drew their "business plan" on a napkin actually speak at the local college's business school occasionally—Ska is still the same adolescent upstart it always has been.

Yes, Thibodeau, Graham and Vincent now are responsible for paychecks and health insurance for forty workers. In fact, all three are married and have kids of their own.

But growth has not spoiled Ska's carefree personality.

"Dave's the president of this company, and I've seen him passed out at a beer festival with toothpaste in his hair and a dog eating it out," Graham observes. "If we do start taking ourselves too seriously, that's when we've lost our niche."

In times like that, it's good to know that the new facility shares one thing in common with Ska's humble beginnings. It has a shower.

BACKCOUNTRY BREWERY

720 Main Street www.backcountrybrewery.com
Frisco (Map 1) 970-668-BEER (2337)
Signature beers: Telemark IPA, Maybock Lager (maibock),
Breakfast Stout
11:30 a.m. to 11:00 p.m. Sunday–Thursday; 11:30 a.m. to midnight
Friday–Saturday

Backcountry Brewery, on the main road into the Breckenridge ski resort, is the United Nations of Colorado's brewing scene. You're likely to find skiers and hikers from around the globe stopping in for a drink, a burger and some incredible mountain views.

Because of that, brewer Alan Simons says, Backcountry looks to make beers that appeal to a broad range of tastes. Telemark IPA is hoppy, but not overly so. Ptarmigan Pilsner is malty, but not so much that it can't be sold to those who order a brand-name lager. And seasonals largely reflect classic German styles.

"There's a lot of experimentation going on these days, and I wish I had the opportunity to do that sometimes," Simons says. "But sometimes a lot of breweries are really overlooked for making really solid styles of beer."

Backcountry Brewery sits in the heart of Colorado's tourist playground, Summit County, surrounded by summer and winter recreation. *Courtesy of Backcountry Brewery.*

That doesn't mean that beer geeks sidling up to Backcountry's bar can't find something for them too. Barleywines, espresso porters and oak-aged beers pop up on Backcountry's taps in limited-time intervals.

And Backcountry's large foreign following doesn't mean locals aren't also devotees. They know the late-winter seasonal Breakfast Stout is the closest thing to hopped coffee you'll find. And they've made Mayfest an annual tradition in which post–ski season crowds cram the brewery to listen to music, eat barbecue and celebrate the seasonal rollout of the Maybock Lager, a German-style maibock.

Backcountry, a two-story brewpub shaped like a backcountry ski hut, hosted a classic rowdy ski bar on its first floor when it opened in September 1996. It's now rented that space to retail shops, however, and concentrated on its window-lined upstairs brewpub, complete with several fireplaces and a family-friendly menu.

Beer is available on tap or in party pigs to go. And twenty-two-ounce bombers of its most popular selections can be found throughout Summit County, as well as in a few liquor stores along the Front Range.

Original owners Woody Van Gundy and Anthony Carestia were trendsetters. Backcountry was the second brewery in the county, opening six years after Breckenridge Brewery and months before Dillon Dam and Pug Ryan's. It's now part of what Simons calls a great local beer culture in a tourist mecca.

"Because Colorado is saturated with good beer, I think sometimes Summit County gets overlooked," he opines. "But there is a lot of good beer here."

BLUE MOON BREWING

2161 Blake Street www.bluemoonbrewingcompany.com
Denver (Map 2) 800-642-6116
Signature beers: Blue Moon Belgian White, Chardonnay Blonde,
Summer Honey Wheat
Tastings available at Coors brewery or SandLot Brewery at Coors Field;
beer sold statewide

Blue Moon Brewing is, in many ways, a paradox.

It is the "craft beer" unit of Coors, a distinctly non-craft brewery.

It is a uniquely Colorado beer—developed at Denver's Coors Field—that now is produced partly outside the state.

It is a brewery that's received honors for experimental beers and taken the prestigious Large Brewing Company of the Year award at the Great American Beer Festival. But if you want to try its most unique beers, you'd better hit the once-a-year festival, because you'll never see them elsewhere.

Blue Moon is made famous by one beer: the Belgian-style white ale brewed with coriander and orange peel that was developed by Keith Villa in 1995 and sold as Bellyslide Belgian Wit in the SandLot Brewery at Coors Field. It outsold everything else at Colorado Rockies baseball games, and the parent company, deciding that a beer like this comes along only once in a blue moon, renamed it Blue Moon Belgian White and launched the product nationwide.

Blue Moon's signature Belgian white ale, now served throughout the country, was launched from the SandLot Brewery at Coors Field. *Courtesy of Blue Moon Brewing.*

One problem: Coors didn't want to give up capacity at its Golden brewery. So Villa, a brewer at Coors, contracted it to be made at a brewery in Utica, New York. Then he took to the road by himself to sell it, having to explain to skeptical bartenders that unfiltered wheat beers are naturally cloudy.

By 2008, Blue Moon Belgian White was the top-selling craft-style beer in America. Coors moved some of the brewing back to Colorado but has kept much of it at its plant in Eden, North Carolina.

Early on, Blue Moon also offered a Nut Brown Ale, Raspberry Cream and Honey Blonde. It peeled them back, though, and only reintroduced some of them, as well as seasonals, near the end of the 2000s.

The brewery has gained a certain mystique from its Peanut Butter Ale—which is so popular that volunteers come to scoop peanut butter into the brew tank—and its Chardonnay Blonde, winner of multiple GABF medals. Neither is available in bottles, increasing their celebrity status.

Blue Moon is now, as Villa describes it, "our fifteen-year overnight success story."

"We had to think like entrepreneurs and craft brewers," he says. "We didn't have a lot of money to launch. So the beer had to sell itself."

BONFIRE BREWING

127 Second Street www.bonfirebrewing.com
Eagle (Map 1) 970-306-7113
Signature beers: Two Hands Wheat, Demshitz Brown Ale,
Firestarter IPA
5:30 to 10:00 p.m. Monday–Thursday; 5:30 p.m. to midnight
Friday–Saturday

Bonfire Brewing was born of need. Specifically, Andy Jessen and Matt Wirtz needed to make $525 more a month to meet the rent when their roommate moved out. That meant expanding the long-standing homebrewery they'd had in their garage into a bigger, commercial space. They hit up Jessen's dad for a loan, leased a store in a well-traveled area and Wirtz built the brewing system out of spare parts. And on November 16, 2010, Bonfire Brewing was born.

The simple décor is built around a theme: Jessen and Wirtz want visitors to feel like they're hanging around a campfire with friends. A cooler in the middle of the room holds the serving kegs. A projector shows ski films. And a shuffleboard table is front and center of the usual action.

"We want to build our brand focused on the concept of the bonfire: something that is built from the ground up and spreads as more and more people come to it and feel the warmth of it," Jessen says.

Bonfire is the first brewery in Eagle, a town of three thousand that's home to many of the workers at nearby ski areas and outdoor recreational

ventures. Within a month of opening, Jessen and Wirtz were doing three times the business they'd planned.

The beer is "what we like to drink," says Jessen. Two Hands Wheat, Demshitz Brown Ale and Firestarter IPA developed instant followings. But customers also asked for lighter beers for their wives, so Wirtz obliged.

Bonfire's brewmeisters are "definitely not style nazis" when dreaming up new creations to fill their seven taps, Jessen says. Their popular "Save Christmas" ale came about when a batch of brown ale turned out too watery and Wirtz salvaged it by whipping up a honey-and-cinnamon brew and blending the two.

But it's really the attitude that defines the brewery. From its hilarious website (description of the taproom: "It started as an empty shell and has turned into an empty shell with stuff in it.") to its weekly darts tournament to its ceramic mugs designed by Jessen's mom, it's a fun atmosphere.

Oh, and while Jessen and Wirtz made enough money to forgo a third roommate, they got one anyway: Jessen's fiancée, Amanda Hensley, who also does all of the design work for the brewery.

BULL & BUSH PUB AND BREWERY

4700 Cherry Creek Drive South www.bullandbush.com
Glendale (Map 2) 303-759-0333
Signature beers: The Tower E.S.B.; The Legend of the Liquid Brain
Imperial Stout
11:00 a.m. to 2:00 a.m. Monday–Friday; 10:00 a.m. to 2:00 a.m.
Saturday–Sunday

The fermenting tanks at the Bull & Bush aren't original to the restaurant, which opened in 1971. But the satellite dishes on the roof are. They bring all sorts of sports to the televisions in the darkly lit English pub, a place second-generation owners Erik and David Peterson call the oldest sports bar in America. And with the wooden tables and warped copper-topped bar, the atmosphere feels rustic. "It's kind of weathered. It's got a homey feel to it," says Gabe Moline, the brewer who's been with Bull & Bush since seven months after beer making began.

Bull & Bush Pub & Brewery is known for its cheeky logo and its barrel-wearing employees who grab attention at the Great American Beer Festival. *Courtesy of Bull & Bush.*

The torch had passed from founding brothers Dale and Dean Peterson to Dale's sons when they decided a brewery would complement the pub, named after an establishment founded in 1645 in England. The first beer rolled out on January 1, 1997.

Bull & Bush has six year-round beers—including its award-winning The Tower E.S.B.—and about thirty rotating taps, from mild entry-level lagers to rye wines and the 12.5 percent alcohol-by-volume English barleywine Royal Oil.

Experimental beer lovers will want to get on its e-mail list, as the pub usually has at least one beer on tap that it doesn't advertise. It also features some 60 vintage beers from around the world—some that are twenty-five years old—and about 250 kinds of American or single-malt whiskeys.

And true to its origins, about twenty TVs hang around the bar and outdoor patio. They originally broadcast largely English soccer games but now show a variety of sports.

Bull & Bush is not just a sports bar, though. It features Dixieland jazz concerts each Sunday night.

And Great American Beer Festival aficionados know it also as "that brewery"—the one whose employees dress in garish orange jumpsuits and tour the Colorado Convention Center, sometimes in barrels. Erik Peterson started the tradition because he wanted an advertising platform and because brewers didn't seem to be having enough fun.

"I was like: 'How can we make the most noise of anyone there?'" Peterson recalls. "Now you talk to a lot of brewers and they think we're this huge brewery in Denver. But we're just pretty tiny."

Colorado Mountain Brewery

11202 Rampart Hills View www.cmbrew.com
Colorado Springs (Map 5) 719-434-5750
Signature beers: Roller Coaster Red Ale, Panther India Pale Ale,
7258 Blonde Ale
11:00 a.m. to close daily

One look at Colorado Mountain Brewery's menu, and you know you're in Air Force Academy territory. Old 59er Amber Ale is named for the class of 1959, the first to graduate from the academy. Panther India Pale Ale references a Special Forces unit. And 7258 Blonde Ale, with its label featuring a high-flying jet, denotes the academy's elevation.

Scott Koons and John Bauer, two of the brewery's owners, are Air Force Academy graduates, and the brewpub's clientele includes the college's upperclassmen. The men's room door sign features the words "Bring Me Your Men," the academy's former motto when it was a unisex institution.

"This is such an untapped area," says head brewer Andy Bradley of Colorado Mountain's location in a new commercial area across Interstate 25 from the academy on the north side of Colorado Springs. "I'm really trying to build community around beer up here."

When Colorado Mountain—which is not named after any mountain in particular—opened in 2010, it immediately drew a cadet crowd for its beer and its fire pit–lined patios, perfect for late-night stargazing.

Inside, wood beams and comfortable booths give the restaurant an Aspen feel. The food menu, featuring burgers named after local mountains, flatbread pizza and Colorado-themed dishes, reaches out to area residents who have few options other than chain restaurants.

Bradley, who is not an Air Force Academy grad, designed the beer menu around ales that are accessible to a general crowd but exemplify their styles. The malty Roller Coaster Red Ale, named after a nearby highway, became a bestseller.

In addition to red and hoppy ales, Colorado Mountain offers a UniBräu Hefeweissen beloved by U.S. Air Force veterans who have been overseas.

Colorado Mountain beers can't be found anywhere but the brewpub. That exclusivity is part of its appeal—as is the view of the night sky, which draws Independence Day crowds eager to watch the city's fireworks displays from its top-of-the-bluff location.

"We're trying to really concentrate on an experience that's unique to here," Bradley says.

EQUINOX BREWING

133 Remington Street www.equinoxbrewing.com
Fort Collins (Map 3) 970-484-1368
Signature beers: Eclipse Brown, Sunrise Golden Ale, Jonas Porter
Noon to 8:00 p.m. Sunday–Wednesday; noon to 9:00 p.m.
Thursday–Saturday

When you head to Equinox Brewing in the college town of Fort Collins, you'd better bring a pen and paper. You're about to get educated. Owner Colin Westcott doesn't want you just to enjoy his beer; he wants you to know everything about it. Beside the bar is a book of recipes for each creation that you're encouraged to write down and try making yourself. With each recipe comes an explanation of the history of that style.

It's not that Westcott is going for the Colorado State University crowd, which does enough reading and note taking as it is. But as owner of the neighboring Hops & Berries homebrew shop as well, he wants to give you the one-on-one education that many of the bigger breweries can't.

Equinox Brewing is named after the celebration of the changing of seasons, symbolizing the connection of the past and the present woven throughout its recipes. *Courtesy of Equinox Brewing.*

"Here in Fort Collins, we fill this niche that the other breweries can't fill," says Westcott. "We're small enough that we can talk to people about beer and interact with our customer base. It's all about beer education."

Westcott learned quickly himself after stealing his father's homebrew kit at age nineteen. He brewed professionally in Montana and Alaska and then moved to Colorado to open Hops & Berries. Five years later, in April 2010, he started Equinox.

To almost all of his classic styles, Westcott adds a twist. The Orbit ESB is made with American hops. The Zenith IPA is a blend of British

malt and a variety of American hops. The Jonas Porter, named after his son, is a foreign export stout. The Vernal Hefeweizen is an unchanged traditional Bavarian style. But that, in itself, is rare in the United States.

If you want to know more, feel free to pull down any of the brewing books that line the shelves of Equinox's interior. (There are also board games.)

If you're not in the mood to re-create Equinox's recipes, have a seat on the back patio. The brewery offers ten taps of its own creations, rotated constantly to keep homebrewers and casual tasters alike interested.

The brewery is named after the changing of the seasons, symbolizing the connection between the past and present woven throughout Equinox's recipes. Talk to Westcott and you'll learn that too.

"We want people to leave here knowing more about beer than when they came in," he says.

FLOODSTAGE ALE WORKS

170 South Main Street no website
Brighton (Map 1) 303-654-7972
Signature beers: Rowing Frame Irish Red Ale, Strong Ale,
Oatmeal Porter
3:00 p.m. to 1:00 a.m. Monday–Thursday; 11:00 a.m. to 2:00 a.m.
Friday–Saturday; noon to 1:00 a.m. Sunday

John Thorngren's decision to open Floodstage Ale Works came not from a business plan so much as an intervention. One very late, beer-sopped night in 2006, five friends were chiding the longtime restaurant worker to do something with his life. Tired of the harassment, Thorngren agreed to fire up the old brewing equipment he'd stored for six years.

A little more than a year later, Floodstage opened in Brighton, a blue-collar suburb northeast of Denver, offering its own product, plus an ambitious menu of twenty Colorado microbrews on tap and forty in bottles. Customers include locals, beer lovers from neighboring suburbs and even some out-of-towners who make the twenty-mile trip from Denver International Airport on long layovers.

Like he does many things, Thorngren eschews convention when it comes to brewing. His "recipes" are stored on water-stained napkins with

211

descriptive notes like "Good shit!" Even that system is fairly pointless, as he changes ingredients each time to produce beers that don't fit classical styles.

He makes his beer according to what his customers tell him they want, and they also vote on names, producing gems like Crazy Bitch Blonde Ale. "It's a little bitter, like most crazy bitches," he says.

Thorngren, who got the loan to transform an old transmission shop into his brewpub after giving the banker three of his beers, keeps his experiments simple: three or four ingredients, one or two varieties of hops, reds and blondes and rye beers.

The atmosphere at Floodstage—a name reflecting his love of rafting—is simple too. All food orders are cooked on a grill outside, where the huge patio hosts beanbag-tossing games in the summer.

And in case he forgets the inspiration for his venture, those intervening friends framed the paper he signed promising to open the brewery and hung it on the wall.

"I got a little something that works, and it works real well," says Thorngren.

KANNAH CREEK BREWING

1960 North Twelfth Street www.kannahcreekbrewingco.com
Grand Junction (Map 1) 970-263-0111
Signature beers: Lands End Amber, Standing Wave Pale Ale,
Island Mesa Blonde
11:00 a.m. to 10:00 p.m. Sunday–Thursday; 11:00 a.m. to 11:00 p.m.
Friday–Saturday

Jim Jeffryes traveled across the United States to bring better beer to Grand Junction.

Residents of his town, as he puts it, "are a little behind the curve with craft beer." A good number lean toward local wines. Of those who choose beer, many prefer light lagers.

So when Jeffryes opened Kannah Creek Brewing in 2005—along with his wife, daughter, son-in-law and two friends—he knew the brewpub wouldn't stay open long if he were pushing experimental styles. So he kept it simple, with seven mainstay selections, from a blonde ale to a lower-alcohol porter to an IPA with a big malt backbone.

Kannah Creek Brewing is named after the main water source for Grand Junction and aims to be a brewery that is enjoyed locally. *Courtesy of Kannah Creek Brewing.*

But there are two asterisks on that workmanlike selection.

The first is that Kannah Creek has won two World Beer Cup gold medals for its Standing Wave Pale Ale and its Lands End Amber. Jeffryes describes the amber, a German-style brown ale, as "a beer that lets mainstream drinkers step out of their box a little bit and be cool for a minute."

The second is that Kannah Creek offers nineteen more exotic rotating beers, from a huckleberry wheat to a hopped doppelbock, for the more daring drinker.

Brewing was not Jeffryes's first career. He worked in high tech until he was diagnosed with multiple sclerosis in 1994, when he decided to look for something less stressful. The longtime homebrewer then went to the American Brewers Guild school in Vermont to learn to brew professionally. He spent six months working at a C.B. & Potts in the Denver Tech Center before coming home to work at Palisade Brewery, where he stayed about two years before striking out on his own.

Today, Jeffryes, who named his brewery after the mountain creek that serves as Grand Junction's primary water supplier, makes no apologies for catering to locals. "We're a typical throwback to the days before Prohibition when every town had at least one brewery," he says. "Beer's got to start local, and if you abandon your local market, you're really sort of throwing in the towel."

Though Kannah Creek is near Colorado Mesa University, it's more of a hangout for professors, doctors and nurses. It specializes in pizzas, but Jeffryes takes pride in noting that his tables are set with cloth napkins.

MAHOGANY RIDGE BREWERY & GRILL

435 Lincoln Avenue no website
Steamboat Springs (Map 1) 970-879-3773
Signature beers: Alpenglow Ale (amber), Spring Creek Stout on nitrogen
4:00 p.m. to 11:00 p.m. Sunday–Thursday; 4:00 p.m. to 2:00 a.m.
Friday–Saturday

Walk into Mahogany Ridge Brewery & Grill in downtown Steamboat Springs, and you may see Olympic medalist skier Johnny Spillane sitting on his usual stool at the end of the bar.

What you definitely will see is a highbrow restaurant, where dishes such as adobo-rubbed lamb sirloin or tandoori-spiced yellowfin tuna are standard fare. "Most people, when they see the word 'brewpub,' have a certain expectation of what the level of food is going to be, and when they come in here, they're totally amazed," owner/brewer Charlie Noble says unabashedly. "We're more of a really good restaurant that happens to make its own beer."

But for a place where the beer might seem secondary, Mahogany Ridge has no shortage of its own offerings. Noble rotates twenty to thirty recipes a year, keeping his signature Alpenglow Ale on year round.

The beers aren't flashy. One tap will change from a wheat to a Bohemian pilsner to a honey blonde throughout the year, and another to several types of brown or dark ales. You might even get a Jane's Brown Ale, a non-trademark-infringing play on the name of the legendary singer whose moniker graces the city's James Brown Soul Center of the Universe Bridge.

Typically, you'll find two taps with beer dispensed with nitrogen, especially the Spring Creek Stout. Every once in a while, Noble breaks out unique creations, like the summertime Charlie's Cherry Ale, made with 240 pounds of cherries per batch.

Mahogany Ridge has been part of this athlete-studded ski town since 1993. The place is a tourist magnet, busiest in the winter. And if skiers seem drawn to it, there's a reason. For many, the last run of the day is at a wood bar that serves adult beverages—as in, "Let's go ski the mahogany ridge."

Main Street Brewery

21 East Main Street no website
Cortez (Map 1) 970-564-9112
Signature beers: Schnorzenboomer Amber Doppelbock,
Crystal Wheat, Porter
11:00 a.m. to 10:30 p.m. daily

Between the beer mecca of Durango and the Four Corners border with Arizona sits the little town of Cortez, whose main claim to fame is its proximity to Mesa Verde National Park.

But the brewpub in this farming community of eight thousand is also a big draw. The Main Street Brewery, instantly recognizable by an oversized Kokopelli figure (the ancient Anasazi flute-playing storyteller) drinking a mug of ale out front, is a haven for meat lovers, softball players and craft beer fans.

Its offerings range from wheats to a maibock to an IPA. It also has the Schnorzenboomer Amber Doppelbock, a high-alcohol bestseller that itself tells much of the brewery's story. "It's a made-up word," brewmaster Branden Miller says. "It's one of those talkin'-German-when-you're-drunk-in-a-pub words."

Main Street opened as a restaurant in 1995 on the town's brick-lined main drag, the brainchild of a German couple who, five years later, tapped into the microbrew craze. They went through a series of brewers before settling on Miller, their former janitorial contractor who picked up the trade quickly.

Main Street Brewing is, as its name implies, right in the middle of downtown Cortez. Its beer-guzzling Kokopelli symbol is hard to miss. *Courtesy of Main Street Brewery.*

Miller helped to expand the offerings and to introduce Main Street's menu of blends—two kinds of the brewery's beer, combined to approximate another style. Among them is "brown ale" made of 80 percent Crystal Wheat and 20 percent Porter that the brewpub advertises as "tastier than Newcastle."

Oklahomans Bob and Janet Woods bought Main Street in late 2010. Their goal: grow it and get Miller's beer distributed statewide.

Still, the pub is the heart of the brewery, a place where locals and tourists can stare at a massive mural above the bar featuring the see-no-evil monkeys, the crew of the USS *Enterprise* and a hookah-smoking caterpillar. It's the creation of a local artist.

Under the mural are thirteen taps of Main Street beer, evolved over the years from having an almost wholly German character to a more typical Colorado menu. "We have some that are malt-extreme and some that are hop-extreme," Miller explains. "There's a little bit for everybody."

Given the crowd—both American and European tourists headed to Mesa Verde Indian cliff dwellings—it's a can't-miss strategy.

PITCHERS BREWERY & SPORTS SHACK

2501 Eleventh Avenue no website
Greeley (Map 1) 970-353-3393
Signature beers: Sensuous IPA, 808 Wheat, Stampede Nitro Stout
11:00 a.m. to 1:15 a.m. daily

Pitchers Brewery & Sports Shack can be a bit confusing for first-time visitors. On one side of the place, surfboards and sunny spring break pictures fill the wall; the Duke Kahanamoku poster may make you think you've turned left and ended up on the beach. Yet the opposite side is decorated with skis and snowboards, imparting a very outdoorsy Colorado feel. Behind the long bar, TVs blare five different sports simultaneously.

Put them all together and what do you have? A "Sports Shack," naturally.

Pitchers is the oldest brewery in Greeley, and its Sybil-like personality is reflected in its crowd, ranging from the blue-collar workers who dominate the town to students from the nearby University of Northern Colorado crowding in for happy hour discounts on beers and burgers.

Gus Christopoulous's beer, too, is diverse, though most of it tends toward the lighter-bodied side. Baja Mexican-style lager, Apricot Ale and 808 (unfiltered) Wheat are typically on tap for those with a lighter palate. Mid-range beers include the Sunset Amber and U.S. Brown Ale. And Sensuous IPA—along with a series of occasional Belgian ales and brewers' reserve offerings that have included an espresso stout and imperial hefeweizen—round out the list. Pitchers normally features one or more nitrogen-infused options as well, usually involving the IPA or Stampede Stout.

Besides beer, Pitchers offers billiards, darts or chess. Just don't take the surfboards off the wall.

Greeley has never had a reputation as a craft-brewing town, and Pitchers, with its Hawaiian-mountain-sports bar theme, doesn't look like a typical craft brewery. In that sense, maybe it's a match made in heaven.

Or Hawaii.

Or the Himalayas.

Index

A

AC Golden Brewing 102
Amicas Pizza & Microbrewery 119
Anheuser-Busch 180
Asher Brewing 64
Aspen Brewing 66
Avery Brewing 80

B

Backcountry Brewery 201
BierWerks Brewery 86
Big Beaver Brewing 67
BJ's Restaurant and Brewhouse 182
Black Fox Brewing 103
Blue Moon Brewing 203
Bonfire Brewing 205
Boulder Beer 21
Breckenridge Brewery 184
Bristol Brewing 68
Bull & Bush Pub and Brewery 206

C

Carbondale Beer Works 120
Carver Brewing 28

C.B. & Potts 185
Colorado Boy Pub & Brewery 114
Colorado Mountain Brewery 208
CooperSmith's Pub & Brewing 46
Coors Brewing 30
Copper Kettle Brewing 161
Crabtree Brewing 163
Crazy Mountain Brewing 87
Crested Butte Brewing 32
Crooked Stave 89
Crystal Springs Brewing 164

D

Dad & Dudes Breweria 166
Del Norte Brewing 105
Denver ChopHouse & Brewery 187
Dillon Dam Brewery 121
Dolores River Brewery 123
Dostal Alley Brewpub 140
Dry Dock Brewing 157
Durango Brewing 33

E

Eddyline Restaurant & Brewery 70
Eldo Brewery and Taproom 124
Elk Mountain Brewing 167
Equinox Brewing 209
Estes Park Brewery 35

F

Falcon Brewing 141
Floodstage Ale Works 211
Fort Collins Brewery 106
Funkwerks 107

G

Glenwood Canyon Brewing 47
Golden City Brewery 143
Gordon Biersch Brewery
 Restaurant 189
Gore Range Brewery 49
Grand Lake Brewing 126
Great Divide Brewing 80
Grimm Brothers Brewhouse 109
Gunnison Brewery 168

H

Hops Grill & Brewery 190
Horsefly Brewing 170

I

Ironwork Brewery & Pub 36

K

Kannah Creek Brewing 212

L

Left Hand Brewing 90

M

Mahogany Ridge Brewery & Grill
 214

Main Street Brewery 215
Mountain Sun Pub and Brewery 191

N

New Belgium Brewing 58
New Planet Beer 111

O

Odell Brewing 72
Old Mill Brewery & Grill 37
Oskar Blues Brewery 97
Ouray Brewery 127
Ourayle House Brewery 171

P

Pagosa Brewing 92
Palisade Brewing 145
Pateros Creek Brewing 112
Phantom Canyon Brewing 50
Pints Pub 52
Pitchers Brewery & Sports Shack
 217
Pug Ryan's Steakhouse Brewery
 146
Pumphouse Brewery & Restaurant
 53

R

Revolution Brewing 73
Rifle Brewing 147
Rock Bottom Restaurant and
 Brewery 174
Rockslide Brewery 55
Rockyard American Grill &
 Brewing 149
Rocky Mountain Brewery 172

S

SandLot Brewery at Coors Field
 151
San Luis Valley Brewing 152

Shamrock Brewing 56
Silverton Brewery 129
Ska Brewing 194
Smugglers Brewpub 192
Steamworks Brewing 75
Strange Brewing 94

T

Three Barrel Brewing 131
Tommyknocker Brewery 154
Trinity Brewing 135
Twisted Pine Brewing 95

U

Upslope Brewing 77

W

Walnut Brewery 39
Wild Mountain Smokehouse &
 Brewery 132
Wynkoop Brewing 41

Y

Yak and Yeti 155

ABOUT THE AUTHOR

Ed Sealover has worked as a reporter for daily and weekly newspapers since 1993, including the *Rocky Mountain News* and *Colorado Springs Gazette*. He now reports for the *Denver Business Journal*, covering subjects ranging from state government to the brewing industry. Throughout his career, he's won twenty-six journalism awards in five states in categories including public service reporting, political reporting, investigative reporting and feature writing. He received his bachelor of science in journalism in 1995 from Northwestern University.

Ed has written about beer since 2003, having penned a former column in the *Gazette* and a current website called Beer Run Blog. He is also a member of the American Homebrewers Association. This is his first book.

Visit us at
www.historypress.net